PEOPLE
POWER

LYN SMITH

PEOPLE POWER

FIGHTING FOR PEACE
FROM THE FIRST WORLD WAR
TO THE PRESENT

With a foreword by
SHEILA HANCOCK

———

With 197 illustrations

Thames & Hudson

IN PARTNERSHIP WITH

IWM
IMPERIAL WAR MUSEUMS

Published on the occasion of the exhibition *People Power:*
Fighting for Peace at the Imperial War Museum, London
23 March–28 August 2017

First published in the United Kingdom in 2017 by
Thames & Hudson Ltd, 181A High Holborn,
London WC1V 7QX

Published in association with Imperial War Museums
www.iwm.org.uk

British Library Cataloguing-in-Publication Data
A catalogue record for this book is available from
the British Library

ISBN 978-0-500-51915-8

Printed and bound in China by Reliance
Printing (Shenzhen) Co. Ltd

To find out about all our publications, please visit
www.thamesandhudson.com. There you can
subscribe to our e-newsletter, browse or download our
current catalogue, and buy any titles that are in print.

CONTENTS

FOREWORD

Sheila Hancock

As a Quaker, I aspire to be a pacifist. Along with Winston Churchill, I firmly believe that 'to jaw-jaw is always better than to war-war'. But in the latest type of war, manifesting as terrorism, often carried out by random individuals who justify their savagery by claiming allegiance to a fanatical religion or cause, it is not clear how this belief in the power of persuasion can be effective. Had I chanced to be in Woolwich, with a gun in my pocket, in 2013 when Fusilier Lee Rigby was being hacked to death, would I have refrained from using it? I don't know. I only hope I would have had the courage of Ingrid Loyau-Kennett, who kept talking to the two killers, one with bloody hands holding a knife, until the police arrived, thereby possibly avoiding further carnage.

One answer to my dilemma, as for the conscientious objectors in the two world wars, would be not to have a gun in the first place. Which throws up the question of Britain's involvement in the arms trade. In July 2016, the Unite union issued a statement that, though they firmly believe in 'beating swords into ploughshares', the union had to think first and foremost of 'the protection and advancement of its members interests at work', which included the renewal of Trident. One is sympathetic with their predicament, but would not the billions spent on this outdated weapon be better expended providing alternative work in the area, and, above all, waging an all-out war, through education and improved opportunities, on the radicalization that leads to our modern dangerous scourge of extremism? I am comforted that many protesters against the Trident programme in Scotland and England will continue their mission until, as with Greenham, the missiles are deemed irrelevant in our changed world.

My own efforts at peacemaking have been easy, in fact, rather enjoyable: the CND marches, demos, protest meetings in Trafalgar Square and visits to the women at Greenham, especially the glorious day when thousands of women embraced the base and pinned beautiful pictures and objects to the ugly wire. The march against the Iraq War in 2003 was a deeply felt protest by people from all backgrounds, but there was still room for humour, as revealed in the banners. I particularly liked: 'Notts County supporters say make love not war (and a home win against Bristol would be nice).'

People power does seem to produce creativity. This book covers the years from 1914, but before that arch-pacifist Jesus was telling us all, including the Unite union, to turn our swords and spears into agricultural tools, Aristophanes was writing anti-war plays, and poets, novelists, artists and musicians have spoken to our souls of the horror of war for generations. I got myself into hot water with the press in 2014 by suggesting that the art installation of poppies in the moat of the Tower of London should be completed by being malevolently mown down by a tank, in the way that the servicemen and -women the poppies represented had been. I was worried the reaction to the art had become a beautiful veneration of war, rather than a reminder of the grotesque ugliness of the suffering.

Photographic images are particularly potent. Who can forget the Vietnamese child, her back

burned by napalm, running away with her terrified friends in the Vietnam War? Or the tiny mite washed up dead on the shore of Lesbos in 2015? We find these things painful, so most of us put them out of our minds. I was struck in the Brexit debate by how little discussion there was about the origins of the concept of a united Europe. As a child of the war, bombed, evacuated, full of hatred of the Germans, at one time married to an airman involved in bombing Germany, who in their turn hated him, I rejoiced at the idea of uniting with our erstwhile enemies to build a better world. Flawed, yes, but in many ways a triumph. But there are few of us left to remember.

I had completely forgotten many of the conflicts in this book. I had forgotten how one was appalled at the time by the idiocy of the missiles at Greenham that lumbered clumsily round the countryside, easily stopped by a group of women lying in the mud, who could also get into the camp with some wire-cutters and dance on the silos containing the weapon. The sheer incompetence of the defence system was disturbing. I had forgotten the all-consuming terror in my youth of The Bomb, and the conviction that the much-prized balance of power, which justified the development of nuclear weapons, could easily be blown out of the water by a madman – and God knows we had witnessed several of them during the war, and there are plenty still around now. We were told the destruction of lives and homes in Hiroshima and Nagasaki was to shorten the war. I was moved by the story in the book of the airman who commented, 'I think they may have saved our lives at the expense of our children's.'

This book reminded me of the massive scale of the slaughter and mayhem over the years and pushed me close to despair. But it also made me profoundly grateful to everyone who has tried to stop the devastation. Many felt the march against the war in Iraq in 2003 was a failure as we still went to war despite millions worldwide saying no. Sir John Chilcot's Inquiry recognized that the UK chose to join the invasion before 'the peaceful options for disarmament had been exhausted. Military action at that time was not a last resort.' It was a step in the right direction. Brian Haw's ten-year vigil in Parliament Square, when he was subject to physical attack and ridicule, was not in vain. Thanks to people like him, gung-ho attitudes to war are changing. I pay homage to all the people in this book and beyond, who have pleaded and prayed for peace. E. M. Forster was a pacifist. Something he wrote in *Two Cheers for Democracy* (1951) sums up what this book is about:

> *I believe in aristocracy...Not an aristocracy of power, based upon rank and influence, but an aristocracy of the sensitive, the considerate and the plucky. Its members are to be found in all nations and classes, and all through the ages, and there is a secret understanding between them when they meet. They represent the true human tradition, the one permanent victory of our queer race over cruelty and chaos.*

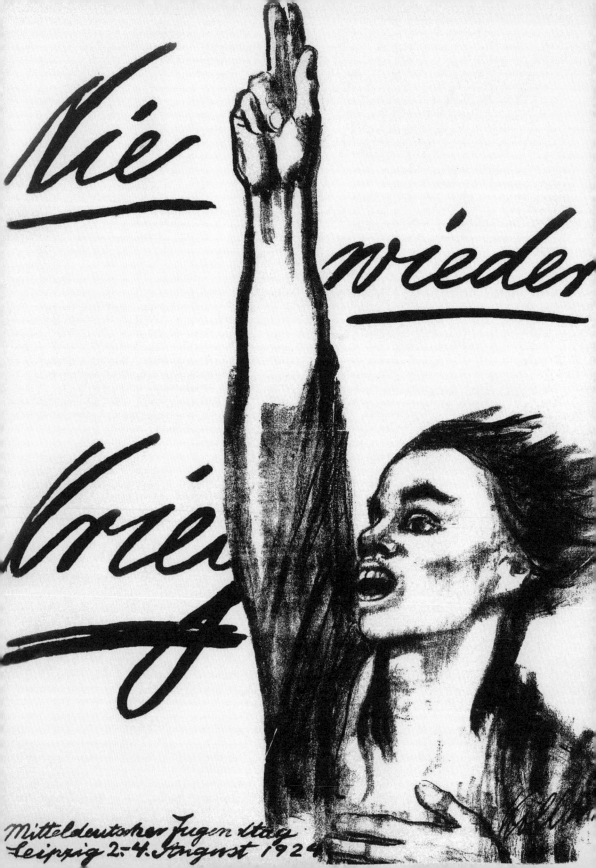

INTRODUCTION

This book accompanies the first major exhibition of its kind at the Imperial War Museum (IWM), London. Based on testimonies from the IWM's vast collection of anti-war recordings, documents and photographs, it traces the complex and evolving history of the British anti-war movement from the First World War to the present, against the backdrop of international events, through the organizations involved and the individuals who made a stand. It also considers some of the ethical and practical problems surrounding the issues of war, peace and conflict resolution.

The story of one of the most enduring movements in British history emphasizes how the museum's remit has always been much wider than the sharp end of war. As its twenty-first annual report, published on the eve of the Second World War, explained, as well as providing a lasting memorial to common effort and sacrifice, the IWM also aimed to demonstrate the futility of war after the carnage of the First World War, which had been regarded as 'the war to end war'.

The modern peace movement emerged in January 1916, in the middle of the First World War, when national conscription for military service was introduced for the first time in British history, and a new group, conscientious objectors (COs) – popularly known as 'conchies' – came into being. In all, 16,300 COs faced tribunals during that war. They were branded as cowards, reviled and persecuted. Many endured repeated prison sentences; some, such as Howard Marten, faced the death penalty; a number

ended the war with impaired health; and sixty-nine died. Yet by 1919 it was generally accepted that a man had the right to follow his conscience in time of war, and the foundations had been laid for all subsequent protest in Britain against war. Among the major belligerents in the First World War, only Britain and the United States, with their traditions of individual liberty and religious freedom, recognized a legal right to conscientious objection.

The story continues through the interwar period, covering the expansion of the peace movement and its increased public legitimacy. Notable personalities were influential to the cause in these years, not least Mahatma Gandhi, whose philosophy of non-violence took a firm hold that has lasted to the present day (as a young boy the future Labour politician Tony Benn sat at Gandhi's feet, and was deeply impressed). In the 1920s and 1930s influential peace organizations were founded, such as War Resisters' International and the Peace Pledge Union (PPU). The PPU, under the leadership of the charismatic parson Dick Sheppard, became particularly important, attracting a vast following of registered supporters by 1938. But, with the rise of Hitler and the spread of totalitarianism during the 1930s, a crisis occurred that led to much painful heart-searching within the anti-war community. Many left the movement, arguing, like the author A. A. Milne, that the Fascist advance had to be stopped. Nonetheless, during the Second World War over 60,000 men applied for CO status, almost four times as many as in the First World War. After women were conscripted in December 1941, 1,074 of them registered as COs.

Testimonies from the Second World War reveal important changes in the treatment of those who opposed war: there was a concern to match objectors to work that they could conscientiously perform and find satisfying, unlike the boring, menial nature of the alternative labour offered to the conchies of the previous war. They also had a comparatively easier time with the authorities and the public, although brutality (albeit more random) did occur, and many suffered physical and mental abuse. There was no major movement in this war to fight against conscription; that battle was in the past. Also, as the COs were more dispersed and less liable to repeated prison sentences, the camaraderie that had been so vital for their counterparts in 1914–18 was not so strongly developed and could lead to feelings of loneliness and isolation. The exceptions were members of tight-knit

units such as the Friends Ambulance Unit and Parachute Field Ambulance, who performed their humanitarian service alongside fighting troops, bonding together as they shared the risks and dangers of war zones. Some COs were confronted by excruciating dilemmas, especially when the full horrors of Nazism began to emerge, which caused them to revise their stance and enter the forces. Conversely, some combatants, witnessing the reality of total war, opted to leave, claiming CO status.

Conscription continued into the postwar period with the introduction of National Service in 1949 for young men between the ages of eighteen and twenty. Just over 9,000 registered as COs, a much smaller proportion than in the Second World War – this was in line with the declining support for the anti-war movement in the years immediately after the war. With the emergence of the anti-nuclear campaign in the late 1950s the movement began to revive, but not quickly enough to have much impact on the attitudes of conscripts, as National Service ended in 1960. Since then service in the armed forces has been voluntary, so Britain has never experienced anything like the anti-draft protests that erupted in the United States during the Vietnam War in the late 1960s and early 1970s.

During the Cold War, it was the growing awareness of the nature of atomic weapons and the developing nuclear arms race between the two superpowers – the United States and the Soviet Union – that gave rise to a new kind of protest, more related to the moral issue of the survival of mankind than to war. From the late 1950s, this led to the formation of a range of anti-nuclear organizations, of which the Campaign for Nuclear Disarmament (CND), launched in 1958, and the Greenham Common Women's Peace Camp, established in the 1980s, are the most well known. Interviews with activists from this period chart the successes and failures of the so-called 'nuclear pacifists', as well as the splits and schisms within the anti-nuclear movement and between this and the more traditional pacifist organizations such as War Resisters' International and the Peace Pledge Union.

The end of the Cold War and initial hopes of a more peaceful world led to a lull in anti-war and peace campaigning. But the failure of the 'peace dividend', which resulted in a new range of regional and intrastate conflicts, led to a resurgence. The first Gulf War 1990–91, the Balkan wars of 1991–95, the start of the Afghanistan War in 2001 and continuing conflict in the Middle

East have had considerable impact on the movement, not least because of the vast numbers of civilian deaths graphically portrayed in the press and on TV. Images of devastation, streams of refugees and terrible human suffering resulted in widespread revulsion against war. These events, together with a growing suspicion of the basis for another conflict building up in Iraq, fed the huge public outcry against that impending war on 15 February 2003 when vast marches of protesters took place across Europe, the United States and in cities worldwide. In the UK, two million are said to have taken to the streets of London to express their discontent, many carrying placards with the slogans 'No' and 'Not in My Name'. This was a record number for any British protest. It also led to increases in the membership of new anti-war organizations such as Stop the War Coalition, the Movement for the Abolition of War and, later, after the war had started, Military Families Against the [Iraq] War. Yet the war went ahead, probably the most unpopular war in British history, and it was subsequently subject to a devastating critique in the report of the Iraq Inquiry, chaired by Sir John Chilcot, which was published in July 2016.

There is widespread acceptance that it was the Iraq War of 2003, and the rise of sectarianism during the subsequent occupation, which provided the opportunity for the birth of the insurgency group that morphed into the so-called Islamic State in 2014. Its evolution and spread to Syria and throughout the whole region of the Middle East, North Africa and beyond has resulted in what has been called an 'endless war', and revealed the failure of George W. Bush's War on Terror. This new type of war against terrorism presents another kind of challenge to the British anti-war movement, in addition to its long-standing concerns, including resistance to the renewal of the Trident missile system.

The twentieth century is now considered the most bloody in history, claiming 187 million deaths in war. A far higher percentage of war fatalities were civilian than in any previous era: in the First World War, one-fifth of casualties were civilian; the figure rose to two-thirds in the Second World War. In the twenty-first century, in the conflicts such as those in Iraq and Syria, the estimated figure is as high as 90 per cent. Along with the horrendous number of civilian casualties there have also been massive displacements of populations. According to the UN Refugee Agency (UNHCR), 65.3 million refugees fled the conflict in Iraq and Syria in the period from 2005 to 2015 – the highest number of displaced

persons since the end of the Second World War, when the whole of Europe was on the move. But as the following chapters reveal, the past hundred years have seen the rise and evolution of an active and persistent anti-war movement in Britain. In the turbulent years since the First World War it has waxed and waned in response to changing circumstances, and although it is not always easy to quantify its impact, it has endured, and continues to demonstrate a robust resistance to warfare and a vigorous commitment to peace, as well as continuing the non-violent activism that started with Mahatma Gandhi.

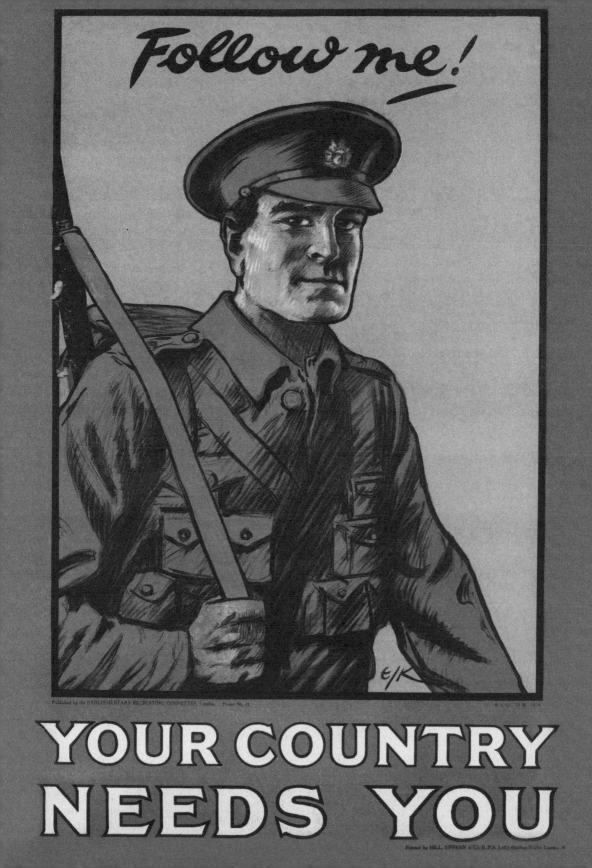

1 THE FIRST WORLD WAR: THE FOUNDATION IS LAID 1914-1918

OPPOSITE Recruitment posters such as this one encouraged huge numbers of young men to volunteer to join the forces in the early months of the First World War.

Within days of the outbreak of war in August 1914, Lord Kitchener, the Secretary of State for War, initiated a major expansion of Britain's land forces, calling for a series of 'New Armies' to be raised and in due course put in the field with the vast number of troops now mobilizing across Europe. Unlike the Continent's conscripts, however, Kitchener's men were to be volunteers, raised from thousands of young men who enthusiastically flocked to the recruitment centres, keen to join the fight before it was over. Eighteen months later, 2,675,149 Britons had volunteered. By this stage, however, the government and public had begun to appreciate just how long and costly the war was going to be. The early war of movement over open ground had given way to trench warfare and stalemate on the Western Front with no breakthrough in sight, and the total number of killed, wounded and missing passed half a million following the ill-fated Dardanelles campaign of 1915. Against this background, the number of volunteers began to decrease significantly. A form of voluntary registration was introduced by Lord Derby, director-general of recruiting, in the autumn of 1915, but it became clear that many more men were going to be required to fight the long war of attrition that lay ahead: conscription had become unavoidable.

On 5 January 1916, the Prime Minister, Herbert Asquith, introduced a Military Service Bill to the House of Commons that established national conscription for the first time in British

15

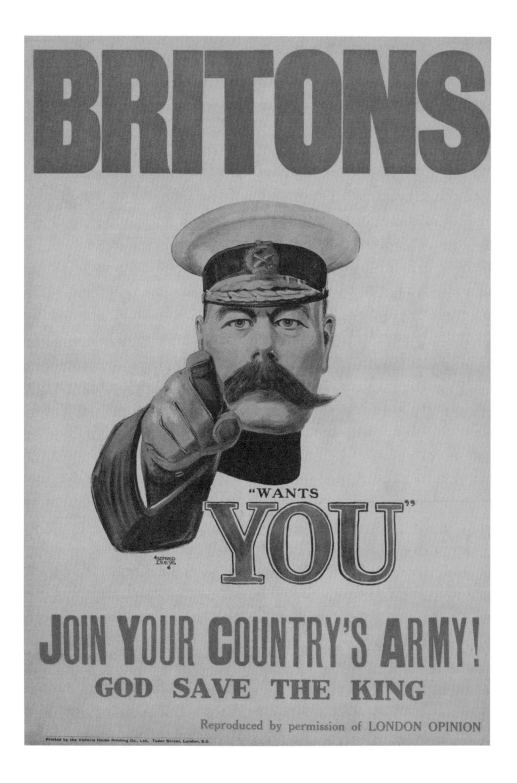

THE VETERAN'S FAREWELL.

"Good Bye my lad, I only wish I were young enough to go with you."

ENLIST NOW!

history. The Bill was enacted on 24 January by 383 votes to 36, after heated and bitter debate. Opposition came not only from pacifists, but also from those arguing on political, moral, legal and humanitarian grounds. By the terms of the Military Service Act, from 2 March 1916 single male citizens aged between 18 and 41 were liable for call up; after a few months the terms were extended to include married men. Exemptions, subject to appearance before a tribunal, were granted for those doing work of national importance; those whose military service would cause serious family hardship owing to financial, business or domestic obligations; those who were ill or infirm; and those with a conscientious objection to bearing arms. It was with this last category that the 'conchies', as they were popularly known, came into being: men who were prepared to go to great lengths to stand up for their beliefs, forming a movement that, in effect, challenged the authority of the state.

The terms pacifism and conscientious objection are often used synonymously, but there is a difference. Pacifism in its basic sense is the belief that all war and violence is wrong and should be rejected; its historical roots go back two thousand years to the teachings of Jesus Christ, with a significant more recent manifestation being the Peace Testimony of the Religious Society of Friends (Quakers) in 1661. Pacifists have always been central to the anti-war movement; logically, in time of war pacifists should be conscientious objectors (COs), but not all COs need be pacifists. Non-pacifist COs may disapprove of war and realize that its prevention must always be attempted, but accept that it is sometimes necessary. Other protesters might take the view that war itself is not wrong but some part of it is unacceptable, or perhaps a particular conflict may be considered unjustified by them.

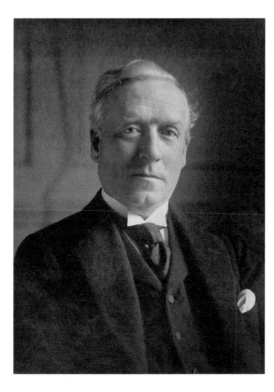

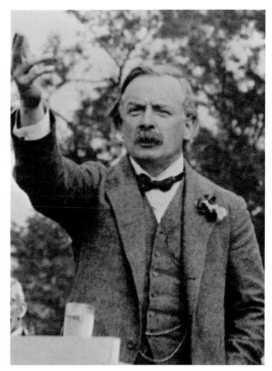

Conscientious objection, as with pacifism, is of a highly individual nature and COs came from different social, political and educational backgrounds; they had a variety of arguments to support the legality and morality of their objection to military service. There were socialists, who believed that the working men of the world should unite, not obey orders to kill each other; those who had religious grounds, including Christians of different denominations, Muggletonians, Jehovah's Witnesses, Plymouth Brethren, Quakers, Christadelphians; and members of intellectual coteries such as the Bloomsbury Group, who believed that the war was a fight against the militarism embodied by Germany and conscription made Britain no better than its enemy. There were great differences in the way these individuals and

ABOVE, LEFT Herbert Asquith, Liberal Prime Minister from 1908 to May 1915 and leader of the coalition government from May 1915 to December 1916, when he was replaced by David Lloyd George.

ABOVE, RIGHT David Lloyd George, Minister of Munitions, 1915–16, giving a rousing speech in Dundee, Scotland. He was in favour of conscription, but also wanted skilled men to be kept working in their factories.

OPPOSITE A poster detailing who could be called up and who was exempted under the terms of the Military Service Act of 1916.

THE
MILITARY SERVICE ACT,
1916,

APPLIES TO UNMARRIED MEN WHO, ON AUGUST 15th, 1915, WERE 18 YEARS OF AGE
OR OVER AND WHO WILL NOT BE 41 YEARS OF AGE ON MARCH 2nd, 1916.

ALL MEN (NOT EXCEPTED OR EXEMPTED),

between the above ages who, on November 2nd, 1915, were Unmarried
or Widowers without any Child dependent on them will, on

Thursday, March 2nd, 1916

BE DEEMED TO BE ENLISTED FOR THE PERIOD OF THE WAR.

They will be placed in the Reserve until Called Up in their Class.

MEN EXCEPTED:

SOLDIERS, including Territorials who have volunteered for Foreign Service;
MEN serving in the NAVY or ROYAL MARINES;
MEN DISCHARGED from ARMY or NAVY, disabled or ill, or TIME-EXPIRED MEN;
MEN REJECTED for the ARMY since AUGUST 14th, 1915;
CLERGYMEN, PRIESTS, and MINISTERS OF RELIGION;
VISITORS from the DOMINIONS.

MEN WHO MAY BE EXEMPTED BY LOCAL TRIBUNALS:

Men more useful to the Nation in their present employments;
Men in whose case Military Service would cause serious hardship owing to
exceptional financial or business obligations or domestic position;
Men who are ill or infirm;
Men who conscientiously object to combatant service. If the Tribunal thinks
fit, men may, on this ground, be (*a*) exempted from combatant service only
(not non-combatant service), or (*b*) exempted on condition that they are
engaged in work of National importance.

Up to March 2nd, a man can apply to his Local Tribunal for a certificate of exemption. There is a Right of Appeal.
He will not be called up until his case has been dealt with finally.
Certificates of exemption may be absolute, conditional or temporary. Such certificates can be renewed,
varied or withdrawn.
Men retain their Civil Rights until called up and are amenable to Civil Courts only.

DO NOT WAIT UNTIL MARCH 2nd.
ENLIST VOLUNTARILY NOW.

For fuller particulars of the Act, please apply for Leaflet No. 65 to the nearest Post Office, Police Station, or Recruiting Office.

groups reacted to the war and how much compromise they were prepared to make. Given the sheer complexity of the issue, it is no wonder that the tribunals, when attempting to test the sincerity of would-be COs, found the task so daunting.

The Labour Party, the most internationally minded of the political parties, opposed the war in principle, but once hostilities started divisions emerged, with many members swept along by the patriotic fervour of the time. The German invasion of Belgium on 4 August 1914, as well as providing justification for the altered stance towards the war, led to a change in the leadership of the party. Ramsay MacDonald, a notable anti-war campaigner, resigned as leader when the party voted to support the government's request for war credits of £100 million. He was replaced by Arthur Henderson who, although he had co-signed an appeal to the British people on behalf of the International Socialist Bureau on 1 August that said 'Down with war', declared that his main concern once the conflict had started was national unity and safety. Henderson became the main figure of authority within the party and when Asquith formed a coalition government in May 1915, bringing in Opposition figures, Henderson became the first Labour politician to be made a member of the Cabinet.

Rifts in the Labour movement were also manifest in the different stances of the Labour group in Parliament, the Labour Party, which had been founded in 1906, and the Independent Labour Party (ILP), a socialist party established in 1893, which had some 30,000 members by 1914. With its ethically based objection to war and militarism, the ILP steadfastly refused to

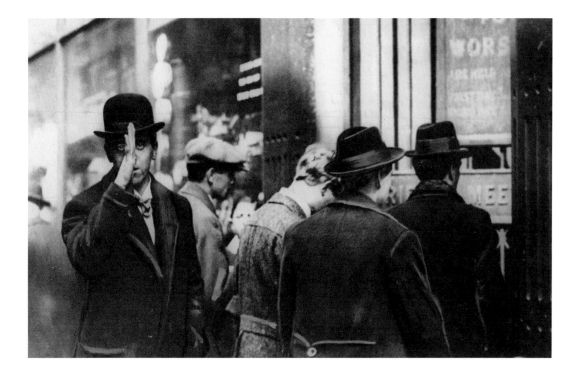

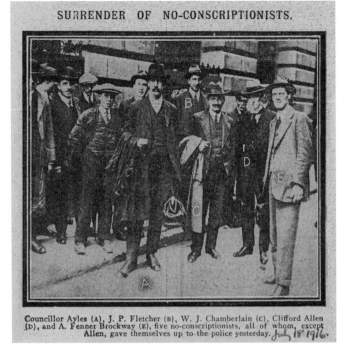

SURRENDER OF NO-CONSCRIPTIONISTS.

Councillor Ayles (A), J. P. Fletcher (B), W. J. Chamberlain (C), Clifford Allen (D), and A. Fenner Brockway (E), five no-conscriptionists, all of whom, except Allen, gave themselves up to the police yesterday. *July 18 1916*.

OPPOSITE Young men entering the No-Conscription Fellowship's second national convention in April 1916. One of them clearly shows his objection to military service.

RIGHT The *Daily Mirror*, 18 July 1916, announces the surrender of the leadership of the No-Conscription Fellowship to the police to face the consequences of their peace activities. Clifford Allen and Fenner Brockway are on the extreme right, marked by the letters D and E.

support the conflict; Keir Hardie and George Lansbury, both leading members of the ILP, continued to speak passionately against it.

The Union of Democratic Control (UDC), a non-partisan pressure group that was concerned about the lack of democratic accountability in the making of British foreign policy, was founded in September 1914 by a number of well-known MPs, including Ramsay MacDonald, Charles Trevelyan and Arthur Ponsonby, and journalists such as Norman Angell and E. D. Morel. Under their guidance, the UDC focused its campaign on the causes of war and on preventing another. It sought to obtain a full examination of the war aims both in Parliament and among the wider public and it also opposed conscription, censorship and other wartime restrictions on civil liberties, which had been imposed under the Defence of the Realm Act (DORA), enacted on 8 August 1914. The Quakers were strong

supporters of the UDC and many members of the women's suffrage movement, such as Helena Swanwick and Florence Lockwood, forged close links with the Union. Towards the end of the war the UDC had 10,000 members in over one hundred branches across Britain and Ireland.

In November 1914, with the prospect of conscription on the horizon, a group of pacifists set up the No-Conscription Fellowship (NCF); this organization was to prove of immense benefit to COs and their families. Fenner Brockway, the editor of the anti-war ILP newspaper *Labour Leader*, credited his wife, Lilla, with the idea that those who would refuse military service should get together. Brockway became the honorary secretary and Clifford Allen its chairman. Membership was open to men of all political and religious opinions liable for call up who would refuse to bear arms for

conscientious reasons. Most of those who joined were of military age and many were Quakers or other religious pacifists. Two-thirds of the membership belonged to the ILP. As Brockway later explained, 'I wouldn't say that we had any common philosophy then... But the statement of principles, which those who joined the No-Conscription Fellowship signed, spoke of the sanctity of human life, and its essence was pacifist.'

Once conscription started, the NCF developed into one of the most efficient and effective organizations the British peace movement has ever had. This was underlined by an impressive intelligence service that helped provide information for the records department established by Catherine Marshall, a militant suffragette. As well as keeping track of those who were arrested and imprisoned, the NCF advised men on how to present their cases at tribunals and monitored these. A visitation department was also formed, which organized prison, camp and guardroom contacts and visits. Means were also found of communicating with the imprisoned men, providing the latest news of policy decisions and smuggling newspapers and journals to them. A press department supplied the newspapers with information on the treatment of prisoners as well as the work of the NCF. More than a million copies of pamphlets and leaflets were published by the NCF's literature department and from March 1916 the NCF published its own weekly newspaper, the *Tribunal*. With its robust advocacy and articles written by contributors such as the philosopher Bertrand Russell, Fenner Brockway and Clifford Allen, it reached a circulation of 100,000 at its peak. A campaign department organized agitation and petitions for the release of COs, as well as innumerable private deputations to government bodies. The political department kept MPs informed as to the treatment of prisoners, and drafted questions for MPs like Philip Snowden, a Labour politician who was against conscription, to put to ministers. Help was given to dependents if necessary. Members were also alerted to watch railway stations to check whether COs were being sent abroad.

In December 1914, shortly after the NCF was created, the Fellowship of Reconciliation (FOR), an association of Christian pacifists of all denominations, was founded by the English Quaker Henry Hodgkins and others. Recognizing the need for healing and reconciliation in the world, the FOR formulated a vision of the human community based upon the belief that love and non-violence in action have the power to transform unjust political, economic and social structures. By November 1915, over 1,500 members were meeting in fifty-five local branches in the UK.

In April 1916, soon after the Military Service Act took effect, the NCF held its second national convention at Devonshire House, the Society of Friends' Meeting House in Bishopsgate, London. Over 2,000 young men from 198 branches across the country attended. During the conference, the framework of resistance to bearing arms was laid down. The men voted to reject service as stated in the Act and refused to engage in all alternative work likely to contribute to the war effort. The exact form of protest was left to the individual. On the second day of the gathering the names of fifteen COs already arrested were

OPPOSITE Emmeline Pankhurst leaving for a lecture tour of the USA and Canada, with her daughters Christabel (centre) and Sylvia (right) at Waterloo Station, 1911.

announced. To finish, Clifford Allen read out the agreed pledge, which vowed, 'Whatever the penalties awaiting us, to undertake no service which for us is wrong.' As members emerged from the convention, pro-conscription hecklers outside gave a taste of the vitriol and hostility that was to increase as the war progressed.

WOMEN'S ROLE IN THE FIRST WORLD WAR

Military conscription for women was not considered in the First World War, but women played an important role in terms of supporting the war effort or sometimes entirely opposing it. The women's suffrage movement had gained in strength by 1914 with a formidable reputation for its daring and ever-increasing militant actions. It was also notable for the fortitude of its members, many of whom, including Emmeline Pankhurst and her daughters, Christabel and Sylvia, had endured repeated prison sentences, during which they had gone on hunger strike and suffered the painful, degrading process of force-feeding. With war's outbreak, Emmeline and Christabel soon decided to halt their pacifist activity and suffrage campaigning and concentrate all their energies on supporting the war. In fact, with Emmeline Pankhurst in the lead, the suffragettes were active in the drive to enlist men in the forces as well as in the recruitment of women munitions workers; and some of its

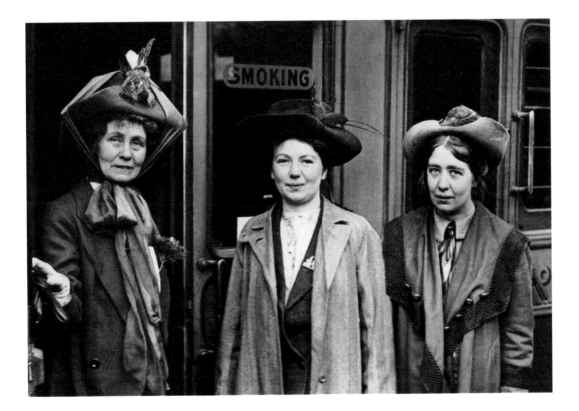

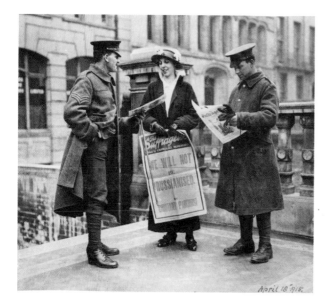

April 18 1915.

LEFT The *Suffragette* newspaper is handed out to British servicemen in April 1915. The poster advertises an article entitled 'We will not be Prussianised' by Christabel Pankhurst, the paper's editor.

BELOW A group of women, and one man, listen with obvious interest to a speaker, probably a suffragette or some other women's rights activist.

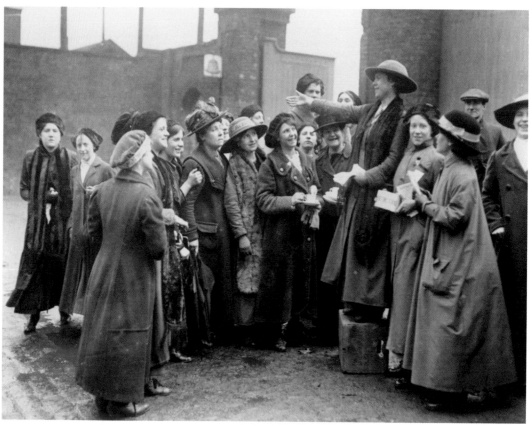

members were soon busy handing out white feathers, the traditional symbol of cowardice, to 'shirkers' and 'cowards'. Not all suffragettes agreed with this abrupt change of mood, and many, including Sylvia Pankhurst, maintained a staunchly anti-war stance.

This group of women, ridiculed in the press as 'peacettes', wished to send 180 delegates to the International Congress of Women at The Hague in April 1915. Owing to the problems of wartime travel, only three managed to attend: Kathleen Courtney, Emmeline Pethick-Lawrence and Chrystal Macmillan. They were among some 1,200 delegates from twelve countries, including those from opposing sides in the war, who attended the four-day conference. The main demands of the congress were: co-operation in place of conflict; an end to the bloodshed; the establishment of a just and lasting peace; and women's participation in the postwar peace settlement. The congress was considered an outstanding feat of organization with the procedure carefully worked out in advance, and was notable for its dignified, internationalist approach. An enlightened rule, established in order to encourage positive thinking, banned any discussion on apportioning blame for the war, as well as for a belligerent country's actions.

Soon after the congress ended, thirteen delegates, divided into two envoy groups, made thirty-five separate visits to governments in the capitals of fourteen different European states in a remarkable attempt at unofficial diplomacy. Although each of the statesmen approached assured the envoys that he was sympathetic to their suggestions, not one adopted them. In the United States, however, which did not enter the war until 1917, President Woodrow Wilson thought that the congress resolutions were 'by far the best formulation which up to the moment has been put out by anybody'. He adopted many of them in his famous 'Fourteen Points' speech in January 1918 that laid the foundations of the League of Nations.

When one considers that the congress was held in a European country in the tenth month of the war, with delegates from several countries, including those at war with each other, that deliberations were harmonious; and that it was followed by determined attempts at unofficial diplomacy in a range of states in wartime, the event should be seen as not only symbolic and extraordinary but also as one of the most creative initiatives against the First World War.

An important outcome of the Hague Congress was the creation of the Women's International League for Peace and Freedom

OVERLEAF, LEFT A cartoon in the *Daily Express*, 28 April 1915, mocks the 'peacettes' stuck at Tilbury waiting in vain for a boat to Holland.

OVERLEAF, RIGHT ABOVE The main platform at the International Congress of Women at The Hague in 1915. This was the first international meeting to discuss what the principles of any peace settlement should be.

OVERLEAF, RIGHT BELOW Delegates to the International Congress of Women aboard the SS *Noordam*. The group includes the British campaigner Emmeline Pethick-Lawrence, the American social activist Jane Addams and Annie E. Malloy, president of the Boston Telephone Operators Union.

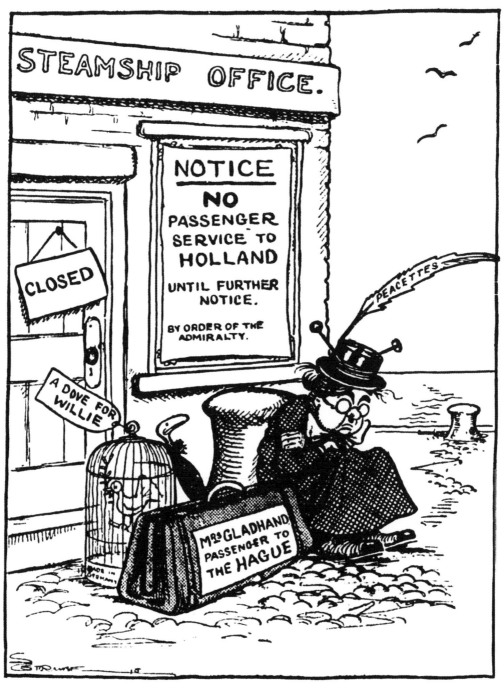

A LITTLE FIT OF THE (H)AGUE.

[*Copyright by the London "Daily Express."*]

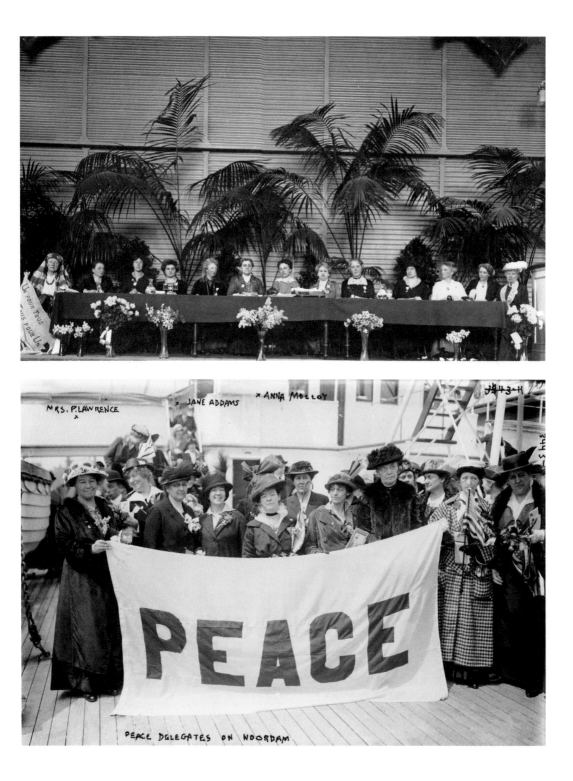

MRS. P. LAWRENCE
X

X JANE ADDAMS

X ANNA MOLLOY

PEACE

PEACE DELEGATES ON NOORDAM

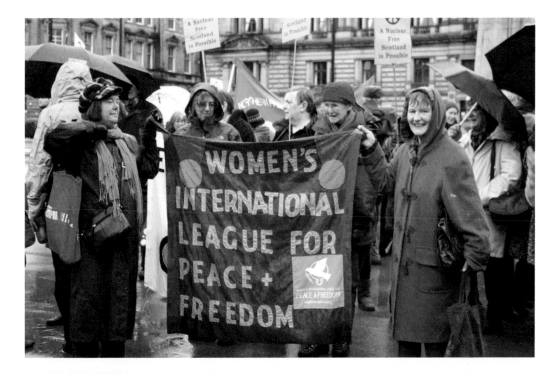

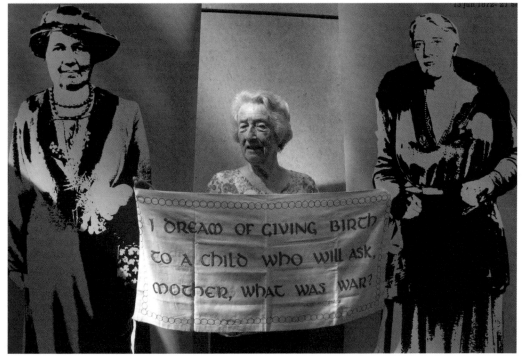

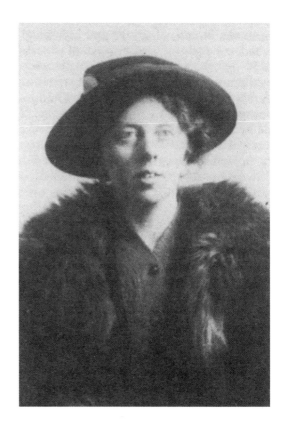

(WILPF), although it was not formalized until the second International Congress of Women held in Zurich in May 1919. Its first president was the American social activist Jane Addams, who later won the Nobel Peace Prize. The WILPF endures to the present day, a fitting tribute to the International Congress of Women in 1915.

In Britain, once conscription was introduced in 1916, women played a vital role in providing practical and psychological support to COs, serving on committees, attending tribunals, speaking at public meetings against the war, and keeping homes and businesses going. By 1918, when most of the leadership of the NCF was in prison, it was the women supporters who helped to keep the organization alive, with Catherine Marshall, the acting honorary secretary, taking over many of Clifford Allen's responsibilities while he was in prison. Other pacifist women, mainly from the upper and middle classes, opted for humanitarian service in the Voluntary Aid Detachment (VAD), or drove ambulances with the First Aid Nursing Yeomanry (FANY).

THE TRIBUNAL SYSTEM

Conscription started on 2 March 1916 and by the end of that month 2,000 tribunals had been established to hear appeals from those who wished to be exempted from service. Initially, the tribunals were under the aegis of the War

Office, but in 1917 the Ministry of Labour and National Service took control of all recruiting matters. Tribunals were composed of eight or nine members (mostly men) appointed by the local borough or district council. They were local worthies who generally had very little legal experience, and were often ignorant of the nature of the religious or political beliefs on which much of the objection to war was based, and the majority had a class-based suspicion of socialism. Although members were meant to have 'impartial and balanced judgment', many were ardent supporters of the war, apart from a small number of Quakers. A military representative also served on the panel; his task was to oppose all claims for conscientious objection and to argue the army's need for manpower. Hearings were held in public and often lasted no more than about five minutes. Applicants were allowed to have a friend or a solicitor to act as a character witness. The justice of the system depended largely on the way in which tribunals interpreted their powers and there were inevitably variations and inconsistencies between panels.

Tribunals had four options to choose from: refusal of exemption; exemption from combatant duty only; exemption conditional on undertaking work of national importance; and absolute or unconditional exemption. If the applicant was turned down, he could appeal and ultimately go before a central tribunal in London.

Religious objectors found it easier to convince tribunals of their sincerity than those who objected on moral, humanitarian or political grounds. Many applicants discovered that it was difficult to place themselves in any definite category, as Stephen Winsten later explained, 'I found that I just couldn't say "I'm a political conscientious objector or a religious conscientious objector". I just couldn't label myself.' Not

surprisingly, he was refused exemption. The writer and member of the Bloomsbury Group Lytton Strachey appealed for absolute exemption on grounds of health and conscience. He expected that after a medical examination and appearance before a tribunal he would be exempted but made to do clerical work in aid of the war effort. His tribunal at Hampstead Town Hall on 16 March 1916 became a celebrated case: confronted with the question, 'Tell me, Mr Strachey, what would you do if you saw a German soldier attempting to rape your sister?', he replied 'I should try and interpose my own body.' Anticipating a judgment that would oblige him to do war work, Strachey was prepared to refuse and go to prison. In the event, he was declared medically unfit for any kind of service.

COs broadly fell into two categories, which were often at odds with one another. Alternativists were those who rejected military service but were prepared to accept alternative forms of service: non-combatant duties in the army, including enlistment in the Royal Army Medical Corps (RAMC); civilian work of national importance; and humanitarian relief work. Civilian work to which they were assigned included agriculture, market gardening, forestry, food supply, transport, mining, shipping, education, and in hospitals, infirmaries and asylums. The alternativists also included those working with the Friends War Victims Relief Committee (FWVRC), which concentrated its efforts on civilians, and the Friends Ambulance Unit (FAU), which was willing to work alongside the fighting troops.

In contrast, the absolutists were those COs who were unwilling to accept anything except absolute or unconditional exemption (which was granted in only 200 cases), as they were not prepared to help the war in any way. They

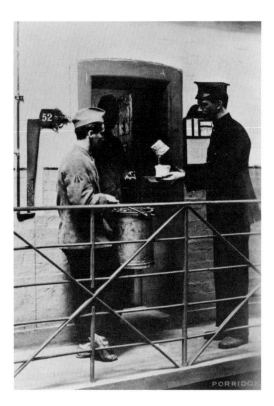

LEFT Porridge being served to a conscientious objector in solitary confinement.

OVERLEAF, LEFT A conscientious objector in solitary confinement stands on a stool to gaze at the outside world.

OVERLEAF, RIGHT An interior of a prison cell, thought to be Wormwood Scrubs, depicting the very harsh conditions for wartime inmates.

were uncompromising in their opposition to conscription and refused any negotiation with the authorities. Of 16,300 COs in the First World War, 1,300 were absolutists. Their applications rejected, they were arrested and taken to the army barracks or camp to which they had been assigned. Sooner or later they would disobey an order – refuse to don an army uniform, for instance – and were then subject to a court martial followed by a prison term. Initially, a standard sentence was 112 days' hard labour, although there could be remission for good conduct. After serving his sentence, the CO was re-arrested as a deserter, court-martialled once more and returned to prison – the so-called 'cat-and-mouse' system. It is calculated that some 655 objectors were court-martialled twice, 591 three times, 319 four times, 50 five times, and 3 six times. As the war dragged on, sentences were increased to up to two years' hard labour.

CONSCIENTIOUS OBJECTORS IN DETENTION

The absolutist George Dutch, who experienced repeated prison sentences from 1916, gave a vivid description of the solitary-confinement cell in Wandsworth detention barracks where he was incarcerated for refusing to put on an army uniform.

It was an underground cell, regulation size, very dirty and being in the basement, the only light was through a skylight in the roof – a dirty skylight. The only piece of furniture was

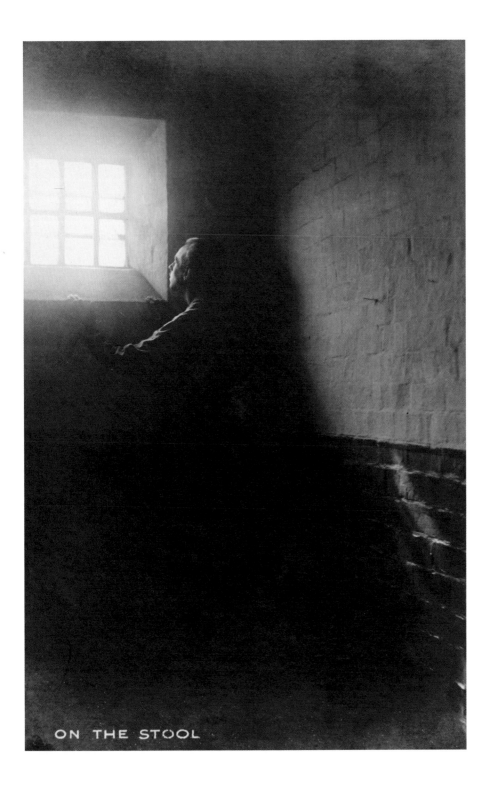

ON THE STOOL

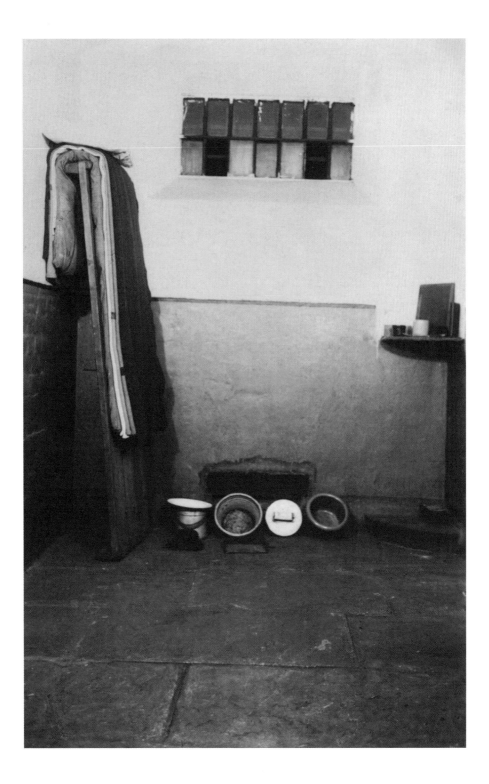

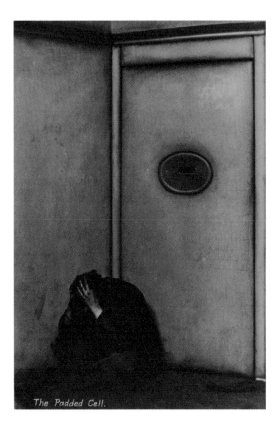

The Padded Cell.

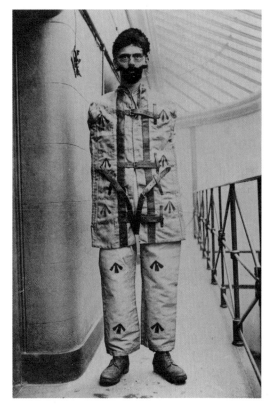

a round piece of wood, which was clamped with iron bands into the wall so that if you sat you had to sit upright. And a bed-board which was clamped down into the floor, which couldn't be moved. There was no bedding at all. You were under punishment and you were on a bread-and-water diet. There were two little wooden pots, one for toilet purposes and the other for drinking water. I'm afraid that they used to get them mixed up, but they didn't care. You never got out of the cell for anything and there was nothing to do in the cell...After three days – the time of the punishment – I was taken to the commanding officer and given another three days.

ABOVE AND OPPOSTIE Three of the postcards published by the No-Conscription Fellowship to show the worst possible extremes of the treatment meted out to conscientious objectors, including a padded cell and a restraining suit for those deemed 'difficult'.

OVERLEAF A parody of Rudyard Kipling's poem 'If' by William Harrison, written in Wormwood Scrubs, March 1918.

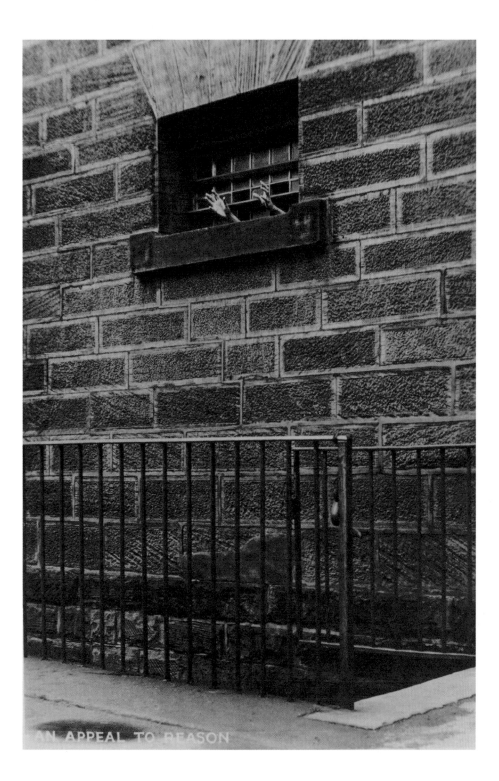

Parody of Kipling's 'If'

William Harrison

———

If you can talk and not get bread and water,
Or if reported take your pegging like a man;
If you can scrub like any woman's daughter,
And eat your scanty dinner from a rusty can;
If you can 'pick that step up' every morning,
And 'Swing those arms' as round the ring you crawl;
If you can rise before the daylight's dawning,
And wash your share of landing in the hall;
If you can take the daily Wormwood rumour,
With rather more than just a pinch of salt;
And treat as nought the officer's ill humour,
But simply think his liver is at fault;
If you can bear to hear the news you're given
Change and increase until it's nowise true;
And though to tell it truly you have striven,
Keep calm when its new version comes to you;
If you can hope, and not get tired of hoping,
For the freedom which must come soon or late;
And never let your comrades see you moping,
But patiently and gladly work and wait;
If you can watch your shadow getting thinner,
And still with smiling face go bravely on;
If you can think of your last decent dinner,
And not complain and think you're put upon;
Then my brother, though all the world may scorn you,
And make your name a jest for thoughtless folk;
You're the saviour of the country that has borne you,
You'll surely break Conscription's evil yoke.

This routine went on for about twenty-seven days, at which point Dutch was informed that His Majesty had granted him a free pardon: 'It sounds lovely, but it only meant that I was to be handed over to an escort and that I was free to be a soldier, which of course I continued to refuse to be.'

Francis Meynell, chairman of the London branch of the NCF and later a distinguished typographer and founder of the Nonesuch Press, subsequently recalled his experience as an absolutist CO. On receiving his call up, rather than await arrest, he surrendered at a police station and was taken to Hounslow Barracks. He decided to go on hunger strike and to refuse all liquids immediately, hoping this would 'quickly bring me to the point of death...The painful thing was the drying up of my tongue; it was really like a little piece of wood in the decaying barrel of my mouth.' After ten days, close to death, Meynell was discharged as unsuited for military service.

There are numerous recorded cases of the brutal treatment COs suffered in the various army camps where they were initially detained. Details of what 19-year-old Jack Gray endured at Hornsea Detention Camp in East Yorkshire were passed to the NCF in June 1917 by James Crawshaw, another objector, and published in its News Sheet no. 10. Having listed a series of ordeals designed to break him as 'being beyond physical endurance', Crawshaw described how on another day, Gray

was stripped naked, a rope tightly fastened round his abdomen, and he was then pushed forcibly and entirely immersed in a filthy pond in the camp grounds eight or nine times in succession and dragged out each time by the rope. The pond contained sewage. He says the effect of the tightening of the rope after the

second immersion cannot be described, and was still more intolerable when, after the last immersion, they put upon his wet and muddy body a sack with a hole through for the head and one for each arm.

The letter went on to say that eight of the soldiers told to carry out these orders refused to do so and took the consequences.

Whatever the prison, civil or military, the majority of COs suffered insults, threats and appalling conditions. This led many of them to become active in the penal reform movement after the war. Harold Bing joined the Howard League. He knew what prison was all about having received repeated sentences between 1916 and 1919, and summed up the effects of incarceration on COs:

Some died in prison, some went mad, some broke down in health completely and never recovered, some were discharged because they were on the point of death, some suffered terribly from insomnia – it was almost unbearable for them. I think it depended on one's temperament...physical and mental conditions would affect whether one suffered much or didn't.

CONSCIENTIOUS OBJECTORS UNDER THE DEATH SENTENCE

The most serious scandal regarding the mistreatment of absolutist COs who had been assigned to the army erupted in June 1916, when some fifty COs were shipped with their regiments to France. Once there, even those who served in the Non-Combatant Corps would be on active service and thus liable to death as the penalty for disobedience. It was soon rumoured

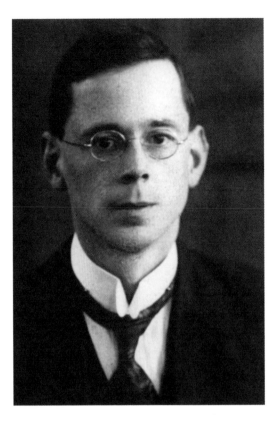 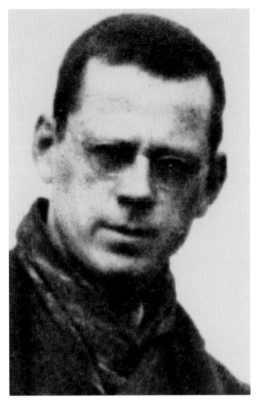

that this sentence was going to be imposed on some of those who continued to refuse military orders. Concerns had been expressed during the passage of the MSA by Philip Snowden and other anti-conscription MPs about a loophole in the Act that permitted this. Now these fears seemed justified.

Howard Marten, a Quaker from Harrow, was among the first batch of seventeen men to be sent from Harwich:

I think there was a very definite movement that they would break our resistance by sending us to France. If they could get us into the firing line, then they could pass the death sentence, and that was that...As it happened, a message got out because somebody in the

train crossing London threw a note which landed on the platform and eventually reached the headquarters of the No-Conscription Fellowship.

Later, on 4 June, another note was received by the NCF. This was from Bert Brocklesby, a CO who had been directed to non-combatant service in the army; it was a Field Service Post Card, issued to all men posted overseas, on which he had crossed out some of the pre-printed words and letters in such a way as to contain a message that evaded the censor: 'I am being sent to b ou long [Boulogne].' Brocklesby was one of sixteen men who had been held at Richmond Castle in Yorkshire and were being despatched to France.

When the men inevitably refused orders, a series of courts martial began in Henriville Camp, Boulogne, on 2 June. Howard Marten was among the first group of four men selected as ringleaders of the Harwich contingent. In an interview he described how they were initially subjected to the unpleasant experience of twenty-eight days Field Punishment No. 1. This punishment, also known as 'crucifixion', consisted of placing a man in shackles and securing him, sometimes with arms outstretched, to a fixed object, such as a gun carriage. There were many variations of this treatment and given the pain the men endured it could be considered torture. As if this were not enough, thirty-five of the men were sentenced to death by firing squad, as the rumours had indicated.

In addition to the question of the death sentences being raised in Parliament by anti-conscription MPs, liberal newspapers reacted strongly to the news. The *Manchester Guardian* declared on 27 June 1916 that 'the final test

OPPOSITE Howard Marten in October 1914 (*left*), and in 1916 (*right*) at Dyce Quarry work camp, near Aberdeen, after being held under the death sentence in France.

BELOW This group of men working at Dyce Quarry is believed to include fifteen of those sentenced to death in France in 1916.

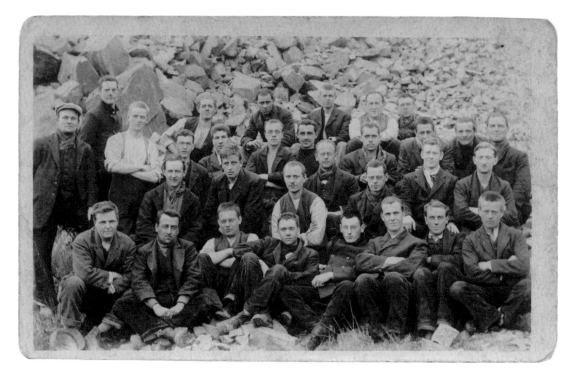

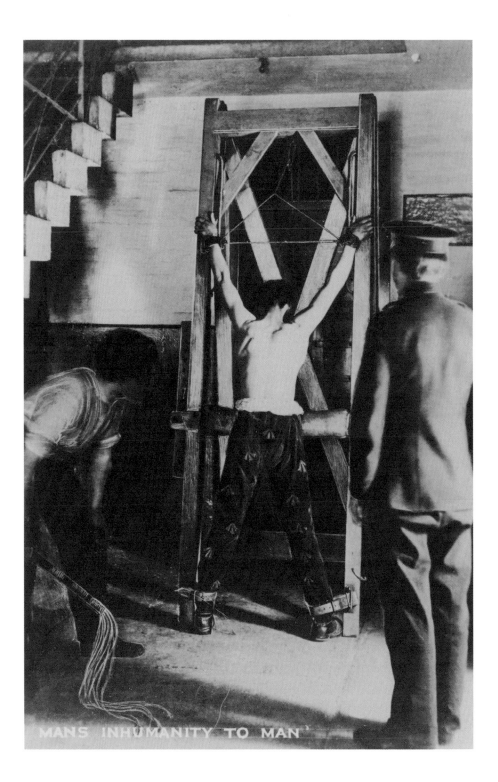

MANS INHUMANITY TO MAN'

of sincerity is the willingness to face conse-
quences...We hope that people will now be
satisfied that the conscientious objector may at
least be what he professes to be, and is not nec-
essarily a mere coward masquerading under a
fine pretence.' Many of those, including soldiers,
who had previously thought COs shirkers and
cowards grew to respect them, realizing that
these men were prepared to face death for the
sake of their conscience.

As for the COs who were under the threat
of death, Fenner Brockway of the NCF explained
how (although he himself was in prison because
of his absolutist stance), 'There was a deputa-
tion to Asquith very late at night, and he gave
instructions that although they had been sen-
tenced, they were not to be shot.'

Howard Marten described how, after their
second court martial, the men were taken out
to a parade ground lined with troops. He was
the first to be escorted to the middle of it:

> Then an officer in charge of the proceedings
> read out the various crimes and misdemeanours
> – refusing to obey a lawful command,
> disobedience at Boulogne and so on and so
> forth – and then: 'The sentence of the court is
> to suffer death by being shot.' Then there was a
> pause, and one thought, 'Well, that's that.' And
> then, 'Confirmed by the Commander-in-Chief.'
> 'That's double-sealed it now.' Then another long
> pause, and, 'But subsequently commuted to
> penal servitude for ten years.'

According to Bert Brocklesby, after the repeated
prison sentences they had endured, 'Ten years
held no terrors for us. We would only be held in
prison till the end of the war, and we should be
saved from all the cat-and-mouse business that
thousands of COs were steadfastly enduring.'
Eventually, the men were returned to Britain;
on arrival at Southampton they were jeered at
and pelted with eggs and tomatoes. They were
then sent to various civil prisons. Brocklesby
was proved right: despite the ten-year penal
servitude sentences, all were released after the
war had ended. The story of the COs' defiance
of military orders even in the face of death has
endured and has served as inspiration for those
taking a similar stance in subsequent wars.

THE HOME OFFICE SCHEME

As the dramatic events were unfolding in France
during the summer of 1916, it was becoming
clear to the government that the numbers of
COs in prison would go on increasing, especially
with a new influx of objectors after a second
MSA was passed in May 1916 that extended
conscription to married men up to the age of
41. Some 1,451 objectors were arrested in June
alone. Fear of a continuing rise in numbers led
to the Prime Minister introducing a new policy
for absolutist COs on 28 June. Known as the
Home Office Scheme (HOS), it was devised
for those who had been forcibly enlisted in
the army, had disobeyed orders and were in
prison and subjected to the 'cat-and-mouse'
treatment. It offered them work of 'national
importance' under civilian control, ceasing to
be subject to military discipline, providing the
men carried out their duties satisfactorily. The
type of employment was to be determined by
a committee appointed by the Home Secretary.

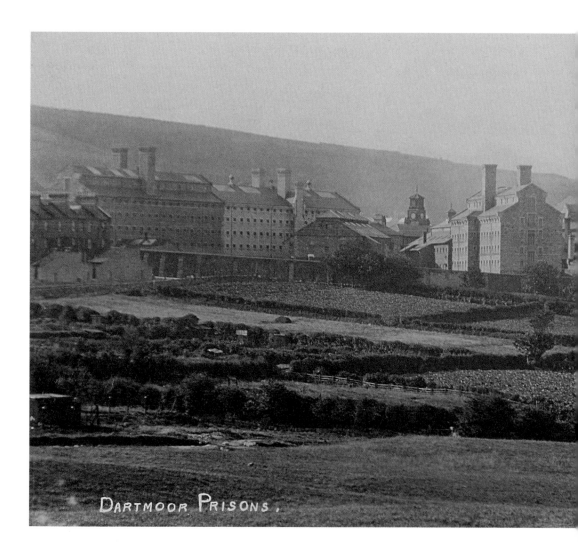

DARTMOOR PRISONS.

It consisted of agriculture, land reclamation, quarrying, building, road-making and work in a range of industries; COs were assured that the work had nothing whatsoever to do with the war effort. Those doing indoor tasks such as sewing mailbags for civilian use (they refused to make coal sacks for the Royal Navy) or basket-making were housed in prisons, workhouses or asylums that had been cleared of their regular inmates; while those engaged in outdoor labour were sent to special camps, living in primitive conditions in huts or under canvas. Around 3,750 objectors were released to work under the HOS, although some revolted against the scheme and rejoined other absolutists in prison.

The HOS generated divisions within the NCF and between COs; many felt that the aim of the scheme was to split and weaken the CO movement. Clifford Allen and the national committee of the NCF, with their uncompromising stand for absolutism, rejected what they considered

an unacceptable compromise with the authorities. Fenner Brockway, in the *Tribunal*, 17 August 1916, wrote passionately against the HOS: 'To term work under such conditions "service" is ludicrous. It is slavery...They will see in the scheme the menace of industrial conscription. They will see that its effect is to fight by proxy since it releases other men to do the fighting which they themselves will not undertake.' But many absolutists, who had suffered army brutality and were weary with the repeated ordeals of prison, welcomed it. They felt that it gave them hope of doing something worthwhile, yet unconnected to the war machine, and did not compromise their principles. It soon became clear that despite the hard line of their leaders, large numbers of COs in prison, including thirty of those who had received death sentences in France, were prepared to join the scheme. Many absolutists who refused to participate nevertheless understood its appeal. Harold Bing, for instance, maintained, 'Although some were inclined to think, "Well, they've let us down a bit", I don't think there was any hostile feeling towards them...In some cases it was necessary to save a marriage and therefore we were not critical.' In the end, many in the NCF leadership became more tolerant and accepted the opportunities the scheme offered, especially the abandonment of the mandatory silence rule that many imprisoned COs had found so isolating. Brockway, for instance, seems to have had a complete change of heart: 'What an opportunity is theirs! What an opportunity of learning the points of view of one's comrades in the fight, what an opportunity of widening one's conception of the truth by frank and friendly discussion!'

One of the first and probably the most infamous of the tented work settlements established by the HOS was a camp situated

Post Card

For Corres[p]ondence Address Only

Documents. 16782/A

Brecon Barracks
Kinmell P[ar]k Camp
Back To Brecon for C.M.
Wormwood Scrubs Prison
Knutsford Prison
Dartmoor Convict Prison
??? June 1918 Wallace.

ABOVE A postcard listing the various prisons where one CO was interned. The question marks before 'June 1918' indicate that additions to the list were anticipated.

on a bleak hillside near the village of Dyce, on the outskirts of Aberdeen. In August 1916, 250 men, including twenty of those who had been sentenced to death in France, were sent there from prison and were paid eight pence a day for ten hours of heavy work breaking stones in the granite quarries. The men, already weakened by months of imprisonment and malnourishment, were lodged in leaky tents and slept in wet bedding on sodden ground. Given the appalling conditions, it is no wonder that one weak young man, Walter Roberts, died of influenza. He had arrived at the camp in a state of exhaustion having spent four months undertaking hard labour in prison. Two days after writing to his mother that, 'As I anticipated, it has only been a question of time for the damp conditions prevailing here to get the better of me', he died. An inquiry followed and a mere ten weeks after the camp had been established, it closed. The scandal of Dyce was an important factor in discrediting the HOS.

In March 1917, when the HOS was rationalized, the occupants of several settlements were sent to Dartmoor Prison, near Princetown, which became the Princetown Work Centre once the usual inmates had been removed. It was the largest of all the HOS's work centres, housing about 1,000 COs. When the first intake arrived, they found the place completely unprepared for them. But the enforced leisure of the first few weeks created the

DARTMOOR'S ARTFUL DODGERS

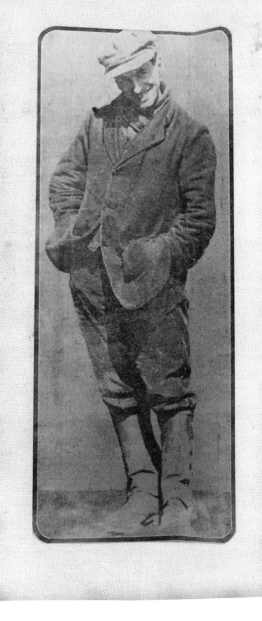

"YOU CAN'T CATCH ME!"

[One of a group of conscientious shirkers now at Dartmoor, who have incensed the people of Devon by their airs of self-congratulation.]

He who does not fight, but runs away may live to run as fast another day!

This *Daily Mail* photograph of a conscientious objector presents him as a weak and simpering 'shirker' having an easy time at Dartmoor, while his service counterpart fights abroad.

opportunity for a men's committee to be formed, with Howard Marten as its first secretary; this gathering permitted the 'frank and friendly discussion' Brockway had anticipated and many COs welcomed it after months of the prison rule of silence.

Once work started, the men became increasingly frustrated with its futile nature, as Mark Hayler noted: 'There was a hand-roller, to which eight men were harnessed, engaged in rolling a field. I have been one of those human horses. The work we did could have been done by one man and one horse in a third of the time. And this, mind you, in a time of the country's [food] crisis.' Despite his frustration with the work, Hayler found some advantages, 'When we were working on the moor, you could really chat and that was such a relief...I remember once this chap said, "Isn't it odd that I'm here in Dartmoor because

I won't kill anybody, and my father-in-law had been here because he had killed someone!"' Hayler also remembered how members of the press would arrive to interview COs and how their activities and conditions 'were fictitiously reported in the papers and there was a storm of protest against us in the House of Commons'.

Although the COs might be portrayed in the press as being 'coddled' while soldiers were experiencing the horrors of the Western Front, the Princetown Work Centre was not without its own tragedies. According to a report of the men's committee, Henry Firth, a young Methodist preacher, arrived at the prison early in January 1918 as 'a mere bag of bones'. He had served nine months in Wormwood Scrubs and at Maidstone and had become so sick that in desperation he applied for the Home Office Scheme. Despite his obvious ill health, he was

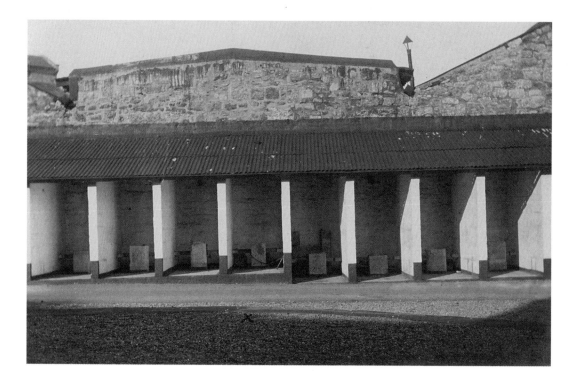

put to work stone–breaking in the quarry. On his third day, feeling ill and unable to eat, he visited the doctor, who regarded him as a 'shirker' and sent him back to work. He was finally admitted to the hospital on 30 January. On the morning of 6 February one of his friends, alarmed at his condition, asked for permission to write to Firth's wife, but this was refused. He died that afternoon. Mark Hayler was an orderly in the hospital at the time and had cared for Firth. In an interview, he recalled the poignant occasion when Firth's coffin was taken to the station and put on a train for Plymouth: 'It was all arranged by our own people. Some of us got hold of some fog signals and put them on the railway line here and there. As the train went out of the little station at Princetown the signals went off, a sort of farewell. And I remember nearly a thousand men sang a hymn, "Abide With Me".'

It was not only the futility of some of the work that angered COs working under the HOS; many of the men discovered that despite promises made, much of the labour was connected to the war effort. Bert Brocklesby's group had been assured that their toil in the granite quarry at Dyce was for the repair of civilian roads. But to their dismay, they 'found that the main objective was a section of road up to a new naval aerodrome'. Walter Griffin, who had refused to participate in the HOS while in prison, concluded, 'Unfortunately I have to say it, but it's truthful, they were damned liars, the military people were...They say truth is the first casualty or war, and I was for the truth.'

Less harsh conditions were experienced at the work centres such as the one at Princetown and other ones around the country, including at Grimsby, Hornchurch, Newhaven and Lyndhurst. Cells were sometimes unlocked and prisoners were allowed out of confinement until 9.30 p.m. Donald Grant at Princetown spoke of how he enjoyed getting out of the prison: 'I galloped over the moors, the Tors, read a lot, ran about a lot, played soccer even.' But this greater freedom meant the COs were often confronted by jeering locals and sometimes viciously beaten. Little sympathy for their plight was given by the police and authorities. When Zeppelin air raids increased in 1917, hostility towards the 'pro-German' COs intensified. At Princetown, Joseph Hoare remembered some COs going to church and being stoned on the way: 'The parson was standing on a flat tombstone, I won't say cheering them on, but any rate encouraging them.'

COs confined to prison or work camps were not the only ones who experienced hostility and brutality. Those awaiting arrest, or experiencing a brief respite from the cat-and-mouse system, or engaged in various forms of alternative service in the community, often found themselves vilified and ostracized. Harold Bing recalled that apart from a few friends and sympathizers, people's attitudes towards him, as an absolutist, were distinctly hostile. A particularly distressing aspect for these men was the social exclusion suffered by their families. Dorothy, Bing's sister, remembered the effect his CO experience had on their mother, 'As soon as her family realized that Harold wasn't going to fight for his country, they just cut us dead. It was never healed. After the war they wouldn't have anything to do with us...And when she died they didn't come to the funeral.'

Lloyd George, who had threatened to make the path of 'hard-core' absolutists as

hard as possible, was in a position to do so at the end of 1916 when he ousted Herbert Asquith and became Prime Minister. As prison conditions became even tougher in 1917 and 1918, the more militant COs who were behind bars began a wave of revolts, work and hunger strikes, usually to protest against specific cases of cruelty, brutality and injustice. These took place in Wandsworth, Winchester, Hull, Newcastle, Maidstone, Carlisle and Canterbury prisons. The force-feeding that followed hunger strikes, as earlier with militant suffragettes, was characterized by sadism, lack of technical expertise, and inhumanity on the part of many doctors administering the punishment, which amounted to medical abuse. Mental breakdown and even death resulted from this treatment. W. E. Burns was the first CO to go on hunger strike in Hull prison. He was force-fed for three days and on the fourth he choked to death when he inhaled the cocoa and milk mixture that was being forced down him. Despite the incorrect length of the tube used, no blame was attached to the doctor.

THE FRIENDS AMBULANCE UNIT

The COs who served with the Friends Ambulance Unit (FAU) had a different experience from that of their absolutist counterparts. Those who joined the FAU, which had been set up by Philip Noel-Baker and other young Quakers at the outbreak of war, found the work arduous and often dangerous, but it could also be richly satisfying, although they, too, did not escape public hostility. Under the terms of the MSA, once conscription started, COs who were alternativists could carry out their non-combatant service with the FAU, even if they were not Quakers. The unit attracted men

who felt the need to bear witness to their belief in the fellowship of humanity through practical action, particularly by assisting the victims of war.

Whereas the FAU was a somewhat ad hoc organization, the Friends War Victims Relief Committee (FWVRC) was an official arm of the Society of Friends. Another distinguishing point was that the FAU members served alongside troops, sharing risks and dangers, but the FWVRC concentrated on relief for civilians affected by the conflict. The first FAU contingent of forty-three travelled to Belgium in the autumn of 1914 and by the end of the war over 1,300 men were working for the organization in Britain and on the Continent. As it increased in numbers, its remit became more diverse: the unofficial motto was 'find work that needs doing. Regularise it later, if possible.' On the home front the FAU set up or staffed four hospitals, and helped to organize alternative work for COs, such as in agriculture and education. On the Continent, they had their own ambulance trains from 1915, and in early 1916 acquired two hospital ships. Eventually at

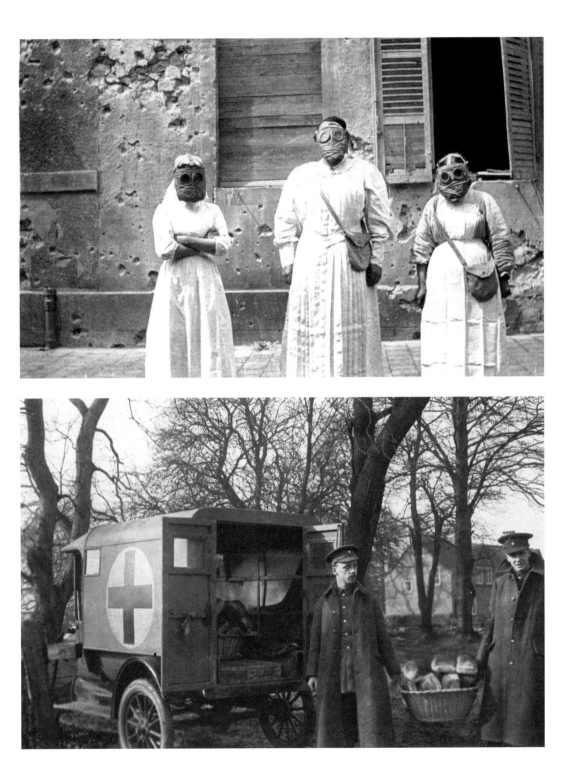

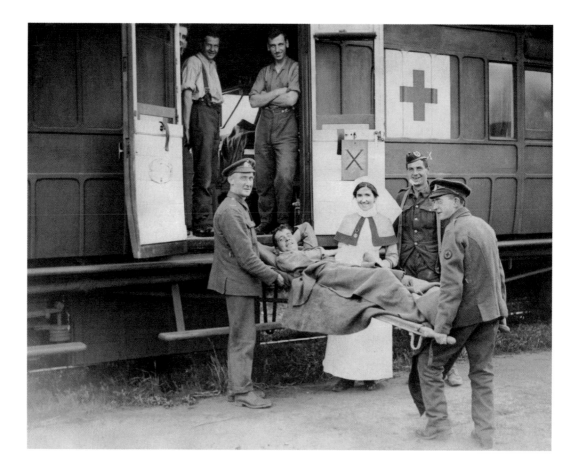

least eight hospitals were staffed by the FAU in France and Belgium.

One of the most challenging humanitarian disasters the FAU dealt with was trying to help a large number of women and children who had been affected by a gas attack in the area of Courtrai as the Germans retreated in the autumn of 1918. Lloyd Fox, a young Quaker, described the horrific scene in a large hall at the Ambulance du Fort where over one hundred gassed women and children were lying wrapped in blankets, their eyesight destroyed by the effects of the mustard and phosgene gas and their breathing painful because of their damaged lungs. He was asked

Members of the Friends Ambulance Unit lift a stretcher case onto an ambulance train, 1916. The FAU had its own ambulance trains bringing wounded soldiers from the front line for treatment in hospitals in France and Britain.

to select a number of children for treatment who had a chance of survival, 'And there was I, this youngster, given what seemed to be the chance of saving the lives of twenty of these. All I could do was pick twenty of the toughest looking children.' He recalled seeing a gas orderly in tears two days later who told him, 'I just can't stand it any longer, they're choking to death and most of them are the children you brought in.' When Fox went in he found the children 'black in the face, absolutely nothing could be done for them…In all about 800 were killed by gas at that time. It passed more or less unnoticed…The war news was more concerned with the falling back of the Germans, but it was one of the worst episodes of civilian gassing in the war.'

Twenty-one men died in action while serving in the FAU; there are photographs of direct hits on their trucks and ambulances that are evidence of the risks they faced. In addition, about twenty former members of the FAU, who left to join the services, were killed.

CONSCIENTIOUS OBJECTORS IN THE BLOOMSBURY GROUP

Among those who opposed the war from the very beginning were the members of the Bloomsbury Group, the circle of English intellectuals, writers, artists and philosophers who lived and worked in the Bloomsbury area of London in the early part of the twentieth century. They included the economist John Maynard Keynes, the novelist Virginia Woolf, her sister the painter Vanessa Bell, the art critic Roger Fry and the journalist Desmond MacCarthy. As well as the effect they had on literature, aesthetics and economics, the members also influenced feminism, attitudes to sexuality and pacifism.

Politically, many were on the Left and as well as being opposed to militarism, they rejected current social mores in favour of more personal, idiosyncratic relationships that involved complicated love affairs and homosexual liaisons.

In the war several of the men were COs, but Maynard Keynes came in for criticism from his friends for continuing his work at the Treasury. Philip Morrell, an MP and one of the founders of the Union of Democratic Control, had trained as a solicitor, and he represented David Garnett, Duncan Grant and Lytton Strachey at their tribunals. Morrell and his wife, Lady Ottoline, having taken possession of Garsington Manor, a Tudor house near Oxford, with its farm in 1915, were in a position to offer the COs alternative work of national importance and to provide a refuge for others. Lytton Strachey spent three weeks recuperating at the manor after he had had his tribunal and had been declared medically unfit for any kind of service, and lay about in a 'limp state' reading Plato's *Republic*. Robert Graves stayed there when on sick-leave from the front in 1917 and fellow-poet Siegfried Sassoon was also a guest. Bertrand Russell, who endured several months in Brixton Prison during 1918 for an article he wrote in the NCF weekly, the *Tribunal*, advocating accepting a peace offer from Germany, and was emotionally involved with Ottoline, asked if he could come and stay at Garsington a few days a week after his release from jail in September. She put him up in a cottage on the estate.

Charleston farmhouse in East Sussex, the home of Duncan Grant, Vanessa Bell and her husband Clive Bell, was another refuge for Bloomsbury's COs. It had been rented in 1916 so that Grant and his lover David Garnett had somewhere to live while they were doing the farm work they had been directed into as conscientious objectors. Situated in a peaceful

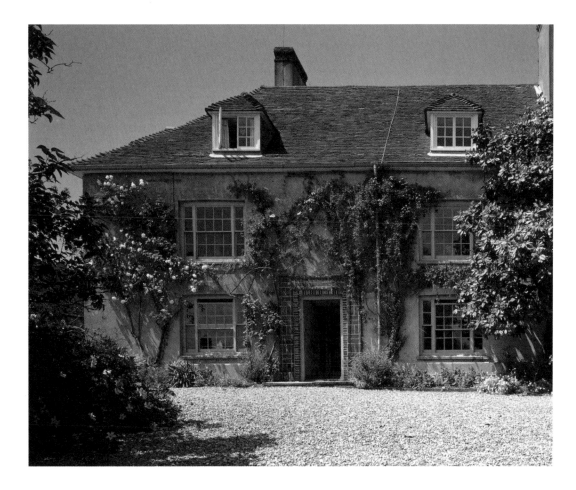

Downland setting, Charleston became an artists' idyll and it was where, in the summer of 1919, John Maynard Keynes wrote the influential *The Economic Consequences of the Peace*, following his experiences as a British government adviser at the Versailles Peace Conference.

AFTER THE ARMISTICE

When the Armistice was signed on 11 November 1918, after over four years of fighting, three-quarters of a million men were dead from

Britain alone. In the election that followed, in December 1918, all the pacifist members of parliament who had opposed the war, including MacDonald and Henderson, lost their seats, although overall the number of Labour MPs increased from the forty-two elected in 1910 to fifty-seven. Conscription lasted until 1919 and the NCF was dissolved in the same year. There were variations in the ways COs were treated after war ended: those who were serving with the army's Non-Combatant Corps were subject to the rules of general demobilization; by the end of April 1919, all those employed under the

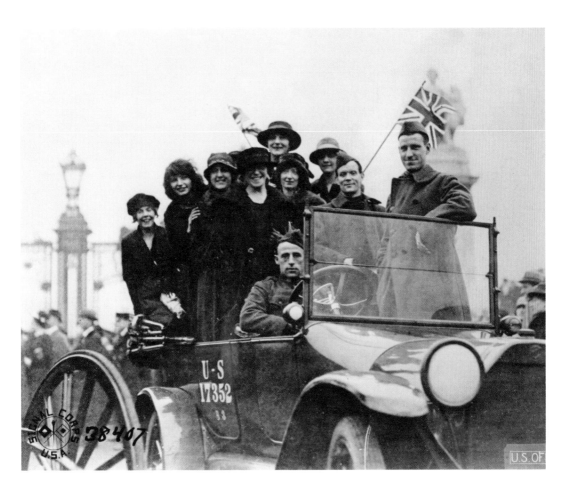

Home Office Scheme had been released and the scheme was disbanded that summer. But for those who had been imprisoned, the Home Office only started to commute their sentences in June 1919. It was not until the end of July that all objectors were released. By early August, they had been discharged from the army; the 'cat-and-mouse' system that had caused so much resentment and dread had finally ended. After just under three and a half years, all COs were free men again. Wilfred Littleboy was given a document when he was released from prison in 1919 on which was written: 'Discharged for

OPPOSITE Charleston farmhouse, near Firle, East Sussex, where Vanessa Bell and Duncan Grant lived from 1916. The house provided a haven for members of the Bloomsbury Group who were COs or pacifists.

ABOVE Young women celebrate with American soldiers in London on the day the Armistice is signed, 11 November 1918.

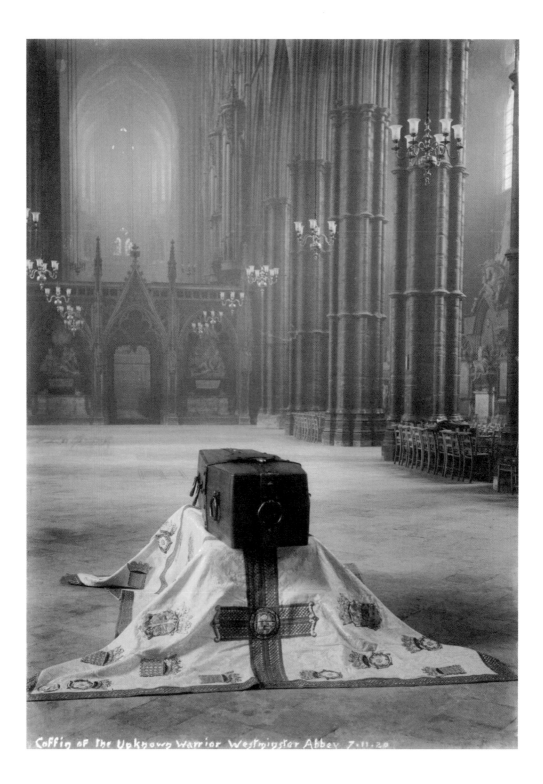

Coffin of the Unknown Warrior Westminster Abbey 7.11.20

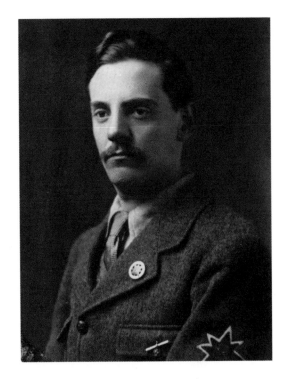

OPPOSITE The coffin of the Unknown Warrior resting in the nave of Westminster Abbey before the Armistice Day ceremony at the Cenotaph and its final burial in the abbey, November 1920.

RIGHT George Dutch, an absolutist CO during the war, worked for the Friends Emergency and War Victims Relief Committee in Warsaw, Poland, in 1919.

OVERLEAF Paul Nash, *The Menin Road*, 1919. The painting depicts what Nash called 'perhaps the most dreaded and disastrous locality of any area in any of the theatres of War'.

misconduct.' He was amused that 'printed over it in red ink was that if I tried to enlist again I was liable to two years' imprisonment!'

Under the Representation of the People Act, 6 February 1918, nearly all those COs sentenced by courts martial to imprisonment or detention were disenfranchised for five years after war ended. This included those who had opted for release under the Home Office Scheme. Few found it easy to return to old jobs or gain new employment. Harold Bing, for instance, found that 'Frequently an advert was headed with "No conscientious objector need apply."' Bert Brocklesby, who had the double handicap of a dishonourable discharge from the army as well as a prison record, was surprised to find how local feeling was even more bitter against him than in 1916: 'I had thought that having proved myself sincere they would give me credit for it. But no, they

had suffered the poisoning effects of nearly three years of war.'

Perhaps the true number of those who opposed the First World War will never be known. There are no figures for those who were reluctant to fight and who successfully evaded call up or worked in reserved occupations such as mining; or for those who were refused exemption and entered the services when called up; or for the members of the armed forces who had become pacifists during the war but continued to serve. Missing, too, are those above the age limits of conscription and the medically unfit. The thousands of women who were against the war are also missing from the statistics. Just over 9,000 of the 16,300 COs who faced tribunals accepted some form of alternative service, including the Home Office Scheme, and 3,300 served in the Non-Combatant Corps of the army. Around 6,000 served prison sentences of

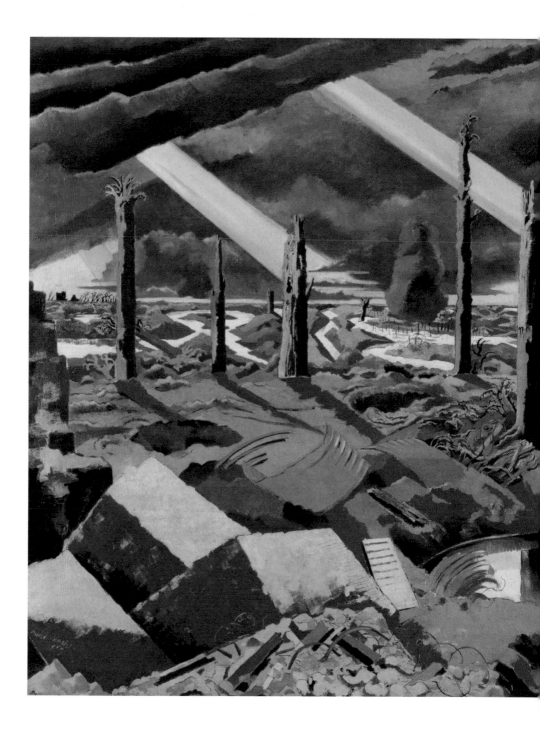

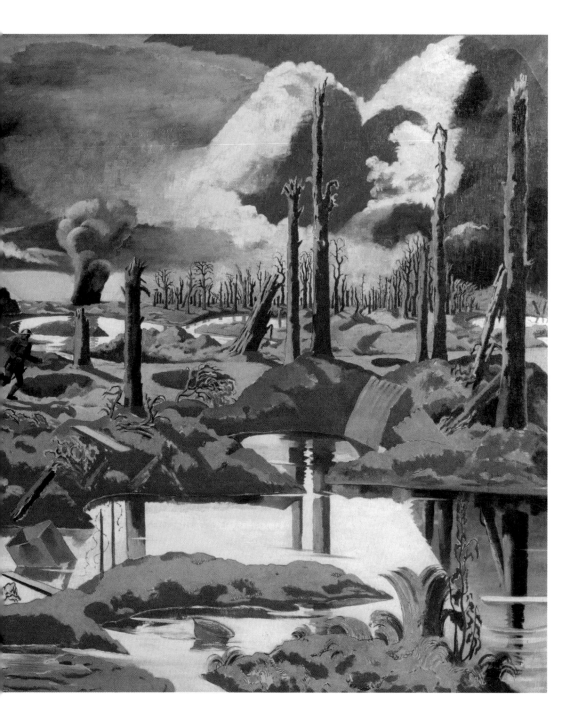

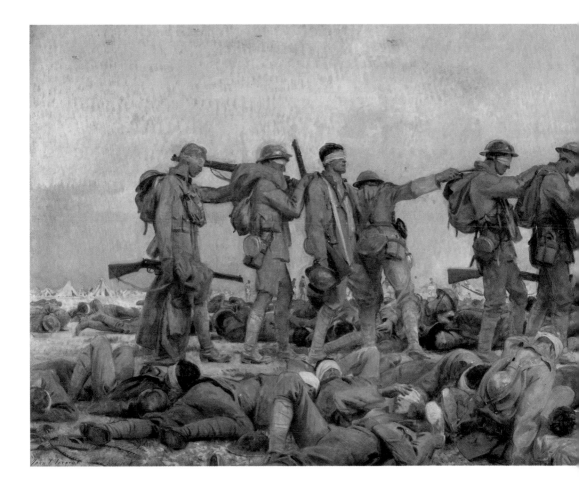

varying terms, with 819 incarcerated for twenty months or more. Sixty-nine COs were confirmed as having died and thirty-nine suffered mental breakdown.

George Dutch, who had endured the harshest of conditions and treatment during his repeated prison sentences as a hard-core absolutist, and who went on to do relief work in Poland in 1919 with the newly reformed Friends Emergency and War Victims Relief Committee, summed up the achievements of conscientious objectors in the First World War:

Well, first of all we proved that any decent modern government could not coerce man's conscience...it was quite plain in the last year of war that they had learnt the lesson, because then it was easy to get exemption...If it wasn't absolute exemption it was something you could do rather than send you to prison, which was a terrible waste of time. We were nothing but sand in the machine, sources of dissatisfaction really...It was utter folly to put us in the army and we proved that. Also, we set the notion of conscientious objection really going. There's no doubt that in any future war, small or large,

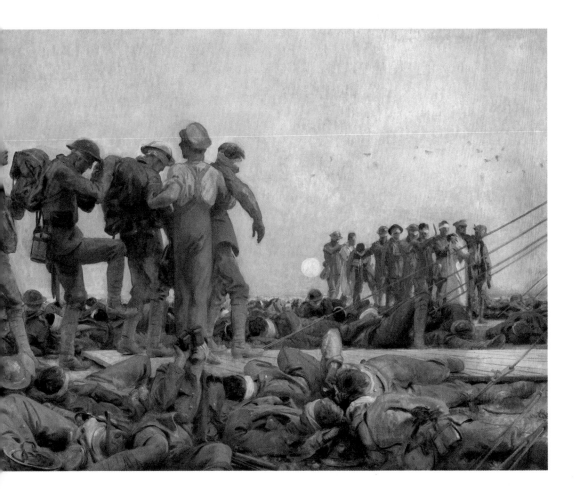

you'll have conscientious objectors. Even in countries where they don't recognize it, it will happen. We started a movement which means that no war can be fought in the future without conscientious objection coming up.

John Singer Sargent, *Gassed*, 1919. Sargent's grimly realistic painting of men suffering the terrible after-effects of a gas attack was based on what he had seen on a visit to France in 1918. It was voted picture of the year by the Royal Academy of Arts in 1919.

PEACE PLEDGE UNION
FOR NONVIOLENCE

THE PEACE PLEDGE UNION IS AN ORGANISATION OF PACIFISTS WHO SIGN THE PLEDGE: "I renounce war and I will never support or sanction another".

WE WORK AGAINST WAR AND PREPARATIONS FOR WAR AND WE TRY TO BUILD PEACE

WILL YOU JOIN US?

THE PEACE PLEDGE UNION WORKS FOR A FUTURE WITHOUT WAR
Dick Sheppard House · 6 Endsleigh Street · London WC1

2 THE INTERWAR YEARS: THE DEVELOPMENT OF THE PEACE MOVEMENT 1919-1939

OPPOSITE The Peace Pledge Union, founded in the 1930s, has been one of the most enduring organizations opposed to war.

A robust public denouncement of the punitive terms of the Treaty of Versailles by delegates at the second International Congress of Women, held in Zurich in May 1919, was followed by John Maynard Keynes's attack in *The Economic Consequences of the Peace,* which was published at the end of the year and made him world-famous. Keynes gave a passionate indictment of the level of reparations imposed on Germany and criticized the fact that the treaty made no provisions for the economic rehabilitation of Europe. The book was influential in building up the belief that the peacemakers were vindictive and that Germany had been treated unfairly, and it is thought that it contributed to the decision of the United States Congress not to join the fledgling League of Nations. Later, Keynes was criticized because the arguments he had put forward were taken up by Nazi propagandists to justify Hitler's policies; but in Britain during the early postwar years his book reinforced the perceived injustice of the peace, which contributed to the development of a widespread revulsion against rearmament, war and militarism in general.

The carnage and devastation of the Great War was another factor in the change of attitude. Leslie Hardie, a factory worker in the East End of London, recalled the anguish behind all the stories he was told about the war and was appalled at the distressing sight of ex-servicemen, blind or badly mutilated, on the streets of London, begging for pennies or selling things of little value: 'There

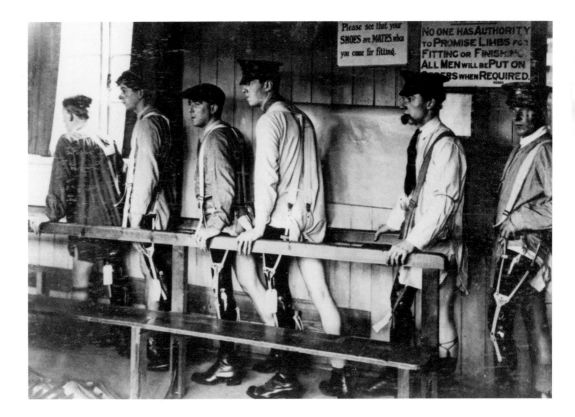

Please see that your SHOES are MATES who you come for fitting.

NO ONE HAS AUTHORITY TO PROMISE LIMBS FOR FITTING OR FINISHING. ALL MEN WILL BE PUT ON ⬛RS WHEN REQUIRED.

was a man who affected me deeply who had a row of rather tatty pictures, he sat there and he had only half a face. I began to think, 'These were the heroes that a country should have been grateful to.' Many veterans were totally disillusioned: J. R. Skirth, an NCO in the Royal Garrison Artillery, who had fought in the Battle of Messines, had lost faith in all institutionalized religion:

> My Church had authorized me to break the sixth commandment in the name of patriotism. The 'Love Thy Neighbour as Thyself' part didn't fit in; 'Blessed are the Peacemakers'? No! Not in 1917. Blessed are the War Winners, Yes. Blessed are the Munition Makers. Yes...I know what I had become now. It's a word that is distasteful to many. Pacifist.

This kind of thinking among both those who had fought in the war and the wider public who had lived through the conflict, led to the growth of an anti-war movement during the 1920s, with combatants as well as COs from the First World War playing leading roles in its development. The newly founded League of Nations, which promised co-operation rather than strife between nations, was welcomed with great enthusiasm and there was huge support for the League of Nations Union (LNU), established in 1918, a lobbying organization.

A rapprochement between the former Western European belligerents was sealed with the Locarno Treaties of 1925, whereby Germany recognized its new western borders established by the Treaty of Versailles and France, Belgium

OPPOSITE Disabled servicemen learn to walk using their newly fitted artificial legs, *c.* 1917.

BELOW The Peace Pilgrimage of June 1926 was initiated by the Women's International League for Peace and Freedom and involved twenty-eight women's and peace organizations. Marchers came to London from all over the country, including this contingent from North Wales, to lobby the government.

and Germany undertook not to attack each other, with Britain and Italy acting as guarantors. In 1926, Germany was admitted to the League of Nations. The Kellogg-Briand Pact of August 1928 was signed by fifteen countries; with its renunciation of war as an instrument of national policy, and pledge that all disputes were to be settled by peaceful means, it was viewed as a major landmark. International relations, disarmament, peace and war were earnestly and widely discussed, and a whole range of new peace organizations was formed and rallies held.

One of the most impressive gatherings was the Peace Pilgrimage of 19 June 1926, instigated by the Women's International League

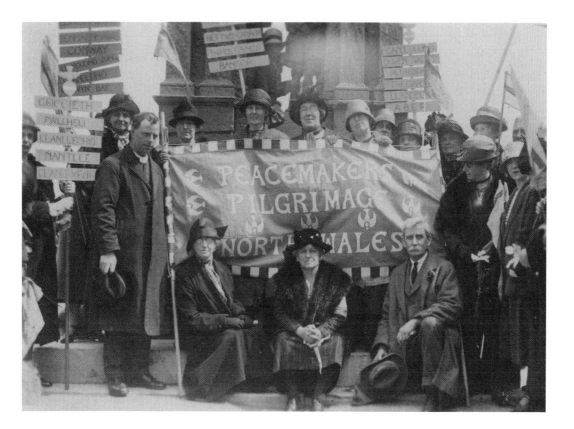

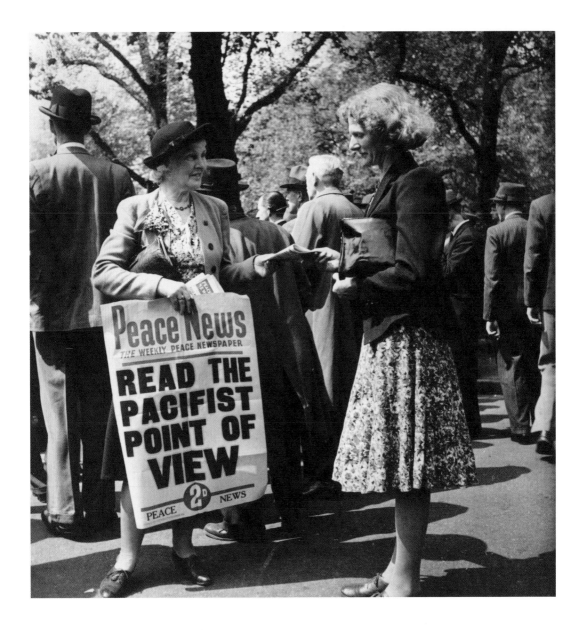

A woman selling *Peace News*,
the newspaper of the Peace
Pledge Union, at a meeting in
Lincoln's Inn Fields, London, in the
1930s. Circulation had reached
24,000 by the end of the decade.

for Peace and Freedom, the organization that had grown out of the 1915 Hague conference. Representatives of twenty-eight women's and peace organization groups were involved in the planning and about 10,000 women converged on London from all over the country, where they listened to speeches by the Labour MP Ellen Wilkinson, the women's suffrage campaigner Millicent Fawcett and many other local leaders at a mass demonstration in Hyde Park. The women were pressing for a world disarmament conference and for the government to sign the Optional Clause of the International Court of Justice, which required all signatories to refer certain classes of dispute to the court; it constituted by far the most important compulsory treaty of arbitration in the postwar era. Before the rise of fascism, hopes were high for a new dawn of international peace.

Among the other organizations that sprang up in these years was the No More War Movement (NMWM), founded in 1921, with Fenner Brockway as its secretary. It was an anti-capitalist, anti-militarist peace group, and a direct successor to the No-Conscription Fellowship. It became the British section of the War Resisters' International (WRI), founded in 1921, and later merged with the Peace Pledge Union. The Fellowship of Reconciliation (FOR), which had proved its mettle with the support it had provided for COs in the war, expanded in 1919 into the International FOR (IFOR), and was notable for its youth work in Europe in the 1920s. It sought to achieve a peaceful world through nonviolent means and continues to the present day.

One of the largest and most influential bodies to emerge in the interwar period was the Peace Pledge Union, founded after an appeal in the press in October 1934 by the Revd Dick Sheppard, who had been an inspiring

vicar of St Martin-in-the-Fields in Trafalgar Square in London from the First World War up to 1926. He became well known when the BBC started to broadcast religious services from St Martin's in 1924. A prominent pacifist, Sheppard requested those men who would sign the pledge 'I renounce war and never again, directly or indirectly, will I sanction or support another' to join him in a public demonstration of their views. This took place in the Albert Hall on 14 July 1935 and in May 1936 the Sheppard Peace Movement became the Peace Pledge Union. Among its sponsors were the former Labour leader George Lansbury, the prominent Methodist minister and socialist Donald Soper, and Bertrand Russell, continuing the commitment to pacifism that he had shown in the First World War. The PPU's newspaper, *Peace News*, became a vital source of information for campaigners.

Tens of thousands of people from all walks of life signed the PPU's pledge. Gerald Gardiner, who became Lord Chancellor in the Labour government of 1964–70, had served in the Coldstream Guards in the First World War when he left Harrow but joined the PPU after meeting Sheppard: 'I became a pacifist, as most of his congregations in St Martin-in-the-Fields were. My objection was that it was anti-Christian to kill and fight.' Another member from the late 1930s, Leslie Hardie, was spat upon, pushed and molested as he walked along with his PPU banner: 'In our street people whom I'd known for years turned their backs on me. It didn't worry me. I'd heard stories of what happened to COs in the First World War and how some were carted off to France [to be shot]. I thought: could I stand this?'

Sybil Morrison, a former suffragette who had become a pacifist in the First World War,

The Women's Co-operative Guild (now the Co-operative Women's Guild), founded in 1883 as part of the burgeoning co-operative movement, had fought for women's welfare provisions and peace from before the First World War. In 1933, before Dick Sheppard launched his own campaign, a Guild Peace Pledge Card was introduced: a few thousand Guildswomen and their supporters committed to take no 'part in, or help towards, the propagation of war'. In the same period, the members mounted a powerful 'Never Again' campaign against any return to military conscription. They also lobbied for the elimination of the militarist content in children's textbooks and for an annual peace day in schools. The number of Guildswomen rose through the 1930s, reaching a peak of 87,246 members in 1,819 branches in 1939.

One of the most enduring aspects of the Guild's work is the white peace poppy. Initiated by the organization in 1933 (and distributed by the PPU since the mid-1930s) as an alternative to the Royal British Legion's red poppy, it was intended to commemorate civilian victims of war as well as servicemen and -women, and represented a 'pledge to peace that war must never happen again'. For Armistice Day in 1938, 85,000 were sold, an all-time record.

In the interwar era the peace movement took many different forms. In 1920, the Kindred of the Kibbo Kift (an old English expression for 'proof of great strength') was founded by John Hargrave, a Scout master who was disillusioned by the militaristic tendency of Baden-Powell's organization, with backing from pacifists such as Emmeline Pethick-Lawrence. It placed emphasis on camping and naturecraft as well as disarmament and international education. It gave opportunities for thousands of young girls and boys to engage in open-air activities and to work for world peace.

became a member of the PPU as soon as women were admitted in 1936, and well-known writers such as Vera Brittain and Rose Macaulay were galvanized into joining by Sheppard's evangelical appeal. Around the country, PPU women became active, selling *Peace News*, speaking in crowded market places, putting up posters and delivering pamphlets. By the summer of 1939 the PPU had in the region of 130,000 supporters, of whom 43,000 were women.

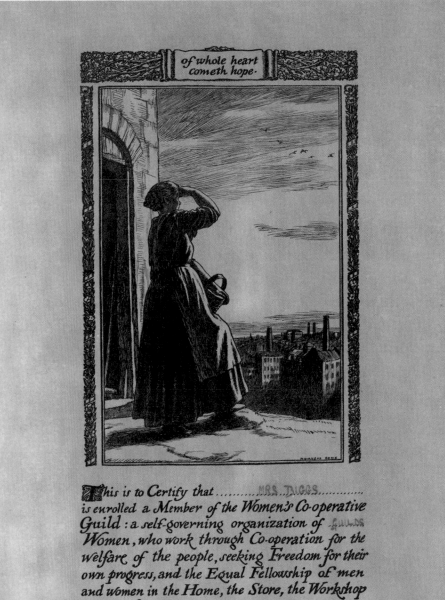

of whole heart cometh hope.

This is to Certify that............MRS. DIGGS...............
is enrolled a Member of the Women's Co-operative
Guild : a self-governing organization of GUILDS
Women, who work through Co-operation for the
welfare of the people, seeking Freedom for their
own progress, and the Equal Fellowship of men
and women in the Home, the Store, the Workshop
and the State.

Date. MARCH 13 1933. General Secretary.

PRESENTED TO MRS DIGGS FROM HER FELLOW-
GUILDS WOMEN OF THE CHISWICK BRANCH.

OPPOSITE A membership
certificate of the Women's
Co-operative Guild, presented
to Mrs Biggs on 13 March 1933.
The image was known as
'The Woman with the Basket'.

RIGHT A banner possibly
associated with Mabel Barker,
one of the guiding spirits behind
the Kibbo Kift's Regional Survey
work in the early 1920s. The
star contains the Mark of the
Kibbo Kift.

BELOW A group of Kibbo Kift
kinsmen in camp. Hargrave
wanted the kinsfolk to be healthier,
fitter and morally stronger than
the previous generation.

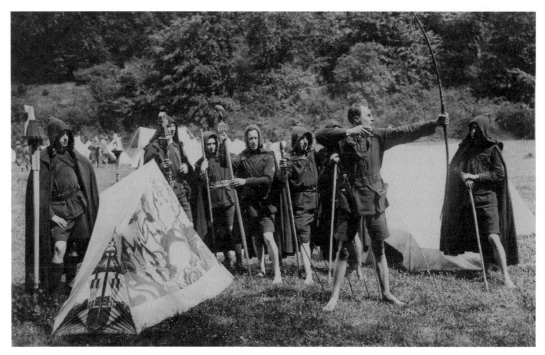

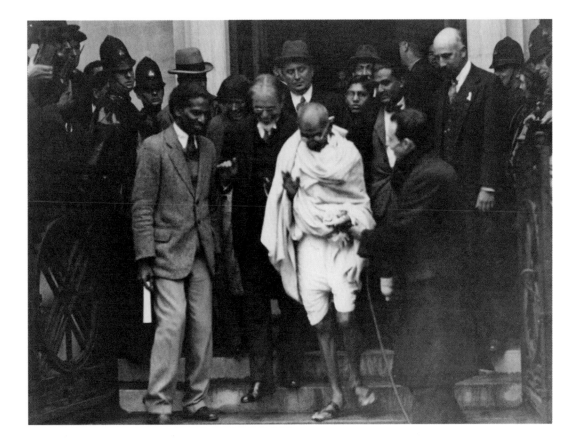

Individuals made their own contributions in the effort to avoid another war. Some, such as the pacifist Kenneth Wray and his wife, 'in an infinitesimal small way tried to do something positive'. In 1932, they ran an international peace camp in their garden under the auspices of the International Friendship League (IFL), an organization founded the year before by Noel Ede to foster international understanding by developing friendships between people of different countries. The Wrays' camp welcomed Nazis as well as Jews: 'We had to tell the Nazis, "You have to behave; you're here for friendship, not for political reasons; if you don't like it, you have the right to go back home." After that we had no trouble.'

ABOVE Mahatma Gandhi leaving Friends House in the Euston Road, London, in September 1931. Many people were influenced by his philosophy of non-violence.

OPPOSITE The Reverend Donald Soper, a prominent Methodist minister, socialist and pacifist, woos a crowd on Tower Hill, London, January 1931. Quick-witted and articulate, Soper became so well known at Tower Hill and at Speaker's Corner, Hyde Park, that he earned the nickname 'Dr Soapbox'.

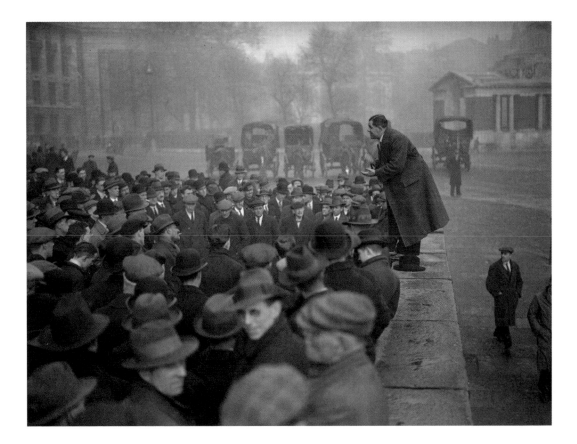

A large range of religious groups were also set up in these years, including the Methodist Peace Fellowship, established in 1933, and the Anglican Pacifist Fellowship, founded in 1937 as an offshoot of the PPU. Many of these peace associations were to play an important role for COs in the Second World War, not only providing advice and assistance but also representatives who sat on the Central Board for Conscientious Objectors, which was established in 1939.

Prominent personalities of the day also gave weight to the peace movement through their ideas or moral standing. Mahatma Gandhi attracted huge publicity when he visited London in 1931. His theory of *satyagraha* (Sanskrit: 'holding onto truth') or non-violent civil resistance struck a chord with pacifists and non-pacifists alike. The Labour politician Tony Benn, a small child at the time, remembered meeting him on this visit: 'He was sitting on the floor and...he said, "Come and sit next to me." And I sat with my brother and he talked, and the *power* of the man and the power of non-violence got into my mind.'

Throughout the history of the peace movement its leaders have frequently been men of the cloth. In the 1930s, the Revd Dick Sheppard was one, and the Revd Donald Soper, a Methodist minister, socialist and pacifist was another. Preaching at open-air meetings on Tower Hill, and from 1942 at Speaker's Corner,

Dulce et Decorum Est

Wilfred Owen

———

Bent double, like old beggars under sacks,
Knock-kneed, coughing like hags, we cursed through sludge,
Till on the haunting flares we turned our backs
And towards our distant rest began to trudge.
Men marched asleep. Many had lost their boots
But limped on, blood-shod. All went lame; all blind;
Drunk with fatigue; deaf even to the hoots
Of tired, outstripped Five-Nines that dropped behind.

Gas! GAS! Quick, boys! – An ecstasy of fumbling,
Fitting the clumsy helmets just in time;
But someone still was yelling out and stumbling,
And flound'ring like a man in fire or lime...
Dim, through the misty panes and thick green light,
As under a green sea, I saw him drowning.

In all my dreams, before my helpless sight,
He plunges at me, guttering, choking, drowning.

If in some smothering dreams you too could pace
Behind the wagon that we flung him in,
And watch the white eyes writhing in his face,
His hanging face, like a devil's sick of sin;
If you could hear, at every jolt, the blood
Come gargling from the froth-corrupted lungs,
Obscene as cancer, bitter as the cud
Of vile, incurable sores on innocent tongues, –
My friend, you would not tell with such high zest
To children ardent for some desperate glory,
The old Lie: Dulce et decorum est
Pro patria mori.

Hyde Park, he was enormously influential, always ready with his argument of the need to harness pacifism to solve many of the world's problems, relishing hecklers and treating them with humour and panache, which won many over to the cause. Ernest Goldring, a bank clerk, remembered him clearly:

> He had a very powerful voice and was a brilliant orator...He would be very provocative – deliberately so, I think – and he loved the arguments he used to have with people...He had people almost eating out of his hand. My recollection is that a great cheer would go up as he got up on the parapet.

The Dutch anarcho-pacifist Bart de Ligt, a former pastor, was another influential speaker and writer who made an important contribution to the debate on non-violence. With the rise of fascism in the 1930s, he devised an elaborate 'Plan of Campaign against All War and All Preparation for War', which he delivered in a speech at a War Resisters' International congress in Welwyn, Hertfordshire, in July 1934. Published in *The Conquest of Violence* in 1937 (the year before De Ligt died) and translated into several languages, his plan was widely discussed, and won De Ligt numerous supporters, including the writer Aldous Huxley, whose collection of essays on war, religion, nationalism and ethics, *Ends and Means*

(1937), was influenced by his discussions with the campaigner.

The revulsion so many felt against war was reinforced by a proliferation of books, plays and poetry written not only by those such as De Ligt and Huxley who were active in the peace movement but also by men who had seen active service. The poetry of Siegfried Sassoon, Wilfred Owen, Edward Thomas and Edmund Blunden, with the message of the pity and futility of war, had an appeal that extended beyond intellectual circles. From the late 1920s, autobiographical writings such as Robert Graves's *Goodbye to All That* (1929), Erich Maria Remarque's *All Quiet on the Western Front* (1929) and Vera Brittain's *Testament of Youth* (1933) had great impact on those too young to have served in the conflict. Similarly, R. C. Sherriff's play *Journey's End* (1928), starring the young Laurence Olivier, had a two-year run in the West End and became an international success. Set in a British dugout near Saint-Quentin in 1918 and based on Sherriff's own time on the Western Front, the play provided an insight into the awful reality of life in the trenches, which was particularly telling for those who had not been there. Other ex-combatants who managed to translate their experiences into powerful literature include David Jones, whose epic poem *In Parenthesis* (1937) was praised by T. S. Eliot as 'a work of genius'.

A continuing target of the peace movement has been the armaments trade and the writer Beverley Nichols's pacific *Cry Havoc!* (1933) against the 'angels of death' was one of the most influential books of the 1930s. Ron Huzzard, later secretary of Labour Action for Peace, found Philip Noel-Baker's *The Private Manufacture of Armaments* (1937) an eye-opener: 'It convinced me that one of the main causes of war is the profit that people make out of war, out of

OPPOSITE Wilfred Owen's poem was published posthumously in 1920 but remains powerful today. The final lines in Latin are from the Roman poet Horace: 'It is sweet and fitting to die for one's country.'

IN PARENTHESIS

seinnyessit e gledyf ym 24/8 *penn mameu*

DAVID JONES

LONDON: FABER & FABER LTD

COTCHFORD FARM,
HARTFIELD,
SUSSEX.

1. xii. 39

Dear Sir,

I am afraid I am not with you; for I believe that war is a lesser evil than Hitlerism. I believe that Hitlerism must be killed before war can be killed. I think that it is more important to abolish war than to avoid or stop one war. I am a practical pacifist. In 1933 when I began Peace with Honour my only (infinitesimal) hope of ending war was to publish my views and hope that the world have time to spread before war broke out. They did not. One must try again. But since Hitler's victory will not abolish war; and since peace now (which is the recognition of Hitlerism) will not abolish war; one must hope to be alive to try again after England's victory — and in the meantime to do all that we can to bring that about.

Yours faithfully,

A A Milne

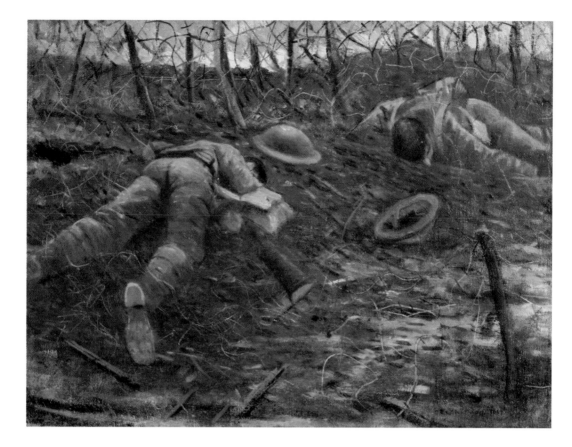

armaments, and the way that behind the scenes disarmament talks are undermined by arms companies.' The author A. A. Milne, who had served in the First World War, denounced war in *Peace with Honour* (1934), writing that war was 'silly', and that politicians were responsible for 'lies, lies and still more lies'. Five years later his views would change.

Norman Angell's *The Great Illusion* (1933), had an enormous impact both in the UK and internationally; it was a new edition of *Europe's Optical Illusion* (1909). The book argued that 'war is bad economics' for interdependent industrialized nations and respect for international law and a world court were the only route to peace. Angell, a politically active writer and journalist – he was a Labour MP, 1929–31 – was awarded the Nobel Peace Prize in 1933.

The focus of these books was underlined by the images of human suffering and devastated landscapes captured by the war art of painters such as George Clausen, Eric Kennington, C. R. W. Nevinson, William Orpen, John Singer Sargent, and John and Paul Nash. Some of the music of contemporary composers, including George Butterworth, Ivor Gurney and Ralph Vaughan Williams, who all served on the Western Front (Butterworth died at the Somme in 1916), and others such as Edward Elgar, added to an all-pervasive sense of sorrow and loss and contributed to a 'never again' determination in large sectors of the British public.

OPPOSITE C. R. W. Nevinson,
Paths of Glory, 1917. Banned by
the official censor, the painting
was exhibited anyway by
Nevinson, with 'censored'
taped over the canvas.

ABOVE George Clausen's *Youth
Mourning*, 1916, captured the
wartime grief of so many.

On 9 February 1933, ten days after Hitler came to power in Germany, undergraduates at the Oxford Union debated the motion 'that this house will in no circumstances fight for King and Country'. The motion was carried by 275 votes to 153. Three weeks later, when Winston Churchill's son, Randolph, a student at Christ Church, proposed the motion should be deleted from the Union records, the majority against was even bigger: 750 to 138. The whole issue generated intense press interest and discussion across Europe as to the implications of the vote. Charles Kimber, who co-founded the Federal Union five years later, was up at Oxford at the time and present at the debate:

I've always felt it was misrepresented; all the belligerent warriors at once identified it as a pacifist vote. It was nothing of the kind. Large numbers of people who voted that way fought subsequently in the Spanish Civil War. What people haven't realized is that it was very carefully worded, 'In no circumstances will I fight for King and Country.' This is what our generation was about and what the League of Nations was about: 'My country right or wrong', was a thing that was not acceptable. And wording that resolution in that way enabled pacifists and League of Nations people to vote together...It was not a vote against war, it was a vote against 'my country right or wrong' –

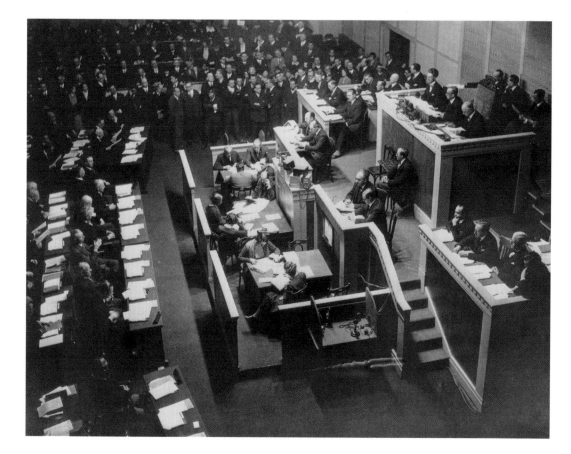

OPPOSITE The opening of the
Geneva Disarmament Conference
on 2 February 1932. It was hoped
the delegates would find an
acceptable disarmament formula.

RIGHT These notes on disarmament,
from 1936, by an 11-year-old Tony
Benn, show how the future Labour
politician had an early grasp of
international affairs and was a
peace activist in the making.

D. A
keep armaments down so that alone you can do nothing but united in a "League of nations" could quell any wars springing up and keep a world peace.

DISARMAMENT 1936
MORE TAXES concentrated on new houses
NEW ROADS Built WITH MONEY CONCENTRATED ON ARMS
LESS TAXES
cleanliness
Employment
LESS TROUBLES for parliament
LESS POVERTY
MORE MON TO AFFORD DOCTER

a nationalist war. That was the thing that finally allowed me to sign on [as a CO] when war came, that the war was a nationalist war.

This debate was held at a time when the effectiveness of the League of Nations in maintaining peace was being challenged. Established in 1920 as a result of the Versailles Peace Conference, the League, based in Geneva, was intended to help prevent war and to assist in settling international disputes by negotiation. Lack of American participation, and the rise of the Axis powers, whose aggression it could not fight, weakened its power. When the Japanese invaded Manchuria in September 1931, the Chinese government appealed to the League and to the United States as a signatory of the Kellogg-Briand Pact. Neither made a response prompt or decisive enough to halt the Japanese advance; Japan refused to leave Manchuria and withdrew from the League in March 1933. This episode rang alarm bells for many in the anti-war movement, compounded by the failure of the Geneva Disarmament Conference that first convened in February 1932. Expectations had been reasonably high for this gathering, not least because the Great Depression, which shattered the world's economies between 1929 and 1932, had made the cost of armaments a greater burden for all nations, but other indicators were not auspicious, particularly the polarized positions regarding armament levels taken by France and Germany. When Hitler became Chancellor of Germany, he stepped up rearmament, secretly underway since the 1920s, and withdrew Germany from both the conference and the League of Nations in October 1933. The conference dragged on into 1934 but it was effectively dead. With the failure of multilateral action in favour of peace, and the fascist powers on the rise, the international situation looked bleak.

THE RISE OF FASCISM: THE FRACTURING OF THE PEACE MOVEMENT

The Italian invasion of Abyssinia (Ethiopia) in October 1935 was the wake-up call that led to divisions within the peace movement. Sylvia Pankhurst was one of the first to grasp the ominous implications of the growth of fascism in Italy and warned against Mussolini's expansionist ambitions. Italy's aggression confirmed her worst fears and led to vigorous campaigning on the twin causes of anti-fascism and Abyssinian liberation. Although still a pacifist in the 1920s, she gradually came to believe that fascism was itself such a threat that it could be defeated only by a resort to arms; Mussolini's occupation of Abyssinia confirmed her belief and led to her life-long crusade for that country. The invasion was yet another blow to the League of Nations's core principle of collective security – whereby the member states pledged to defend each other from attack – and brought the issue of the effectiveness of sanctions to the fore.

In Britain, the government was aware of strong support for the idea of economic sanctions, thanks to the efforts of the League of Nations Union, which had become the leading pressure group supporting the work of the League in these years, peaking at over 400,000 members in 1931. It had organized a Peace Ballot asking voters a range of questions and

Members of one of the International Brigades gathered at the British cookhouse in Albacete during the Spanish Civil War, c. 1936. Their fists are raised in the Communist salute.

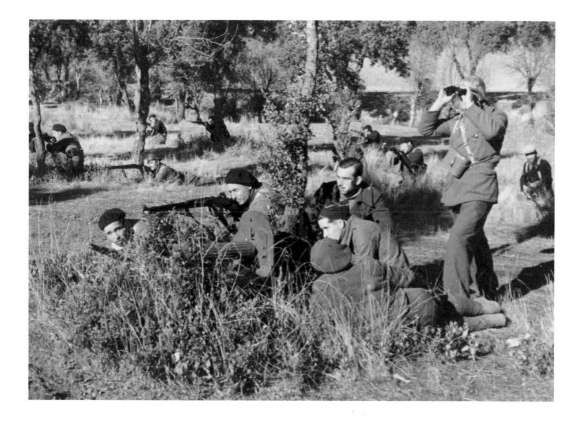

the results were announced in June 1935. Of over eleven million people canvassed, or 38 per cent of the adult population, only 355,000 were against Britain remaining in the League of Nations and 635,000 against imposing economic sanctions if one nation attacked another. Perhaps more significantly, 6,780,000 voted in favour of military action to stop international aggressors as a matter of last resort.

As with Manchuria, the League's response to the Abyssinian crisis was weak, and the political situation deteriorated further when Hitler occupied the Rhineland in March 1936, in contravention of the Versailles Treaty. The debate regarding the use of military force intensified with the outbreak of civil war in Spain, when members of the army rose up

ABOVE Members of an International Brigade training in Spain, c. 1936. Many of them had renounced their pacifism in order to fight for the Republican cause against General Franco's Nationalists.

OPPOSITE The writer Vera Brittain in her VAD uniform during the First World War. She became a committed pacifist in 1936.

OVERLEAF A group of Basque girls, refugees from the civil war in Spain, enjoying the seaside near their camp at Dymchurch in Kent, c. 1937.

against the left-leaning Republican government in July 1936. For pacifists, the conflict presented the central dilemma of that decade, especially for those who were socialists, many of whom ended their pacifist commitment and opted to join the war on the Republican side. Fenner Brockway, who had published *The Bloody Traffic* against the arms trade in 1933, was one of those who now moved away from pacifism: 'I so wanted them [the Republicans] to win! I felt I couldn't want them to win without *doing* something to help them win.' He assisted in recruiting British volunteers for the ILP contingent that went to fight the fascists in Spain. There were others, such as Vic Newcomb, who regarded the Spanish war as a turning point in their lives: 'I began to understand...that ideologies, politics, religion and all those convictions had a greater importance on life than I had given credence for.' He became a CO in the Second World War.

Hitler's increased belligerence and persecution of German Jewry caused deep schisms within the anti-war movement: peace was no longer the clear-cut issue it had appeared to be in the 1920s. For Christian pacifists, guided by doctrine, the situation was relatively straightforward: war was contrary to the spirit and teaching of Jesus Christ. The Council of Christian Pacifist Groups, founded in 1933, started to promote a more united Christian opposition to war, and the PPU, under the leadership of the Revd Dick Sheppard, played a major part in this development. When he died in 1937, another prominent clergyman, Canon Stuart Morris, became chair of the PPU.

For some people, the prospect of another major war stimulated them to join the peace movement or to campaign harder. The writer Vera Brittain was not a pacifist in the First World War and it was not until 1936, when many others felt that they could not subscribe

to pacifism, that she had a change of heart. A regular speaker for the LNU since the 1920s, she began to question both the LNU's advocacy of collective security reinforced by sanctions and whether war should be even a last resort. At a peace rally in Dorchester in June 1936, after hearing the pacifist speeches of George Lansbury, Donald Soper and Dick Sheppard, with whom she was sharing a platform, Brittain changed her talk and with it began to commit herself to Christian pacifism. Sheppard invited her to become a sponsor of the PPU and she worked for peace until her death in 1970.

In 1938, as support for the League of Nations waned, two young men, Charles Kimber and Derek Rawnsley, founded the Federal Union (FU). This was at the height of the Munich crisis

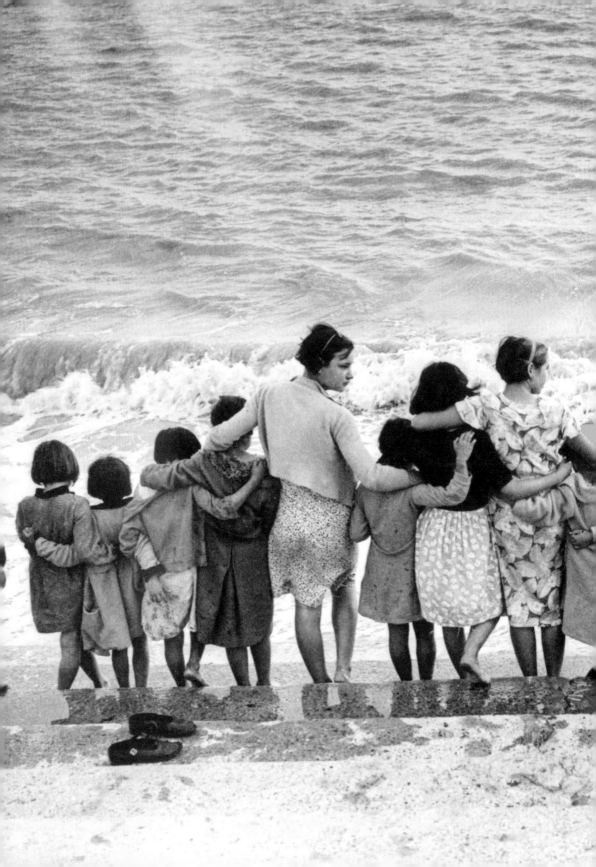

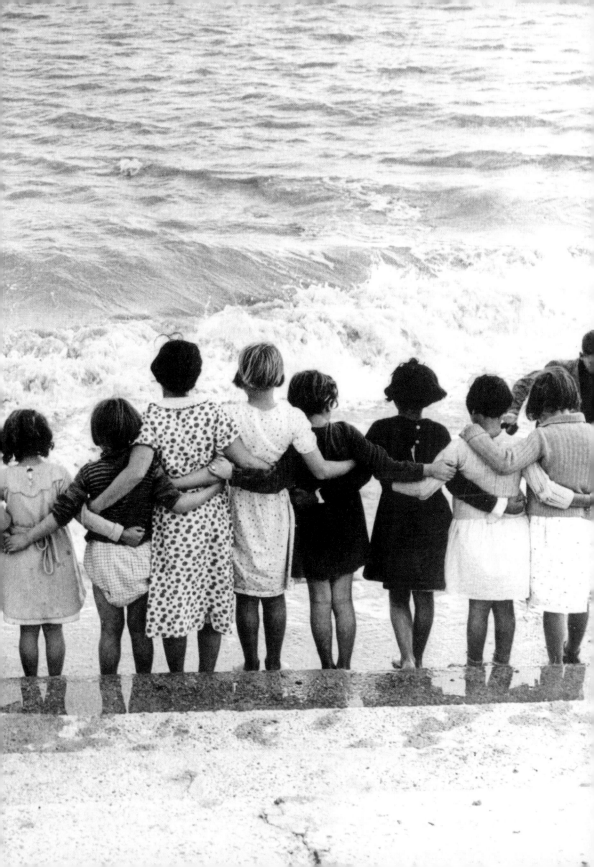

and the Prime Minister Neville Chamberlain's policy of appeasement to Hitler's demands. Kimber later recalled how:

> My friend Derek Rawnsley rang me and said,
> 'Look, we've got to do something!' By then our
> ideas were fairly clear, a league but with powers
> of its own and independent of nation states…
> The pamphlet we produced was just headed
> Federal Union, and the gist of the text was to
> say that the reason the League of Nations had
> failed was because you couldn't trust national
> governments to keep their word and what was
> needed was a federal government that had
> to be democratic.

A distinguished panel of advisers was recruited and by June 1940 the FU had over 200 branches. The economist Sir William Beveridge agreed to chair a Federal Union Research Institute and leading academics such as Lionel Robbins and Barbara Wootton wrote 'Federal Tracts' on the idea of European federation.

The interwar peace movement, particularly the PPU, has been accused of supporting appeasement, with many believing Hitler's claims to the Sudetenland to be valid, given the onerous terms of the Versailles Treaty. Some members of the PPU were considered so sympathetic to the German position as to be pro-Nazi. Furthermore, the disarmament campaigns of the 1920s and 1930s laid the peace supporters open to the accusation of contributing to Britain's military unpreparedness in the face of aggression from the Axis powers. These criticisms highlight the divisions that emerged in the peace movement as the 1930s progressed. At the other end of the gamut, as early as 1933 many of those who later joined the PPU and other campaigning organizations were expressing their hatred of fascism, protesting against its advance, warning of the dangers it presented and the need to stand up to it, short of actual force.

Meanwhile, there were those who became involved in practical forms of peace work, mostly from the mid-1930s, helping refugees escaping the oppression of Franco and Hitler.

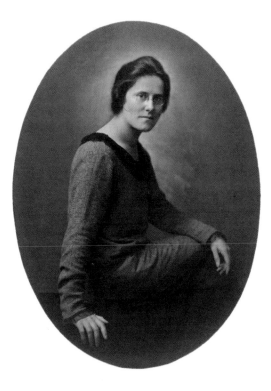

For example, on 23 May 1937 nearly 4,000 Basque children arrived at Southampton on the SS *Habana*, having left Bilbao shortly before the city fell to the Nationalists, and had to be found accommodation in camps and homes around the country. On 9–10 November 1938, the shock of *Kristallnacht* – the Night of the Broken Glass – when Jewish synagogues, businesses and shops in Germany were attacked, impelled a delegation of Jewish and Quaker leaders to ask the British government to accept 10,000 mostly Jewish children in an evacuation from Germany and Austria that became known as the *Kindertransport*. Such was the speed with which they acted that the first train set off on 1 December, only three weeks after *Kristallnacht*, and the rescue continued until war broke out in September 1939. The threat of Nazi invasion in Czechoslovakia in March 1939 prompted the London stockbroker Nicholas Winton to arrange the escape of 669 Czech children. The actor Paul Eddington, a pupil at the Quaker Sibford School in Oxfordshire in the late 1930s, remembered different groups of refugee children arriving: 'As war approached we got more and more. There were Austrians, Czechs, but many, many Germans, almost all of them Jews... and of course we got to know them well.' The WRI and PPU, as well as the Society of Friends, were particularly active in facilitating sponsorship and assistance for these children, as well as helping adults who needed refuge. In addition, many peace activists took refugees from Spain, as well as German, Austrian and Czech Jews, into their own homes.

During the last year of peace, attention was turning towards preparations for war. Germany's annexation of Austria in March 1938, followed by that of the Sudetenland in October, which had been acquiesced to in the Munich agreement of 30 September, caused great debate within the peace movement. There were those, such as Jean Greaves, the daughter of a former CO, Corder Catchpool, who were grateful for the way Chamberlain had preserved the peace: 'I think people nowadays, especially those who weren't there, don't realize that we felt, "Thank God, another war has been averted."' George Lansbury, president of the PPU from 1937, called for a world peace conference, but despite over one million people signing a petition in support by March 1939, nothing came of this.

The Nazi occupation of Czechoslovakia in March 1939 made it apparent that war had merely been delayed. Some pacifists, now fully realizing the evil nature of Nazism and the threat the fascist powers presented, reluctantly abandoned their anti-war stance, not only accepting that military force was going to be necessary but also that it would be a conflict in which

they must fight. The international situation they faced differed greatly from the old balance-of-power system that had existed in 1914, when Britain had fought to restore the state of affairs upset by Germany and her allies; the looming war seemed more difficult for them to reject.

It could be an agonizing decision. Some well-known pacifists, such as the philosopher and lecturer C. E. M. Joad and Bertrand Russell, came to the view that defeating Hitler overrode their objections to war, and A. A. Milne, who regarded himself as a 'practical pacifist', argued in a letter of 1 December 1939 that, 'war is a lesser evil than Hitlerism', and as for abolishing war, 'one must hope to be alive to try again after England's victory – and in the meantime to do all that one can to bring that about'. In *Outside the Right* (1963), Fenner Brockway recorded the difficult situation he felt himself to be in at this point:

> If I had been unreservedly anti-war I would have had a clear purpose as I had in the First World War; but I was too conscious of the evil of Nazism and Fascism to be completely pacifist. Yet I could not be pro-war...I was in the dilemma of seeing everyone around me supremely engaged and I could neither join in nor actively oppose.

Other pacifists did not waver. The critic John Middleton Murry, one of the noted public figures who acted as sponsors of the PPU and author of *The Necessity of Pacifism* (1937), maintained

his stance throughout the war, during which he was editor of *Peace News*. Although he recognized the tyrannical nature of Nazi rule, he felt this was preferable to the horrors of total war. Nonetheless, he renounced his pacifism in 1948, during the early stages of the Cold War, when he urged a preventative war against the Soviet Union.

Virginia Woolf had always been against violence and most of her male friends had been COs in the First World War. In the 1920s and 1930s, although a committed pacifist, she became increasingly alarmed at the spread of fascism in Europe. Although she never under-estimated the horrors of the fascist regimes, she did not support the decision of her nephew Julian Bell to renounce his pacifist stance and

go to Spain in 1937 as an ambulance driver with the British Medical Aid Unit. E. M. Forster tried to persuade him it would be an immoral act to participate in war, but in 'War and Peace', an open letter written to the author in response, Bell justified his change of position, arguing that 'the time for the soldier had arrived; that to be anti-fascist means one had to prepare for war'. Many people, including Woolf, were coming round to this position, but what was anathema to her was Bell's overt masculinist approach as revealed in the letter. After pleading from Woolf and his mother, Vanessa, Bell went to Spain in his non-combatant role, but was killed by a bomb only a month after his arrival.

After Bell's death, Woolf completed *Three Guineas,* in which she presented the close connection between male vanity, patriarchy and militarism. Published in 1938, it was a robust attack on patriarchal structures in society and the reluctance of men to share their privileges in terms of education, property, salaries, opportunities and patronage with women. The only solution for Woolf was to narrow gender inequality by expanding opportunities in all the above fields – the 'three guineas' were to be used for this purpose.

Woolf's argument contributed to the ongoing debate, dating from before the First World War, on the connection between gender and militarism. But she rejected the romanticized maternalism and women's virtues rhetoric of the earlier generations, stressing the way women connived with men by admiring their deeds and thus perpetuating war. She suggested that patriarchy, war and fascism were closely linked, all based on the will to dominate. Feminists were therefore the advance guard of the pacifists, struggling against the tyranny of the patriarchal state in the same way that pacifists were struggling against the fascist state.

As late as 31 August 1939, four days before war was declared, Woolf still fervently hoped that it could be averted; but on 6 September, she wrote in her diary that although it was the worst of her life's experiences, she realized that Hitler had to be resisted, and there was no way one could be both anti-fascist and anti-war. With the outbreak of war, her husband, Leonard, as a Jewish socialist, would be at risk if the Germans invaded; and the couple was on Hitler's blacklist. The war contributed to a recurrence of the author's depression and she committed suicide in March 1941.

As the international situation deteriorated from the mid-1930s, the coalition National Government made repeated assurances in Parliament that conscription would not be reintroduced in peacetime. In fact, a conscription bill had been in readiness since the end of the First World War. The government attempted to encourage volunteers by methods similar to the Derby Scheme of the earlier war. In December 1938, the Lord Privy Seal, Sir John Anderson, announced plans to compile registers of those men and women willing to volunteer for the regular, auxiliary and reserve forces and the various services of civil defence. The vast majority who responded opted to join the civil defence services. More severe measures were introduced the following spring as war came to be seen as increasingly inevitable. The Military Training Act of May 1939 instated a limited form of conscription for men aged 20 and 21, with provision for COs, but was soon superseded by the National Service (Armed Forces) Act, which came into force on 3 September 1939, the day on which Britain declared war on Germany. Conscription now covered men aged between 18 and 41, with exemptions for COs, those in reserved occupations, students and various other categories, such as clergy.

3 THE SECOND WORLD WAR: AGAINST TOTAL WAR 1939–1945

> " IT WASN'T A POSTER OF KITCHENER POINTING AT YOU, 'YOUR COUNTRY NEEDS YOU!' BUT MUCH MORE SOBER, QUIET AND SAD...I FELT AN OUTSIDER. "

OPPOSITE A print by John Petts, an artist who was a conscientious objector in the Second World War, of the 'Red Cross Devils' of 224 Parachute Field Ambulance during Operation Varsity, the drop over the Rhine, March 1945.

The outbreak of war in September 1939 witnessed little of the rejoicing and eagerness of 1914. Instead, the successive crises provoked by Germany's aggressive moves in Europe allied to the legacy of the earlier war produced a mood of sombre resignation. Harold Bing, a former CO, found that 'those who went into the Second World War went there with the feeling, "well, this is an unpleasant necessity". There was no glorification of war, no enthusiasm for it...Generally it was, "Well, Hitler's got to be disposed of somehow or other, and we've got to see it through, but it's not a job we like."' The long lead up to war meant, however, that the government was better prepared than it had been in 1914, including in the area of manpower planning.

Lessons had also been learnt concerning the treatment of conscientious objectors. On 4 May 1939, the Prime Minister, Neville Chamberlain, had spoken in the House of Commons of the need to respect the rights and status of COs. He had been a member of the Birmingham tribunal between 1916 and 1918 and that experience made him realize that to force absolutists to go against their principles was 'an exasperating waste of time and effort' and there should be no persecution of those with scruples 'conscientiously held'. By the terms of a second National Service Act, passed in December 1941, conscription was extended to women, initially those who were unmarried and aged between 20 and 30, and for the first time there were female applications for CO status.

For most people in Britain, the first months of the war brought little immediate change: although action had started at sea, at home there was no sign of the expected bombing raids and gas attacks. It was considered 'the strangest of wars', as Neville Chamberlain put it, and during this period of the 'Phoney War', from September 1939 to April 1940, many pacifists felt there was a chance that a negotiated peace could be achieved. Within days of war being declared the PPU launched a Stop-the-War campaign and organized demonstrations throughout the country, but from its inception the campaign was beset by differences of opinion, which only increased as the gravity of the war became apparent. At a personal level, as Tom Haley recalled, it was 'Make up your mind time'. For some, the choice was straightforward – there was no hesitation in refusing to fight – but for others it was more complex. Hugh Jenkins, who later became a Labour politician, observed: 'On the one hand I loathed the idea of war and was, I think, a pacifist at heart. On the other hand I came to the conclusion that Nazism had to be stopped, and I was uncertain about what I ought to do. My friends and I knew that eventually we would be called up – would we be COs or wouldn't we?' The dramatist William Douglas-Home considered himself a political objector, and when he received his call up he warned the authorities that 'a situation might arise in the future when they wouldn't find me all that reliable. They never answered that. It was a difficult decision for me because I was against the whole idea of the war and wanted peace aims – there weren't any.'

The German Army's blitzkrieg through Denmark, Norway, then the Low Countries and into France in the spring of 1940, leading to the fall of France in June and the evacuation of British and French forces from Dunkirk, clarified the situation for many. Winston Churchill, who replaced

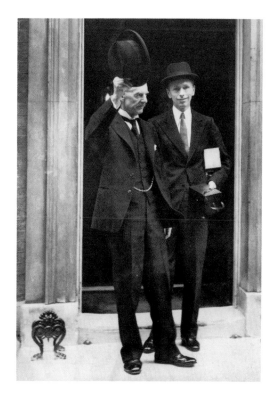

Chamberlain as Prime Minister in May 1940, encouraged the British to stand firm in the face of the Nazi onslaught. Mervyn Taggart explained how 'there were a great many who were pacifists up to the time of Dunkirk, but when they saw a real possibility of England being invaded, at that point they changed. And this would go for people who were lifelong pacifists.' Many of the latter entered the services at this point. Ron Huzzard felt that it 'was not an easy war to oppose'. It was the defection of prominent pacifists such as C. E. M. Joad and Bertrand Russell, however, that proved such a blow to many young COs. John Marshall, then working on an agricultural commune in Hampshire, regarded them as the 'arch intellectuals who had provided and stoked up the rational, intellectual side of the movement...So one felt completely abandoned and betrayed.'

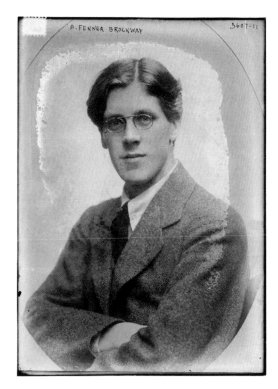

OPPOSITE The Prime Minister, Neville Chamberlain, leaving 10 Downing Street on the day war was declared, 3 September 1939. He is accompanied by his Parliamentary Private Secretary, Alec Douglas-Home, whose brother William was a political objector to the war.

RIGHT Fenner Brockway, although imprisoned as a CO in the First World War (around the time this photo was taken) and chair of the Central Board for Conscientious Objectors in the Second, supported British participation in the fight against fascism.

OVERLEAF, LEFT Conscientious objectors take to the streets of London and march against conscription, November 1939.

OVERLEAF, RIGHT Free advice being offered to potential COs in June 1939, after the Military Training Act was passed.

Those who remained committed and were called up had to apply to a tribunal to obtain official status as a CO, as in the First World War. During the Phoney War, more than 50,000 applicants were processed and initially the decisions reflected a general public tolerance of COs, with 14 per cent of all objectors being granted unconditional exemption in 1939. The proportion dropped to 5 per cent in 1940 and 2 per cent by 1941. As with the tribunals of the First World War, political objectors attracted the most scorn, and they could not easily shake off the popular perception that their appeal to conscience was a cloak for cowardice. Overall, the COs were a very mixed group. There were religious objectors of all denominations and pacifist and non-pacifist objectors whose views ranged from socialists who would not fight in any war to those who objected to this particular war but were willing to

take up some alternative service. There were also those who had been COs in the First World War and others whose experience of fighting in that conflict had led them to believe that, whatever the cause, war is wrong.

An indication of how the government attitude to the treatment of COs had changed since the First World War was the recognition of the Central Board for Conscientious Objectors (CBCO) as a vital resource that could be consulted on matters relating to conscientious objection. Set up in 1939, under the chairmanship of Fenner Brockway, the CBCO had representatives from the organizations that supported COs and advised and assisted objectors of all persuasions. There were about 100 groups around the country that kept records, monitored tribunals and lobbied Parliament on behalf of the COs.

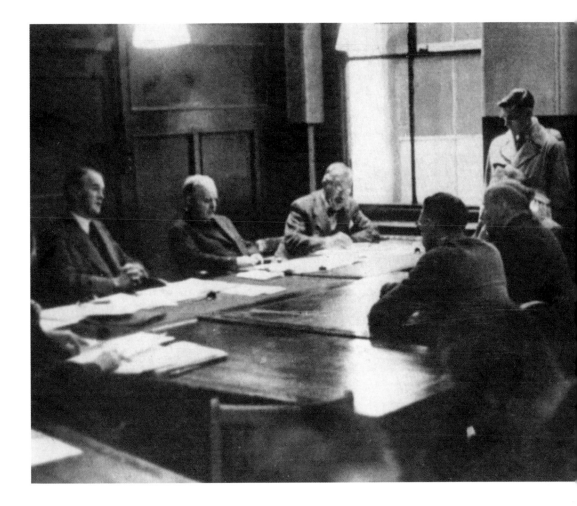

THE TRIBUNAL SYSTEM

In the First World War there had been little central control of the tribunals but the system changed in the new conflict. The panels dealing with applications from those wishing to be exempted from all or part of the war effort were administered by the Ministry of Labour and National Service, which had strict supervision of their membership. Local tribunals consisted of a chairman, who had to be a lawyer (usually a county court judge, or his Scottish counterpart), and four other 'impartial' members, one of whom had to be a trade-union representative. If there was a woman applicant, a woman panel member was required. Forces representatives were not mandatory this time, although there were cases of military men serving on panels. It is generally accepted, however, that the war ethic, which had so strongly pervaded the tribunals of the earlier war, was largely absent. The hearings were usually held in public, and, as in the First World War, the applicants could bring a supporter, preferably someone of standing in the community, to testify on their behalf.

The tribunals were still something of an ordeal for the young men and women facing them, but they are now regarded as having been relatively fair, with panel members more open minded, tolerant and striving to understand those standing before them than their predecessors had been. Nonetheless, there continued to be discrepancies between tribunals, and the attitudes of chairmen varied, ranging from the tolerant and sympathetic to the hostile and insulting. His Honour Judge Richardson, chair of the Newcastle Tribunal, was particularly notorious. His name was

A tribunal considering an application from someone wishing to be put on the Register of Conscientious Objectors, during the Second World War. The applicant could bring a character witness, such as a lawyer or priest, and friends sat in the audience to give support.

mentioned in the press and Parliament more than once for his dismissive, insulting behaviour towards COs, with remarks such as, 'It is a pity that we cannot put you people on a desert island so you could all enjoy yourselves.' He seemed particularly vindictive towards the women COs who appeared before him, once remarking to a group of Rotarians in Hexham that he found women far more assertive than men and 'more poisonous'.

The tribunals divided the applicants into categories that followed much the same pattern as had been established in the First World War. A: unconditional exemption – the absolutist position – which was the most difficult to obtain; B: conditional exemption, which was the most common, whereby the applicant was directed into work of a civil character and under civilian control; C: registration as someone liable to be called up for service, but to have non-combatant duties only. In August 1940, the Non-Combatant Corps (NCC) was re-formed expressly for receiving category C objectors into the army. If applicants failed to convince tribunals of their sincerity, they could be directed into military service, although there was recourse to an appellate tribunal. From 1941, women who registered as COs were directed into civilian work as no NCC was formed for any of the women's services.

Of the 62,301 applicants for exemption from armed service in the Second World War, of whom 1,074 were women, 2,937 were awarded unconditional exemption. Around 18,000 were turned down altogether, and the rest either had conditional exemption and undertook various forms of civilian work or did non-combatant military service. About 6,750 served in the NCC. Around 5,000 men and 500 women faced charges to do with conscientious objection and served prison sentences,

but very few were incarcerated for more than a year.

The composer and entertainer Donald Swann, then an undergraduate at Oxford University, described how his case was followed by that of an inarticulate butcher whose statement consisted solely of, '"You're all murderers, I won't do anything for you." "No good," they said and dismissed his Objection...Fortunately he was swept up by the CBCO people who said, "You must have an appeal. We will tell you how to write it out."' Doris Nicholls acted as an adviser to COs, attending tribunals on their behalf. She recalled the patience and humanity of one group of panel members trying to coax a sincere but inarticulate young pacifist to present his case, rephrasing their questions over and over and eventually, knowing of the conversations she had held with him, calling on her to expand on his case. He was given unconditional exemption. Peter Sharp's case was dismissed and he decided to appeal: 'Well, the difference!... They could sense the nervousness of objectors and were understanding. I was given a chance to go on the land, and I got a job with a very mixed bunch of pacifists at Ripley, near Guildford.'

As a member of the Religious Society of Friends, Mervyn Taggart felt he had a relatively easy time, 'because most people understood the Quaker position, it was an historical one... I was one of a very, very small number of people who were given unconditional exemption. That means that they left it to me to do what I thought was right during the war.' Reginald Bottini, on the other hand, had the misfortune to appear before the notorious Fulham tribunal; its harsh reputation was confirmed when he witnessed the severe treatment of seven 'obviously religious fanatics' who went before him. Convinced that he would be dealt with in the same way, he reacted aggressively to the hard

RIGHT Peter Sharp, a CO during the Second World War, with his three servicemen brothers (from left), Jack, Cyril and Eric.

BELOW The national registration card of actor Paul Eddington, who as a Quaker was granted conditional exemption as a CO at a tribunal just a few weeks before the end of the war.

CLASS CODE: B272

DZBQ W 116

EDDINGTON Paul C.

PHOTOGRAPH OF HOLDER

Signature of Holder

Paul Eddington

HOLDER'S:—

Visible Distinguishing Marks NONE.

Place of Birth St. Johns Wood London.

Date of Birth 18:6:1927.

Registered Address of Above Person

257 Granville Rd

OFFICIAL STAMP SHEFFIELD

KIA KIA

51-8084 N.R.101

FOR INSTRUCTIONS, SEE BACK

questioning. 'In fact, they gave me conditional registration, the only one out of eight. I reached the conclusion, cynical youngster that I was, that it wasn't on the basis of conscience at all, but that here they saw a red-haired troublemaker of Irish/Italian descent that might be difficult for army discipline.'

Douglas Beavor, like all Jehovah's Witnesses, took the absolutist position. He later recalled how 'the pressure was on after Dunkirk and our stand, being absolute, brought down the wrath of the authorities on us. Towards the end it was the maximum sentence every time.' Some tribunals were known for a particular prejudice against Jehovah's Witnesses, and they came in for criticism from the Duke of Bedford, speaking in the House of Lords on 2 March 1943:

> I must say that the theology of Jehovah's
> Witnesses seems to me to be lamentable, and
> their objections to participation in war when
> based on that theology to be very weak indeed.
> Nevertheless, it is undoubtedly true, I believe,
> that such people are usually perfectly sincere
> and there is not the slightest reason why
> we should tolerate their being treated with
> special severity.

Women had to register for work of national importance from April 1941 and when some were subject to conscription there were applications from a small number to be put on the Register of Conscientious Objectors. When Kathleen Wigham went to register as a CO, she was met by an outraged official who said, '"Oh, you're one of *those*, are you, we didn't expect *women* coming along"...he took various particulars and dropped some casual remarks about being a coward and not being able to see straight.'

Women in this category were directed into work on the land, in hospitals or any occupation that would release other women for the services. If they refused such direction, they had to appear before a tribunal. Angela Sinclair-Loutit, an undergraduate at Somerville College, Oxford, was pleased to have her case considered by a tribunal, feeling that it gave her some status with the men she hoped to work with in the Friends Ambulance Unit: 'Tribunals were a subject of gossip; we all compared them. It was stressed that what they were after was sincerity of belief, not in fact what the beliefs were. How difficult it is to judge sincerity!' Nora Page, who took the absolutist position, was disgusted with the arbitrary sentencing system:

> The chairman would say, 'By the law I will
> sentence you to three months, six months,
> twelve months...' It could be anything
> according to the mood of the magistrate on
> the panel. For my sentence I got fourteen days,
> but a week afterwards a Tottenham girl got
> a month, others got three months, and it was
> exactly the same offence – refusal of direction
> of labour.

Not all panel members were as misogynistic as Judge Richardson in Newcastle. As an absolutist, Kathleen Wigham refused the work to which she was directed, and was given a fine of £5, which she refused to pay. When she was summoned to appear at the Sessions House and still declined to pay the fine, she found the chairman reluctant to send her, a quiet young woman, to prison; she was given the shortest sentence possible – fourteen days – in Strangeways Prison, Manchester. Wigham was then gently urged, 'If at any time you change your mind, all you have to do is let the governor know that you'll pay your fine and you'll be released immediately.' She reflected: 'They were almost *begging* me to pay my fine.'

THE ABSOLUTIST EXPERIENCE

Fewer COs were involved in breaking the laws relating to compulsory military service in the Second World War than had been the case in the First World War. This is thought to be because tribunals offered a much larger number of applicants alternative work that they could conscientiously perform. Nonetheless, there were still some absolutists who did not receive unconditional exemption and wanted nothing to do with the military machine. By refusing to accept the tribunal's decision, they faced a court martial. The process was similar to that of the First World War: absolutists would initially refuse to report for duty when summoned; they were then arrested and taken to an appropriate guardroom. Forcible dressing in military uniform and a compulsory medical examination were attempted. Refusal to accept the rules could lead to repeated courts martial and prison sentences. A sentence might start out as a fine, then progress to indefinite detentions (for a maximum of two years) or what would have been a huge fine of £100. In the First World War, at least 800 COs had been incarcerated for twenty months or more but in the Second World War it was rare for COs to be imprisoned for more than a year. By 31 January 1943, 195 had been court-martialled once, 101 twice, 33 thrice, 2 four times and 2 five times. At this point, much publicity was given to the cases of the two Jehovah's Witnesses who had been repeatedly imprisoned; this led to an administrative concession that on completion of a third sentence a man would be discharged. Finally, the hated 'cat-and-mouse' system had ended. It meant that no CO would have to spend more than three terms in prison if he claimed that the offence was committed on conscientious grounds.

In general, the treatment of COs in prison is considered to have been more lenient than it had been in the earlier war. Yet the stigma of CO status remained and many stories of brutality have been recorded. One absolutist, John Radford, likened the regimen imposed on him and fellow COs by some non-commissioned officers at an Auxiliary Military Pioneer Corps camp at Dingle Vale, Liverpool, to that of a Nazi concentration camp. In a letter to Donald Soper on 27 September 1940, he described the deprivations, beatings, abuse and insults he had endured and wrote, 'I feel pretty badly about my failure to stick it out. I am now in the NCC...I have applied for a transfer to the RAMC [Royal Army Medical Corps], which I suppose is a little more humane in its work.' Thanks to complaints from the CBCO and others, an inquiry was set up to look into Dingle Vale, but although the perpetrators were prosecuted, their punishment was trifling. As the Duke of Bedford remarked in the House of Lords on 2 March 1943, 'people seem to be increasingly conscious of the acts of cruelty and oppression committed by the enemy and increasingly callous towards similar acts committed by their own government'.

The abuse the COs received was most acute at the beginning of the war, particularly after hostilities began in earnest in 1940. William Heard, a Jehovah's Witness, experienced brutal treatment at Feltham Borstal in May 1940. He had all his front teeth knocked out during one beating and a slop pail poured over him when he was in bed.

They knew why I was there and that's why they bullied me. Another nasty habit they had was putting my boots in this bucket all night and the warder would make me wear them the next day. And when the rations came, one particular officer cut mine down.

WARTIME SERVICE FOR CONSCIENTIOUS OBJECTORS

The Second World War was a very different conflict from the First World War. Major technical developments in the machinery of war, theatres of conflict across the whole globe, the mass mobilization of populations and the blurred boundaries between the home front and the battlefield meant that it was a total war of epic proportions. In Britain, civilian deaths on the home front outnumbered those of the services up to September 1941, and by the end of the war they totalled 66 per cent of casualties worldwide. The authorities were acutely aware of the need for labour in humanitarian work as well as in vital industries to replace those who had been called up. The COs assigned to category B by tribunals provided manpower for a wide variety of jobs, which also met their need to bear witness through practical action. Employment was found in agriculture, forestry, coal mining, community projects, hospital and ambulance services. More unusual occupations included serving as human guinea pigs for medical research. From March 1941, COs could also be directed into civil defence. Many willingly undertook such work, but others declined,

including the composer Michael Tippett, who was sentenced to three months in prison for refusing to do full-time civil defence work. The Jehovah's Witnesses, with their fundamentalist stance, particularly objected to the element of compulsion. One Witness, George Elphick, was prosecuted nine times for refusing fire-watching duties in Lewes, Sussex. The sort of people who sought CO status were, on the whole, individualistic and disposed to be socially useful, and welcomed the opportunity for worthwhile employment. Many COs found their work in the humanitarian field hugely rewarding, even life-changing. The 'alternative' label, used for this group in the First World War, was rejected by the new generation: it was considered misleading, disguising the compulsory nature of their service. Instead, they preferred it to be called 'humanitarian service' or 'work under civilian control'.

A number of COs served with the Royal Army Medical Corps, which had a good record for its treatment of COs in the First World War, and many felt satisfied with the humanitarian work they were doing. However, the RAMC was not a non-combatant service, and objectors might be put in the situation of having to take up arms. This was resolved in March 1940 when the War Office made it clear that doing drill or otherwise handling lethal weapons would not be required for those performing non-combatant duties.

The Peace Pledge Union played its part in providing COs with the opportunity to give active assistance without contributing to the war effort. It set up relief projects, called Pacifist Service Units (PSU), in the major cities. Tony Gibson, serving as a CO with the PSU in London during the Blitz, worked in the air-raid shelters. The tasks ranged from dealing with excrement to rescuing people's possessions from bombed-out houses. 'At the time of Dunkirk', he explained, 'when there was talk of "bloody

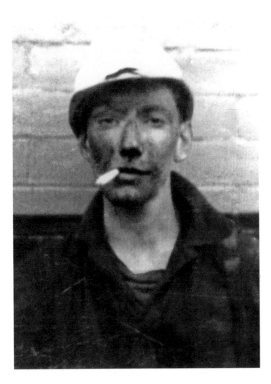

OPPOSITE Conscientious objectors attend a course in mechanized agriculture under the Ministry of Agriculture's labour-training scheme in 1940.

ABOVE Tony Parker was among the forty-one COs who worked as 'Bevin Boys' in the coal mines in the Second World War. Owing to a shortage of miners, the Minister of Labour Ernest Bevin introduced compulsory conscription into the mines for nearly 50,000 young men. The work was alien to both groups but it was a vital contribution to keeping the country running.

conchies; what are *they* doing?", our shelterers said, "Don't you *dare* talk about them, about time *you* started doing something useful!" So it was a rewarding and happy time and we felt ourselves needed...we were regarded as good people.' Ernest Goldring, a former bank clerk, found that working on the land in a small community was exhausting and demanding, but once he got used to it, he enjoyed it immensely: 'I'd always had a great feeling for nature...I learnt some skills such as milking cows and to plough and dig properly.' John Petts's experience on a farm in Derbyshire was very different:

> This farm manager said, 'Today we're carting quicklime and don't forget its bloody quick!' He meant corrosive, the sort of lime they dissolved bodies in during the Great Plague. My body started to dissolve too. There was always this wind and rain...I had two livid lines from my eyes straight down my face, raw-meat canals... nothing was said about my burns, it was impossible to complain. The answer would have been, 'You shut your mouth; men are dying out there.'

Denis Hayes, a CO and member of the CBCO, felt that the COs who worked on the land eventually helped to upgrade the status of agricultural workers: 'They were town folk, had the education, known other standards, it soon got around – why should farm labourers live in feudal conditions? The COs gave a push in the right direction.'

The exposure to men of different backgrounds happened across the board. Tony

Parker, one of only forty-one COs who were employed in the coal mines, found that his experience working as a collier's lad alongside colliers – 'the crème de la crème' – not only gave him a very privileged position, but also had an enormous impact on his life. 'But the thing that impressed me the most was the feeling of solidarity among the miners...I remember having some quite extraordinary conversations with them.'

Other COs had more direct and unexpected contact with the war itself. One hundred COs were sent to work on farms in Jersey; they came under German control when the Channel Islands surrendered in July 1940. Some had the misfortune to be deported to civilian internment camps in Bavaria, while others were allowed to continue to work on local farms.

Among the civilian organizations in which COs served was the Friends Ambulance Unit (FAU), re-established at the start of the war by former members from the First World War, including Paul Cadbury and Arthur Rowntree. The aim was to give young COs – not only Quakers – the same opportunity for active service, providing medical relief to civilian and military casualties, as had existed in the earlier conflict. In the course of the war, 1,300 men and ninety-seven women served in the FAU. Whereas in the First World War not all members had been COs, in the Second World War almost all had to attend a tribunal to establish their CO status.

On the home front, FAU members, like many other COs, performed valuable work in hospitals. Michael Cadbury was a medical orderly in Gloucester City General Hospital. He later told how to begin with the COs met a lot of hostility, with several doctors refusing to have them on their wards. The sisters, in particular, made life hell for these 'shirkers' until they realized

OPPOSITE A print by John Petts, based
on his experiences working as a CO on
a farm in Derbyshire during the war.

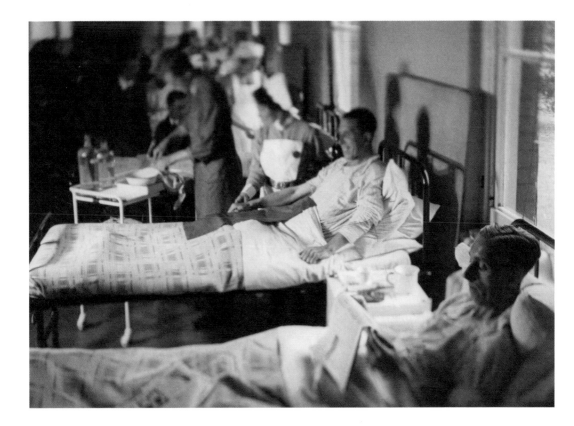

their worth: 'That was the thing that helped all the way through: we weren't running away from anything, we were trying to get *into* things.' Donald Swann, who served as a medical orderly in Orpington Hospital, Kent, recalled how their CO status did not worry the patients, 'You see, this is the thing: a medical passport is probably one of the most wonderful things, because they were glad that there were men around who could produce a bed pan, or whatever it was, and they'd got us to talk to.'

Alan Taylor proved his value in a different way when he was working as a FAU medical orderly at Lewisham Hospital in London. One night a fire started by a bomb that fell on the hospital spread to its dispensary where its stock of oxygen, carbon dioxide and nitrous oxide

A ward in Gloucester City General Hospital, where COs who were members of the Friends Ambulance Unit served as medical orderlies.

cylinders were dangerously exposed and liable to explode if overheated.

Three of us cleared them from the fire. We got recognition for this with a British Empire Medal...I could see there were arguments for both sides in accepting this: one shouldn't accept awards from a government one didn't agree with; on the other hand, I did feel a bit of natural pride and it was a little demonstration that COs and cowards are not synonymous.

Courage was also shown by those COs who volunteered as human guinea pigs for medical research, a scheme that was the brainchild of Dr Kenneth Mellanby, a research biologist. Doug Turner, who took part in experiments for a yellow fever vaccine, suggested that he and other COs 'volunteered because we wanted to express our pacifism creatively and we could do this by contributing towards the health of *all* people. After all, yellow fever is not just a disease affecting soldiers – it has a civil bearing as well.' Angela Sinclair-Loutit took part in an experiment that involved being bitten by malaria-carrying mosquitos twice a week: 'I was prepared to get malaria. I was only too delighted to do what a lot of other people didn't dare do.'

Although relatively few COs suffered the persecution or organized brutality the pioneer COs of the First World War had endured, the majority suffered discrimination, ostracism and disapproval in the workplace, in public places, even in churches, and many lost their jobs. That was when organizations such as the CBCO and PPU came into their own, providing much-needed fellowship, support and alternative employment. Many COs who had contact with service personnel found them more sympathetic to their position than civilians, especially civilian women, whose criticism could be exacerbated by a heavy air-raid or a military reversal. The people in contact with the work COs were doing in air-raid shelters and hospitals during the Blitz appreciated and admired them and, as we have seen in Tony Gibson's case, would stoutly defend them against their critics.

As in the First World War, the most painful difficulty for COs was often the effect that taking their position had on their families. Eric Turner was particularly upset at the pain and embarrassment he caused his parents by his stance:

This meant that my relationships with my own family, friends and neighbours were much more difficult than going through the tribunal, which was a clean and clinical experience compared with the torment I experienced at home...I think my mother suffered more as I was her youngest child and she was very fond of me.

Kathleen Wigham recalled how, 'I got a white feather, the sign of cowardice, sent anonymously through the post. It was in a piece of paper in an envelope; it fell out and Mother just picked it up and put it on the fire and said, "We don't want any of *them* here."' The antagonism Frank Norman experienced was very explicit, especially from one neighbour, an ex-Indian Army man: 'If anybody was in the street – stranger or not – he'd go across and tell them about me, and point at me. I took no notice of this, I felt sorry for him in a way.' Although Denis Allen's mother and stepfather 'excommunicated' him because of his CO stance, he found that his 'friends were all supportive; and the stigma of prison was much less than it had been for COs in the first war'. John Petts, on the other hand, found that he began to feel like an untouchable: 'People withdrew because of your stance...you no longer deserved to be treated like a human being in the community... We were second grade, despised.' For James Bramwell, 'It wasn't a poster of Kitchener pointing at you, "Your country needs you!" But much more sober, quiet and sad...I felt an outsider.' Tony Parker also felt very 'alone' and continued to doubt the CO position he had taken: 'All the time one was saying, "Am I doing the right thing or am I doing wrong?" This was especially so if you had a friend who was killed or injured in the war.'

Many of these feelings would have been familiar to the COs of the First World War but

one of those, Harold Bing, commented on how the experiences of the objectors in the two wars differed in one respect:

There wasn't that sort of cat-and-mouse business – come out of prison, into prison again, for the duration of the war...That meant of course, that there never developed the same kind of strong fellowship among the COs of the Second World War as it did among the First, when we were in the same, or many, different prisons together and there for two or three years; whereas even those who went to prison were only at a local prison perhaps for three months and then they were off, scattered on farms, and never really got to know one another as we did.

Camaraderie was, however, to be found among the members of tight-knit units, such as the FAU and the Parachute Field Ambulance, who performed their humanitarian service overseas alongside fighting troops, bonding together – COs and enlisted men alike – as they shared the risks and dangers of war zones.

CONSCIENTIOUS OBJECTORS AT THE FRONT: THE FRIENDS AMBULANCE UNIT

Many FAU recruits found satisfaction with the work they performed on the home front, but the majority felt the urge to get involved with medical services and civilian relief in conflict zones and by 1943 most members were overseas. Their six-week training course in Birmingham included route marches and learning motor mechanics as well as acquiring nursing skills. They wore khaki uniforms, merely to make them recognizable, as they were a

OPPOSITE An excerpt from 'Chocolate Soldiers', a song written by Sydney Carter and Donald Swann, with music by Donald Swann, for a BBC radio programme in 1989 about conscientious objectors who served in the FAU in the Second World War.

civilian organization, but this and their links with the Quaker chocolate manufacturers Cadbury and Rowntree caused them to be known as the 'chocolate soldiers'. But in comparison to an army private's pay of 75 shillings a month, the FAU members were paid 25 shillings.

The work of the FAU abroad in the Second World War was wide-ranging, from its service in Finland following the Soviet invasion in 1939 through to the help it gave to displaced persons at the war's end, prior to its disbandment in 1946. The global nature of the Second World War meant that the FAU, or the 'Unit' as it became known, served with the Allies in many wartime theatres, including North Africa, Italy, Greece and China, working as medical orderlies and ambulance drivers. The FAU also did much valuable humanitarian work with civilians in other countries: clinics were set up in remote areas of Syria by members of the Hadfield-Spears Unit attached to the Free French Forces. Forty men helped to establish a much-needed system of medical care in Ethiopia by invitation of the emperor, Haile Selassie, after the Italian defeat in 1941, and continued the work under mounting difficulties until the spring of 1945. In 1943, a small team assisted with famine relief and refugees in the Calcutta area of India where 30,000 people had perished in floods.

One of the greatest challenges faced by the Unit was the so-called China Convoy. That

Chocolate Soldiers

Sydney Carter and Donald Swann

———

What were you doing
When the drums were calling?
What were you doing
When the bombs were falling?
When you were still young men
And yes, young women too,
What were you doing in the FAU?

Why did you do it
And what did you do?
Thanks to the Quakers
The chocolate makers,
Preachers and teachers
A rat catcher too
Why did you do it?
And what did you do?

Ethiopia
And Greece and China
Islands round the coast
Of Asia Minor
Whitechapel in the blitz
And Finland in the snow
What were you doing there,
We'd like to know

Why did you do it
And what did you do?
Thanks to the Quakers
The chocolate makers,
Actors and doctors
An architect too,
Why did you do it?
And what did you do?

What were you doing
When the drums were calling?
What were you doing
When the bombs were falling?
They said you had to fight,
You said you would not kill.
Fifty years after, would you say that still?
Doctors and nurses, one baronet too
Why did you do it?
And what did you do?

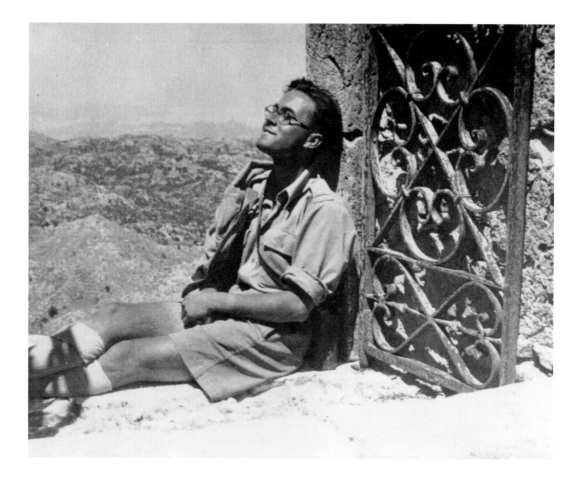

ABOVE Donald Swann, a conscientious objector who served with the Friends Ambulance Unit during the Second World War, enjoys a rare moment of relaxation in Greece. In the autumn of 1944, a Medical Supply and Transport Unit (MSTU) of the FAU covered 250,000 miles and distributed 30,000 cases of medical supplies in Greece.

OPPOSITE, ABOVE In the Syrian desert near Palmyra, a group of Bedouins gather outside a mobile clinic of the Hadfield-Spears Unit, c. 1941.

OPPOSITE, BELOW One of the demanding routes taken by the FAU China Convoy between Kutsing and Kweiyang in the southern part of China. The 'seventy-two bends' were the most challenging.

deployment was distinctive for many reasons: the logistical difficulties of supplying a vast area and the great distance from Britain; the huge need in the face of the paucity of relief organizations there; the international composition of the teams. About 200 members served with the China Convoy in the five years of its existence, ranging from forty in 1941 to 139 in 1946. The majority were British, but Americans, Canadians, New Zealanders and Chinese became part of the China Convoy, including eighteen women. The task consisted mainly of providing the only organized and effective system for the distribution of medical supplies and other necessities to hospitals and missions scattered throughout the huge territory of southwest China and relief to those affected by the Sino-Japanese war. If the rough roads and hairpin bends in the mountains that the convoys traversed in their battered, charcoal-fuelled trucks were not daunting enough, they also had to contend with encounters with bandits and marauding soldiers. As David Morris, reflecting on the challenges they faced, explained: 'We were ordinary human beings trying to live extraordinary lives in China.'

Once the Chinese Army began to drive into Burma as part of the Allied campaign to oust the Japanese in May 1944, the China Convoy not only provided medical teams to work in the base hospitals, but also mobile units that moved forward with those forces. When the fighting ended the Unit started what was to be its third contribution to war-torn China: rehabilitation and reconstruction.

The same kind of work was required in Europe as the tide of war changed, and FAU units helped to deal with the overwhelming civilian need in the newly liberated countries as the Allied armies fought their way through southern, central and also northern Europe.

OPPOSITE A conscientious objector serving with a Royal Engineers bomb disposal squad helps a naval rating of the Rendering Mines Safe (RMS) team uncover a mine. Some 465 COs serving with the Non-Combatant Corps chose to specialize in bomb disposal work.

Some 300 members worked across Europe in transport, health and welfare work in refugee camps. Medical Supply and Transport Units (MSTU) of the FAU covered thousands of miles in Greece and Yugoslavia alone, distributing medical supplies and food. When the Allies crossed into Germany in March 1945, four FAU teams followed them and were among the first to enter Bergen-Belsen concentration camp. In terms of voluntary relief, the FAU operated on a scale second only to the Red Cross.

Sixteen FAU men and one woman lost their lives during the Second World War and several became prisoners of war. On 9 November 1945, Basil Nield MP acknowledged in the House of Commons the respect the Unit had earned:

I do not think that any fighting soldier would hesitate to pay tribute to these men who, prevented by their principles from bearing arms, have none the less willingly suffered the full dangers and rigours of war while pursuing their humane calling to tending the wounded and sick.

THE PARACHUTE FIELD AMBULANCE

For those COs who longed for a more active humanitarian role in the war another opportunity

arose when the War Office asked for volunteers from the Royal Army Medical Corps, in which COs who had volunteered for parachute service were accepted. Five Parachute Field Ambulance units were formed in the war, and COs served in 224 Parachute Field Ambulance (PFA), attached to the 3rd Parachute Brigade of the elite 6th Airborne Division – nicknamed the 'Red Devils' from the colour of the berets they wore. In the spring of 1944, the 'Red Cross Devils' of 224 PFA were preparing for their first active service as part of the D-Day landings, and did parachute training at RAF Ringway like the troops. The initial task of the 6th Airborne Division's drop over Normandy in the early hours of 6 June was to secure the eastern flank for the invasion forces landing along the French coast from the Cherbourg peninsula to the river

Members of 224 Parachute Field Ambulance during the Rhine Crossing, March 1945. The unit had seven dead, nine wounded and seven missing at the end of the first day of Operation Varsity but had conducted nine surgical operations and treated 212 wounded.

Orne. Members of 224 PFA established a main dressing station at Brigade HQ as soon as they parachuted in and by noon had conducted ten surgical operations. Other sections treated and cleared casualties sustained in combat by particular units of the brigade, and dealt with enemy wounded who had been taken prisoner and injured civilians. But even in the heat of battle, the particular status of the COs was not always forgotten. James Bramwell was dropped in 'Bomb Alley', the Bois de Mont, near Bréville:

> Corporal Cranna and I were detailed to take possession of a small house near the battery to be used as an emergency dressing station. He was armed to do the fighting, whereas I, who spoke German, was to do the linguistic part of the exercise. I remember him saying, 'Just my luck to be in a tight corner with one of you conchies.'

Nonetheless, James Baty, a soldier in the 9th Bn Parachute Regiment, recalled a commemorative plaque on the wall of a farmhouse in northern France that bore testimony to the high regard in which 224 PFA was held. It recorded how the unit included members who were conscientious objectors and how, although they refused to bear arms, 'they went right out into battle and brought in bodies, British and German'.

The 224 PFA also saw service in Operation Varsity, the drop over the Rhine on 24 March 1945. It was a daylight assault without the element of surprise – John Petts vividly remembered the casualties they had to deal with right on the drop zone, especially a mortally wounded young man with the tendons of his thigh holding a coin with the king's head on it: 'It was an effigy of the sovereign and a lad of eighteen who had died for his country. All I could do was to hold him like a mother for a moment and give him a

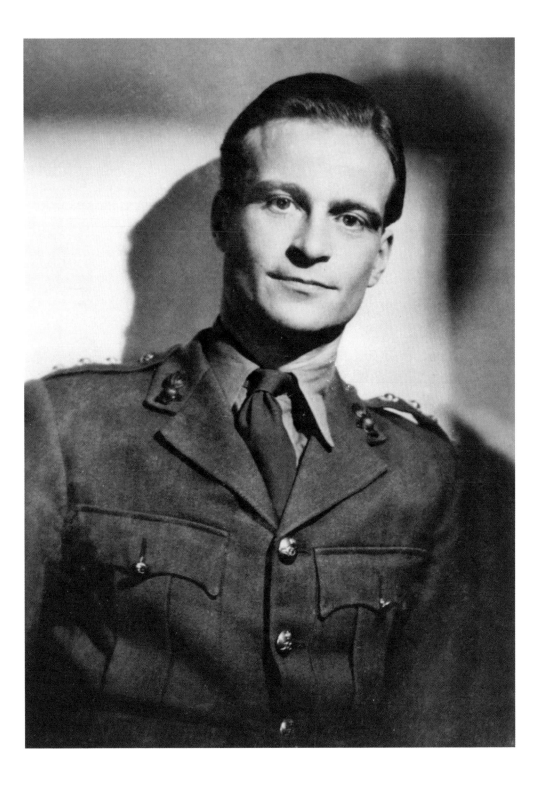

big shot of morphine.' The unit then advanced with the 6th Airborne Division, covering 330 miles in five weeks, to Wismar on the Baltic. It was there that they celebrated VE Day. Along the way they not only treated British casualties but also German prisoners of war and civilians.

After years of theorizing about war and peace, many of the COs working in frontline areas found deep satisfaction at being right in the thick of the action. Some revised their pacifist stance in the face of the horrors of war, such as the concentration camps, and had to deal with bitter criticism from the more purist COs who felt they were making a dangerous compromise with the military machine.

SPECIAL OPERATIONS EXECUTIVE

Among the pacifists who renounced the CO status they had been assigned were a few who found a niche in the Special Operations Executive (SOE), created in 1940 to conduct clandestine operations and help resistance groups in occupied Europe. They were attracted by the informality of the organization, the scope for flexibility and independence it offered, as well as the chance of thwarting the enemy and working behind the lines. All COs serving in conflict areas faced the prospect of injury, capture and death but those who became agents were vulnerable to special treatment if caught: they would not be sent to a POW camp but would be tortured and executed. Harry Rée, a former CO who became a British officer in SOE, F Section, was parachuted into France in April 1943 and operated around Montbéliard, near the Swiss border. It was known that the Peugeot factory at nearby Sochaux was being used by the Nazis to manufacture equipment for tanks and aeroplanes, and Rée orchestrated a sabotage plan to avoid the necessity of RAF air raids that were not always accurate and caused civilian casualties. The scheme was successful and is said to have put the works out of action for three months. Rée could see the irony of the situation: 'Well, this was a wonderful job for an ex-conscientious objector – to stop bombing by blowing up machinery!'

THE SPECIAL CASE OF WILLIAM DOUGLAS-HOME

The case of William Douglas-Home is unique: of the three million people in the British armed forces during the Second World War, he was the only one to be convicted for refusing to obey orders where the defence was based on moral grounds. Despite his abhorrence of war, he accepted conscription and in early September 1944 was serving as a Lieutenant (acting Captain) with 141 Regiment of the Royal Armoured Corps in Normandy. His unit was part of an Allied attempt to take Le Havre, a vital port whose German garrison commander, Colonel Hermann-Eberhard Wildermuth, had been ordered by Hitler to defend the fortress to the last man. Realizing that a pre-assault aerial bombardment by the Allies would result in many casualties, Wildermuth requested the evacuation of civilians still living in the city. His request was refused and about 2,000 French people died in the ensuing air raids.

OPPOSITE Captain Harry Rée, a conscientious objector who changed his mind and joined the Special Operations Executive (SOE). He was parachuted into France in April 1943 to work as a secret agent.

Douglas-Home learnt of the request, and its rejection, which he found morally unacceptable, and refused an order to proceed to 'C' Squadron to act as a liaison officer in the upcoming ground attack. He was placed under arrest and court-martialled, conducting his own defence. The fact that he had disobeyed a specific order from a superior officer was not denied; nor did he resign his commission because he asserted that he did not want his motives to be confused with cowardice. In his pre-trial statement he explained that the central issue for him was, 'whether the conscience of the individual comes before the orders of the state when the individual believes those orders to be wrong'. He was convicted and cashiered and sentenced to a year's imprisonment with hard labour.

Since the postwar Nuremberg Trials, where so many Nazi perpetrators of the most horrendous crimes claimed that they were only obeying orders, it is accepted that people who participate in wars are ultimately responsible and may be held accountable for their actions; they cannot claim that they merely acted on the orders of a superior officer. William Douglas-Home is among a very small group who made such a stand on conscience and principle and accepted the consequences.

Although the stance Douglas-Home took was exceptional, as the conflict continued many servicemen became disillusioned, deploring the way the war was being waged. Many continued in uniform, protesting when possible; others felt they could no longer continue to serve in the forces and were brought before courts martial.

ADAPTING TO POSTWAR LIFE

COs shared in the enormous relief felt by everyone when the war ended with the Japanese surrender on 15 August 1945, although several eschewed the victory celebrations; whether they had fought or not, many still questioned if they had made the right decision.

These doubts were particularly acute when the full horror of the Nazi death camps was revealed. Charles Kimber reflected, 'If one had known then what one knows now about the Final Solution and the concentration camps, would I still have registered as a conchie? That's a very difficult question. But the answer is, yes, I would.' Kenneth Wray found Bart de Ligt's views on non-violence a help in coping with his

heart-searching. De Ligt had argued that even in an occupied country an enemy can be defeated by non-violence, and Wray concluded,

It was the war that allowed Hitler to shoot or gas all those Jews. He couldn't have done it in a peaceful world, but because of war he could just exterminate them. War has caused all that. Hitler was there, yes, but you are responsible, I am responsible for those Jews because we made Hitler.

The issue of how Hitler could have been dealt with short of force was faced by many COs. Ron Huzzard looked to Denmark for an answer:

The Danes, for example, did in fact attempt to resist by non-violent means and had quite

*successful outcomes in their struggles...I have
faith in believing that in the long run evil can
be overcome with good. It may take longer...
But I think the things that were done during
the Second World War are going to be with
us for a long, long time.*

Some former COs found ways to help make
amends for what had happened and to assuage
their guilt in emerging unscathed from the
conflict. Leslie Hardie was one of many who
devoted themselves to humanitarian work:

*I always felt very privileged and very lucky to
have survived, but guilty; I felt I had to repay.
I stayed on in voluntary work after the war and
did two and a half years in India, working in
a voluntary capacity for longer than most
pressed servicemen because of it.*

Other COs found either that their old jobs were
not open to them or that it was not easy to
gain new employment, and many continued
to suffer social disapprobation. According to
Denis Hayes,

*People found doors closed to them that had
previously been open. No explanation was
given, but they knew what it was...There was
always a black mark against me for a long
time, and I think it affected my confidence
for many years.*

There was, however, one positive development
in October 1945 that filled anti-war campaign-
ers with optimism: the founding of the United
Nations. The US had not joined the League of
Nations but took a leading role in this new inter-
governmental organization, called by President
Harry S. Truman 'a solid structure upon which
we can build a better world'.

THE ATOMIC BOMB

The abrupt ending of the war with the use of the
atomic bombs on Hiroshima and Nagasaki on 6
and 9 August 1945 respectively was to have a
profound effect on the postwar world. In 1944,
in a conversation with his fellow physicist Niels
Bohr, with whom he worked on the Manhattan
Project in Los Alamos, New Mexico, Joseph
Rotblat was told that the outcome of their work
would surely be a nuclear arms race with the
Russians and the possibility of complete annihi-
lation. This led to Rotblat's resignation from the
project – the first time anyone had done so.

*I had to promise not to tell the reason why
I was leaving. They were afraid of the effect
this would have on the other scientists...Most
scientists were against the use of the bomb
against civilian populations, but of course the
military didn't take any notice of this.*

Hugh Jenkins, serving with the RAF in Bombay,
was initially very happy to hear the news about
the dropping of the atomic bombs as it saved
his group from going to Burma. But gradually
the realization dawned that this was not only a
bigger bomb, but also something new:

*There was a certain uneasiness, not generally
felt, but with some, and I think I shared this
uneasiness. But something happened which has
been a motivation of mine ever since. Going
down the gangplank preparing to disembark,
an airman came down after me and he said,
'Do you know what I think, Sir?' I said, 'No,
what do you think?' He said, 'I think they may
have saved our lives at the expense of our
children's.' Oh God! It was if he had hit me!
I've had that thought in my mind ever since –
what an extraordinary piece of prescience!*

ABOVE Hiroshima following the
dropping of the atomic bomb on
6 August 1945. The ruined domed
Industry Promotional Hall was
retained as a peace memorial.

OVERLEAF, LEFT David Morris, having left
the FAU in China, received news of the
atomic bomb when he was in Ferozepore,
India, and was moved to write this poem.

OVERLEAF, RIGHT The mushroom cloud
over Nagasaki, 9 August 1945.

Ferozepore

David Morris

———

It's not so very long ago
That life though strenuous was slow,
And there was time to dream.
Horse-power hadn't killed the horse,
A strong right arm was all man's force
Before the Age of Steam.

Now Steam's as slow as horses were
And men go streaking through the air
Faster than waves of sound,
While on the earth their fellow-men
Find sleep and safety only when
They live deep underground.

Man's genius was never more,
Especially in waging war
His deadly works amaze.
We've split the atom without fuss
And soon the atom will split us
Unless we change our ways.

If atom bombs have come to stay,
God help us all on Judgement Day,
For Eliot was wrong.
There'll be no whimpering at the last,
The final act will be too fast,
A bang will end our song.

Cities will vanish in a flash,
The Universe will hear the crash
Of warfare on the Earth.
But when the dust has blown away,
And Western Man has had his day,
The East will see rebirth.

That dirty smear on History's page,
The Ant-heap and Industrial Age,
Will fade from mind of men.
Some Chinese trader will beget
A son by woman of Tibet,
And all will start again.

4 THE COLD WAR: AGAINST NUCLEAR WEAPONS

> ❝ **THINGS IN THOSE DAYS WERE SIMPLE AND STRAIGHT-FORWARD...WE SIMPLY SAID: 'BAN THE BOMB!'** ❞

When the atomic bombs were dropped on Hiroshima and Nagasaki in August 1945, killing an estimated 215,000 Japanese civilians and maiming thousands more, the exact nature of those weapons was not immediately apparent. But, in effect, that marked the end of purely conventional warfare and the opening of the nuclear age. It presaged a new, terrible dimension to how war was conducted and was to have a qualitative effect on the next stage of the anti-war movement, which related to the moral issue of the survival of mankind rather than to war itself.

John Hersey's slim volume, *Hiroshima*, published in 1946, gave a full and graphic account of what the atomic bomb (A-bomb) had done to a city and its population (including a new sickness that was later diagnosed as radiation poisoning). Although the full implications of atomic fall-out were unknown initially, there was much public debate about the ethics of this new weapon. Tony Benn, then an undergraduate at Oxford University, realized the enormity of what had happened when he heard Group Captain Leonard Cheshire VC speak: 'He had been the British War Cabinet's observer on the plane that crossed the bombed area of Nagasaki and said, "Whatever you do, it'll be a complete waste of time unless we get *this* right." He made a deep impression.' With the publication of Hersey's book, the debate became far more intense, and some people, like the physicist Kathleen Lonsdale, protested that nuclear weapons were 'a new crime

THE AUTHOR

JOHN HERSEY was born in Tientsin, China, on June 17, 1914, the son of a Y.M.C.A. worker engaged on famine relief. He was taken to the United States when ten years old, where he attended Hotchkiss School, and later Yale, where he was an active and versatile under-graduate, and assistant Editor of the University's daily paper. He graduated in 1936, subsequently doing a year's post-graduate work in England at Clare College, Cambridge. For a time he acted as private secretary to Sinclair Lewis ; and then joined the editorial staff of *Time*. His " Men on Bataan " (1942) and " Into the Valley " (1943), both received as outstanding war books, were fruits of his three years' experience in war reporting in the Pacific, Italy, and Russia. " A Bell for Adano " won the Pulitzer Prize for a novel in 1944, and was made into a highly successful play. While reporting for New York *Life* on Guadalcanal, he was commended by the Secretary of the Navy for bravery in helping to remove the wounded. To most Englishmen Hersey would seem more like a rising young American businessman than a successful author. He dresses his tall, wiry figure with conservative care, always looking well-groomed and polished. His quiet, earnest, friendly manner and good looks make it seem as if nature has been uncommonly generous with him. He has far more than his quota of good and faithful friends scattered across the American continent, and in the remote lands of his journeys,

against humanity'. Joseph Rotblat, on hearing that the atomic bomb had been used on Japan, was in despair. He knew from his time at Los Alamos that his former colleague Edward Teller was working on the so-called 'Super Project', the hydrogen bomb (H-bomb), and that the atomic bomb was only the first step. His fears echoed those Niels Bohr had expressed: 'I felt that if we went on like this and began an arms race with the Soviet Union, it was bound to end in confrontation.'

Rotblat's anxieties about a nuclear arms race were soon realized when that became the determining feature of the new period of inter-national tension known as the Cold War. With

ABOVE Initially printed in the *New Yorker*, John Hersey's account of the experiences of six survivors of the atomic bomb on Hiroshima was a bestseller when it was published by Penguin Books in 1946.

OPPOSITE *Warhead 4*, a dramatic photomontage interpretation of a nuclear mushroom cloud by Peter Kennard, 1988.

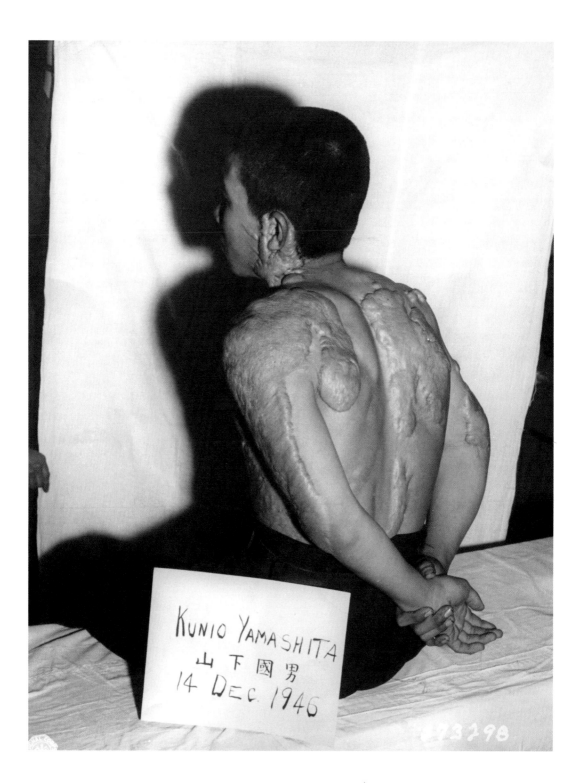

KUNIO YAMASHITA
山下國男
14 DEC. 1946

OPPOSITE A victim of the atomic bomb dropped on Nagasaki shows the severity of his burns, sixteen months after the event, December 1946.

Japan's surrender, it was soon apparent that the postwar world would be dominated by the erstwhile wartime allies, the United States and the Soviet Union, which had emerged as the new superpowers, and their competition for spheres of influence. The rivalry was expressed through ideological propaganda, espionage, numerous proxy wars and a massive conventional and nuclear arms race.

The new alignment was reflected in two military organizations that emerged in the decade after the Second World War: the North Atlantic Treaty Organization and the Warsaw Pact. NATO was founded in 1949 as a system of collective defence between some Western European countries and the USA. West Germany joined in 1955, at which point the Soviet Union and its satellite states in Eastern Europe established the Warsaw Pact. The creation of these two blocs highlighted how the United Nations was often rendered ineffective by the bipolar nature of the Cold War.

The superpowers' relationship fluctuated between 1945 and 1991, when the Soviet Union disintegrated, reaching a critical point with the Cuban Missile Crisis in 1962 but thawing after that with a period of 'détente', when successful negotiations on the reduction of both nuclear testing in the atmosphere and arms occurred. The Soviet invasion of Afghanistan in 1979, however, and further competition over nuclear weapons in Europe led to the cancellation of arms limitation talks and a deterioration of relations once more.

The fears associated with the onset of the Cold War and Britain's worldwide defence commitments meant that conscription was retained after 1945. The 1948 National Service Act, effective from 1 January 1949, made every male citizen between the ages of 18 and 20, with certain exemptions, liable to eighteen months' compulsory military service, or what became known as National Service, with four years in the Reserves. Provision was once again made for conscientious objectors. In 1950, when Britain became involved in the Korean War, fought under the auspices of the United Nations, the period of service was extended to two years. National Service intake ceased on 31 December 1960; the last conscripts were discharged in May 1963, since when all full-time members of the armed forces have been volunteers. This has meant that although Britain has been involved in military conflicts around the world over the last fifty or more years, there has never been anything like the anti-draft movement that erupted in America during the Vietnam War in the 1960s.

Peacetime conscription was obviously not on the scale it had been in the war, but 3,631,500 men registered for National Service between 1945 and 1960. Some found that their duties were merely clerical or they formed part of the occupation forces in Germany and Austria, but others served in armed conflicts in Malaya, Palestine, Korea, Kenya, Cyprus and Suez. Between 1949 and 1963, 395 conscripts were killed in action.

David Larder, a 19-year-old National Service officer, served in the Devonshire Regiment in Kenya during the Mau Mau uprising in the 1950s, when the Kikuyu tribe fought to rid the country of colonial rule. Larder was appalled

by the denial of the rebels' basic rights, and by the arbitrary killing, brutality and callous indifference to the plight of the Kikuyu shown by his fellow officers, particularly the Kenyan police and King's African Rifles. In a letter to the *Guardian* in June 2013, he gave an account, not only of some of the abuses he witnessed and in which he participated, but also of how he was still haunted by them. He described how young officers were offered prize money for shooting every African on sight in certain areas, and how on one occasion, in an ambush, 'the brains of one young black lad I had shot with no warning (by orders) landed on my chest'. Larder explained that the victim had no weapons but 'only a piece of the Bible and part of an English-language primer in his pocket. Before I was ordered to burn his body...I was

ordered to cut off his hands, which I did.' This was done for later finger printing. Sickened by his experience, Larder later disobeyed orders, was court-martialled and dismissed from the service. Back in Britain, because he had not completed his National Service, he soon received his call-up papers, not as an officer, but as a private. It was at this stage that he decided to stand trial and become a conscientious objector; the first British man to get registration as a CO on the grounds of being against colonial warfare. Later, Larder campaigned all over the country for Kenyan independence.

It would be sixty years before a British Foreign Secretary, William Hague, speaking in June 2013, would publicly criticize the treatment the Kikuyu had received: 'Torture and ill-treatment are abhorrent violations of human

OPPOSITE After weeks of basic training,
including the parade-ground drill known
as 'square-bashing', National Servicemen
are inspected for their passing-out parade
at Cove, Hampshire.

BELOW Suspected Mau Mau terrorists
in Kenya being searched by security
forces, c. 1954.

OVERLEAF Oil tanks burning beside
the Suez Canal after the initial Anglo-
French assault on Port Said, Egypt,
5 November 1956.

dignity, which we unreservedly condemn.' Larder, in his letter to the *Guardian*, wrote: 'History has proved me right...I now feel vindicated for being pilloried as a "conchie".'

During the period of National Service over 9,000 men registered provisionally as COs – a much smaller proportion of those called up than in the Second World War. Generally, the COs did not experience a great deal of discrimination and social disapproval. The tribunal system continued to function and, as in both world wars, a large number based their objections on the grounds of religious faith. The Quaker tradition of objection continued to be respected, which gave them advantages in tribunals, a privilege that worried some of them. Moral and political grounds for exemption were put forward, with some applicants objecting to particular conflicts – for example, the controversial invasion of Suez by Britain, France and Israel in 1956, after President Nasser nationalized the Suez Canal. David Morrish, a CO in 1955–56, felt that Suez was a 'watershed' that brought the ethics of war into public debate, including 'the use of armed force for the use of peacekeeping'.

Many COs, such as Ernest Rodker, took issue with the new mass-extermination methods of contemporary warfare. Rodker, whose grandfather John Rodker had been a CO in the First World War, found the members of his tribunal 'compassionate and open' compared with the grim panel his grandfather had faced. He was given alternative work in hospitals and the building trade and found the whole experience 'educational'.

As in the two world wars, perhaps the true numbers of those who objected to conscription will never be known. Many conscripts no doubt found themselves in distasteful situations, defending the principle of Empire, perhaps, when they no longer had any faith in the concept, or were placed in dangerous situations of which they wanted no part; but unlike David Larder, they decided to serve out their time, keeping their heads down.

AGAINST THE BOMB

The Soviet Union exploded its own A-bomb in 1949 and Britain followed suit in October 1952. The Peace Pledge Union had expressed its abhorrence of nuclear weapons in October 1945, soon after the atomic bombs had been dropped on Japan, and held a public meeting to oppose this new type of weapon in March 1946. The PPU set up a Non-Violence Commission, and early in 1952 some of its members formed a breakaway group called Operation Gandhi to employ the tactics of non-violent resistance against the use of nuclear weapons. Although it did not last long, this group can be considered to have laid the ground for later non-violent direct action by other organizations in the anti-war movement, including the Direct Action Committee (DAC), formed in 1957.

Nuclear testing escalated through the 1950s, the US exploding its first H-bomb in November 1952, followed by the Soviet Union in 1953. The American test of a fifteen-megaton H-bomb on Bikini Atoll in March 1954 swelled the ranks of those worldwide who felt that something had to be done to stop the slide into nuclear war. Huge quantities of radioactive dust fell on four neighbouring islands, causing long-term radiation damage to the land and the inhabitants, and affecting a group of Japanese fishermen. This was the spark that resulted in the foundation of Gensuikyo, the Council Against Atomic and Hydrogen Bombs, in Japan in 1955. Since then Japan has had one of the

Royal Engineers building a runway on Christmas Island in the Pacific as part of the construction of the British military base for the nuclear test programme that started on the island in May 1957.

largest and most vibrant peace movements in the world.

In Britain, the trigger for the mobilization of anti-nuclear war protesters and the formation of the Campaign for Nuclear Disarmament (CND) was the outrage felt when the first British H-bomb was detonated near Christmas Island in the Pacific in May 1957. A few weeks earlier the British government, as a member of NATO, had also agreed to house sixty American SM-75 Thor intermediate-range ballistic missiles (IRBM), capable of attacking Soviet targets, in fifteen American bases in different parts of the UK. This made the country,

it was argued by protesters, a prime target for Soviet attack.

CND emerged following an article in the *New Statesman* in November 1957 by the writer J. B. Priestley arguing that now 'Britain has told the world she has the H-bomb she should announce as early as possible that she has done with it'. The response to the piece was such that the *New Statesman*'s editor, Kingsley Martin, called a meeting that launched CND, with Bertrand Russell as president and John Collins, a canon of St Paul's and a well-known activist who was one of the co-founders of War on Want, as chair. The first public meeeting was held at Central Hall, Westminster, on 17 February 1958, and was attended by 5,000 people.

A few weeks later, CND gave its support to the first protest march from London to the Atomic Weapons Research Establishment – the organization responsible for the design

ABOVE Marchers on their way to the Atomic Weapons Research Establishment at Aldermaston from London, Easter 1958. Despite bad weather much of the way, the march was considered a great success, attracting an estimated 8,000 people along all or part of the 52-mile route. Some protesters can be seen carrying placards with Gerald Holtom's nuclear disarmament symbol, which he had recently designed.

OPPOSITE Although the major marches came to an end in 1963, there have been occasional marches to Aldermaston over the years. This poster was advertising a march over the Easter holiday in 1972, following the direction of the first march in 1958, from London.

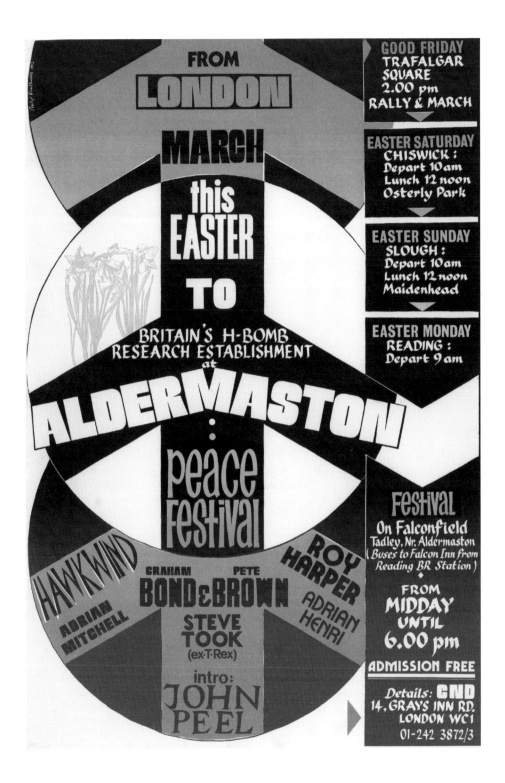

and manufacture of Britain's nuclear deterrent – at Aldermaston in Berkshire. Organized by the DAC, the march took place over Easter weekend, 4–7 April 1958, and attracted up to 8,000 protesters over the four days. It started from Trafalgar Square, and Ernest Rodker recalled 'the enthusiasm and joy at having made it to Aldermaston, and the impact the march was making'. On arrival, a resolution was passed that called on Britain, the United States and the Soviet Union 'To stop testing, manufacturing and storing nuclear weapons immediately'.

It was during this march that Gerald Holtom's distinctive nuclear disarmament symbol was used for the first time. The semaphore signals for N and D set within a circle became an icon of anti-nuclear protest and part of the youth culture of the 1960s worldwide.

From the start, CND counted a range of eminent people among its sponsors, including writers, academics, scientists, religious leaders, actors, composers, and peace campaigners from earlier generations, such as Fenner Brockway, who endorsed the organization's unilateralist position: the argument that if one country gave up its nuclear weapons, others would follow. By 1959, CND had tens of thousands of supporters, who were characterized by a middle-class radical ethos. Hugh Jenkins recalled:

Things in those days were simple and straightforward...we simply said: 'Ban the Bomb!' We thought if we got public support we'd make it clear to the government that the world did not want weapons of such mass destruction that might have the effect, if not of abolishing human life, at least setting civilization back, as the Americans once put it, to the Stone Age.

The second Aldermaston march, at Easter 1959, reversed the route, and had in the region of 15,000 participants by the time it reached Trafalgar Square, where 5,000 more greeted them, including many former COs from both wars. Conspicuous by their absence were those who believed that 'nuclear pacifism' was oversimplistic. Sybil Morrison, speaking for the pure pacifist view as she toured the country, announced, 'Weapons are not the cause of war. It is because of war that weapons are made.'

While some suggested silence for the marches, from the beginning they were organized to involve music. Choirs took part, participants appeared with their guitars, and songs such as John Brunner's *The H-Bomb's Thunder* and Tommy Steele's *Doomsday Rock* became an essential feature. Ernest Rodker designed badges and later observed how the character of the marches changed over time; the high-water mark of participation was the one in 1962, with as many as 150,000 people:

They were amazing. You came into the bottom of Parliament Square and looked up Whitehall and it was absolutely packed with people, flags and banners...all those numbers turning up against the Establishment year after year. Also, the diversity of supporters was greater as time went on. In the early days it would be just the hardened peace activists, then students and

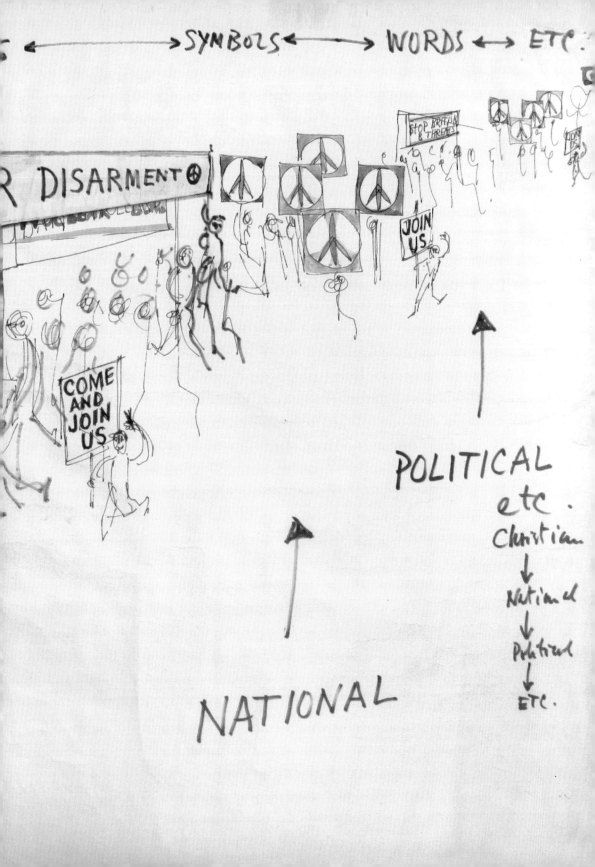

SYMBOLS ←→ WORDS ←→ ETC.

R DISARMENT

STOP BRITAIN
& THREATS

JOIN
US

COME
AND
JOIN
US

POLITICAL
etc.
Christian
↓
National
↓
Political
↓
ETC.

NATIONAL

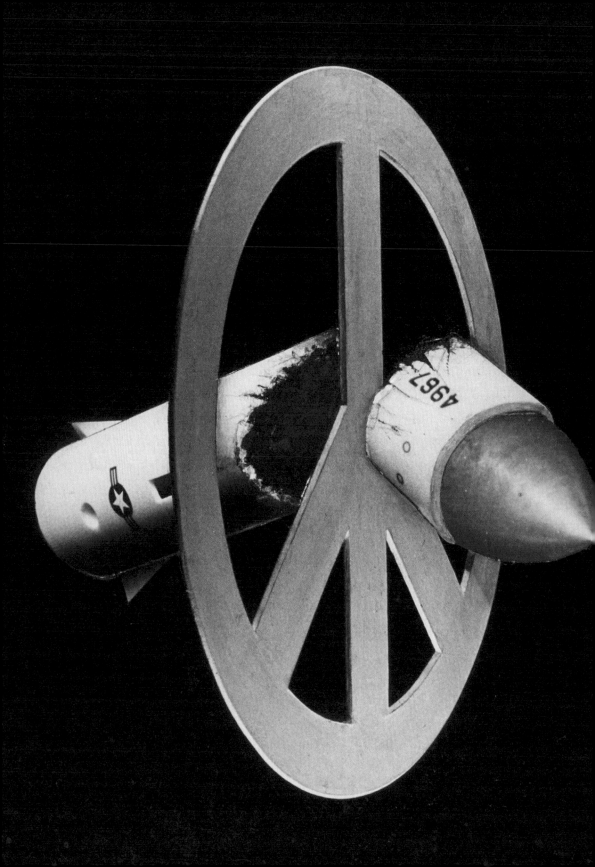

Shalom Bomb

I want a bomb, my own private bomb, my shalom bomb.
I'll test it in the morning, when my son awakes,
hot and stretching, smelling beautiful from sleep. Boom! Boom!
Come my son dance naked in the room.
I'll test it on the landing and wake my neighbours,
the masons and the whores and the students who live downstairs.

Oh I must have a bomb and I'll throw open windows and
count down as I whizz around the living room,
on his bike, with him flying angels on my shoulder;
and my wife dancing in her dressing gown.
I want a happy family bomb, a do-it-yourself bomb,
I'll climb on the roof and ignite it there about noon.
My improved design will gong the world and we'll all eat lunch.

My pretty little bomb will play a daytime lullaby and
thank you bomb for now my son falls fast asleep.
My love come close, close the curtains, my lovely bomb, my darling.

My naughty bomb. Burst around us, burst between us, burst within us.

Light up the universe, then linger, linger
while the drone of the world recedes.

Shalom bomb

I want to explode the breasts of my wife
and wake everyone,
to explode over playgrounds and parks, just as children
come from schools. I want a laughter bomb,
filled with sherbet fountains, liquorice allsorts, chocolate kisses,
candy floss,
tinsel and streamers, balloons and fireworks, lucky bags,
bubbles and masks and false noses.

I want my bomb to sprinkle the earth with roses.
I want a one-man-band-bomb. My own bomb.

My live long and die happy bomb. My die peacefully of old age bomb,
in my own bed bomb.
My Om Mane Padme Aum Bomb, My Tiddly Om Pom Bomb.
My goodnight bomb, my sleeptight bomb,
my see you in the morning bomb.
I want my bomb, my own private bomb, my Shalom bomb.

The H-Bomb's Thunder

Don't you hear the H-bombs' thunder
Echo like the crack of doom?
While they rend the skies asunder
Fall-out makes the earth a tomb.
Do you want your homes to tumble,
Rise in smoke towards the sky?
Will you let your cities crumble,
Will you see your children die?

Chorus:
Men and women, stand together,
Do not heed the men of war.
Make your minds up now or never,
Ban the bomb for evermore.

OPPOSITE Peter Kennard, *Broken Missile*, 1980. The artist used Holtom's nuclear disarmament symbol, coupled with a broken missile, with dramatic effect.

LEFT 'Shalom Bomb', a poem by Bernard Kops, c. 1958. Shalom is Hebrew for peace.

ABOVE The first verse and chorus from John Brunner's *The H-Bomb's Thunder*, sung to the tune of the 'Miner's Lifeguard'. The song was used on CND marches from 1958 onwards.

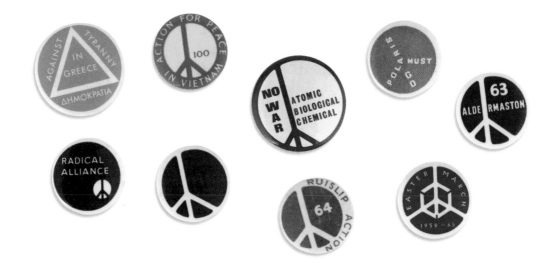

ABOVE The designer Ernest Rodker, a member of the Committee of 100 and CND, designed badges for the Aldermaston marches and other protests.

CENTRE A selection of anti-nuclear protest badges from the 1980s.

BELOW Russians at a youth festival in Moscow gave Ernest Rodker this velvet hat on which he pinned the badges he collected there. It became a familiar sight on the Aldermaston marches.

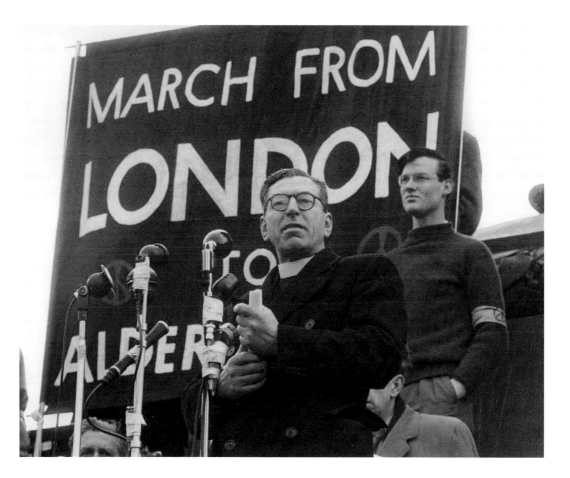

younger people in exotic clothing and families came;...It was a moving festival and for young people it was the thing to do.

The growth of the anti-nuclear movement was accompanied by tensions between organizations, such as the PPU, War Resisters' International, CND and the DAC, and within their respective leaderships, on policy and tactics. Canon John Collins and his supporters felt that any protest should remain law abiding and that the appeal of CND was its simplicity: Ban the Bomb! This 'single issue' focus led to important differences between CND and the DAC, whose members were not only against the bomb, but also pacifists wanting to transform society. They were far more active and increasingly took bold, direct, non-violent actions, facing tough police tactics, arrest and imprisonment. The DAC was also strongly internationalist and had important links to the civil rights and anti-nuclear movements in the

US. But financial difficulties and the launch of the Committee of 100 (C100) led to the DAC being absorbed into the C100 in 1961.

The personal animosity between Canon John Collins and Bertrand Russell, who supported the DAC, was a major factor in the formation of the Committee of 100 in October 1960. As the peace campaigner Pat Arrowsmith remembered: 'Whatever rifts there had been between the DAC and CND were nothing to the anger and antagonism between CND and the C100, partly because of the personalities involved.' Like the DAC, the C100 advocated a far more active approach than that of CND. Its 100 original signatories included well-known radicals such as the Revd Michael Scott and April Carter as well as writers like John Braine and Arnold Wesker. Bertrand Russell's presence was a huge asset – his brilliant speeches attracted the publicity the C100 was after, and he led the first sit-down demonstration on 18 February 1961 at the Ministry of Defence

in Whitehall, London, over the expected arrival of a US Polaris missile submarine tender at Holy Loch in Scotland. Arrests of demonstrators and prison sentences followed at subsequent protests, and Russell, now 89, and his fourth wife, Edith, were among those jailed for breach of the peace. Russell felt direct action was the way to generate the media attention that he wanted for the unilateralist position. A huge rally held in Trafalgar Square on 17 September 1961 with about 15,000 participants is regarded as the highpoint of the C100's campaign – it led to 1,314 arrests with 658 released on bail, the rest spending the night behind bars. By 1962, the C100 had become increasingly radical and half its original signatories resigned. The members began to focus on issues other than nuclear weapons, such as the Vietnam War. Some, such as Pat Arrowsmith, who had experienced the ordeal of force-feeding during one of her several prison sentences, also campaigned

for prison reform. In 1963, Russell resigned and the C100 was wound down in 1968. But it had brought widespread attention to direct action, which was to come to the fore again in the 1980s.

CND stood aloof from the tactics and concerns of the C100, not least because in the late 1950s it had hopes that a more peaceable approach might persuade a future Labour government to adopt its policies. As Hugh Jenkins recalled, for those on the left it had been 'a considerable blow' when Nye Bevan, the shadow Foreign Secretary, declared at the 1957 Labour Party conference that a unilateral stance 'would send a British Foreign Secretary naked into the conference chamber'. Jenkins went on, 'it was then that we realized it was going to be a larger job than we originally thought'. But CND's hopes were raised when two unilateralist resolutions were carried at the 1960 Labour Party conference, despite the opposition of the Labour leader, Hugh Gaitskell. However, they were dashed when the party adopted a multilateral position the following year.

The consciousness that Labour would not deliver, together with the divisions between CND and the C100, were not the only developments to affect the movement in the early 1960s.

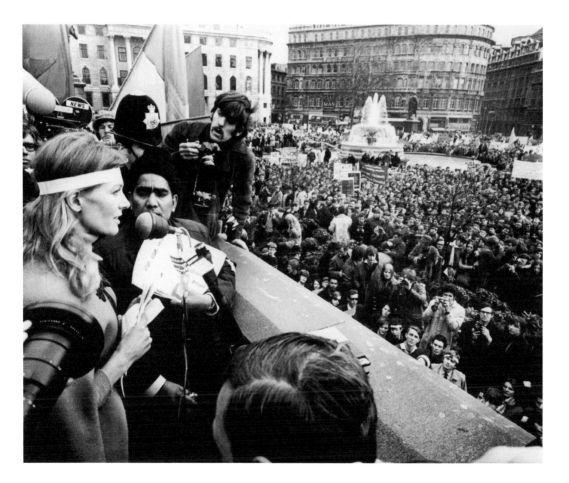

The resolution of the Cuban Missile Crisis in October 1962 showed that the superpowers could achieve peaceful outcomes. Another important step forward was when the USA and USSR agreed in June 1963 to establish a 'hot-line' communications link. It was, however, the signing of the Partial Test Ban Treaty (PTBT), which prohibited testing in the atmosphere and underwater (but not underground), in August 1963 by the USA, USSR and UK, that led to a reduced sense of urgency within CND. As Eileen Daffern, a member of the CND executive in Brighton, said: 'After the Test Ban Treaty of 1963 we felt we had achieved something and people fell away for ten years.' Although small protests continued, for example at Holy Loch in Scotland

Demonstrators step from a ferry at Dunoon, Scotland, on 24 March 1961 en route to Holy Loch to protest against the establishment there of Britain's first submarine-based nuclear deterrent system: Polaris.

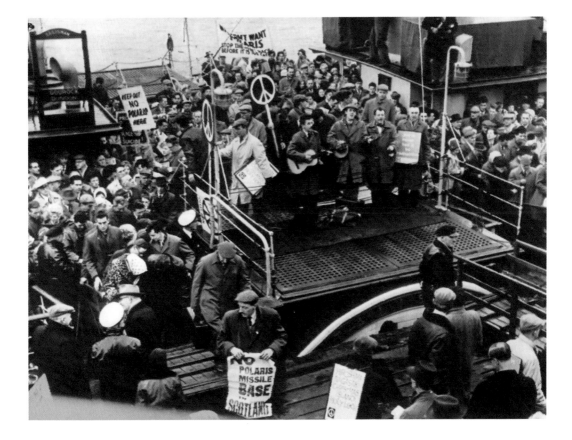

over the use of the base for submarines with nuclear-armed Polaris missiles, people's attention turned to other causes, such as opposition to the Vietnam War. The last major Aldermaston march was held in 1963 but it lacked the vigour of the previous ones.

With the earlier sense of urgency and commitment declining, membership of CND fell in the late 1960s. The signing of the Non-Proliferation Treaty (NPT) in July 1968, again by the USA, USSR and UK, and moves on the Strategic Arms Limitation Talks (SALT 1), signed in 1972, added to the feeling of many in the movement that progress was being made. But others were less optimistic. Bill Hetherington, a member of CND, the C100 and PPU, explained how 'part of the energy of the first wave had gone into banning the tests: they were banned, you had a victory. But of course the bombs were still there.' In June 1979, there seemed to be further advances with the signing of the SALT II agreement in Vienna by the American president, Jimmy Carter, and the Soviet leader, Leonid Brezhnev, although it was controversial and would never be ratified by the US Congress. Hugh Jenkins became chair of CND in 1979, 'when we couldn't really have gone down much further...But we gradually got our determination back.' An increase in membership reflected the deteriorating international situation: the fall of the Shah in Iran and establishment of an Islamic republic there in 1979, and the Soviet invasion of Afghanistan at the end of that year. But the development with perhaps the most impact on the peace movement was the Soviet deployment from 1976 of SS-20 intermediate-range nuclear missiles in Europe, which gave them the ability to neutralize NATO's tactical nuclear forces.

The issue of nuclear conflict also saw a resurgence in print and film and there were battles to be fought there, too. In 1965, Peter Watkins's docudrama *The War Game,* made for the BBC, showing the effects of nuclear war, was considered too horrifying to be broadcast, although it was released in cinemas and won an Academy Award for Best Documentary Feature in 1967. Hugh Jenkins, Minister for the Arts in 1974–76, recalled how 'it was a long and arduous task' to 'get that shown on the BBC'. It was eventually aired on 31 July 1985.

Public pressure led to the publication in May 1980 of a government civil defence pamphlet, *Protect and Survive*, which it had not intended to distribute except in the event of an international crisis. It gave advice on what actions individuals should take if there was a nuclear attack, but it was robustly countered by *Protest and Survive,* a pamphlet written by the historian E. P. Thompson, which showed the absurdity of the government's recommendations and explained the reality of what the use of nuclear missiles in a limited war would do: the complete destruction of Western Europe, including Britain. Thompson was also among the co-authors of the European Nuclear Disarmament Appeal in April 1980, which argued for a nuclear-free Europe, and resulted in annual END conventions from 1982 to 1991.

The *Protect and Survive/Protest and Survive* publicity added to the factors that led to a resurgence of CND after a time when it 'had been in the doldrums', as Christine Kings, a CND activist in London, recalled. She helped to organize a CND demonstration related to *Protect and Survive* in October 1980 and observed how 100,000 people turned up. Kings also pointed to another development. In 1980, CND had appointed a dynamic new general secretary:

*And of course there was Bruce Kent –
Monsignor Bruce Kent – the fact that CND
was headed by a senior Roman Catholic official
gave some legitimacy to the organization. His*

Fall-out

Fall-out is dust that is sucked up from the ground by the explosion. It can be deadly dangerous. It rises high in the air and can be carried by the winds for hundreds of miles before falling to the ground.

The radiation from this dust is dangerous. It cannot be seen or felt. It has no smell, and it can be detected only by special instruments. Exposure to it can cause sickness and death. If the dust fell on or around your home, the radiation from it would be a danger to you and your family for many days after an explosion. Radiation can penetrate any material, but its intensity is reduced as it passes through – so the thicker and denser the material is, the better.

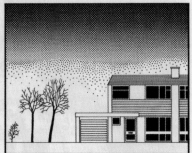

6

Planning for survival

Stay at Home

Your own local authority will best be able to help you in war. If you move away – unless you have a place of your own to go to or intend to live with relatives – the authority in your new area will not help you with accommodation or food or other essentials. If you leave, your local authority may need to take your empty house for others to use.

So stay at home.

Plan a Fall-out Room and Inner Refuge

The first priority is to provide shelter within your home against radioactive fall-out. Your best protection is to make a fall-out room and build an inner refuge within it.

First, the Fall-out room

Because of the threat of radiation you and your family may need to live in this room for fourteen days after an attack, almost without leaving it at all. So you must make it as safe as you can, and equip it for your survival. Choose the place furthest from the outside walls and from the roof, or which has the smallest

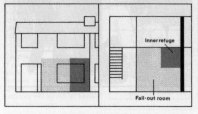

7

ABOVE AND OPPOSITE *Protect and Survive*, a British government pamphlet published in 1980 that gave advice to the public on what to do in the event of a nuclear attack.

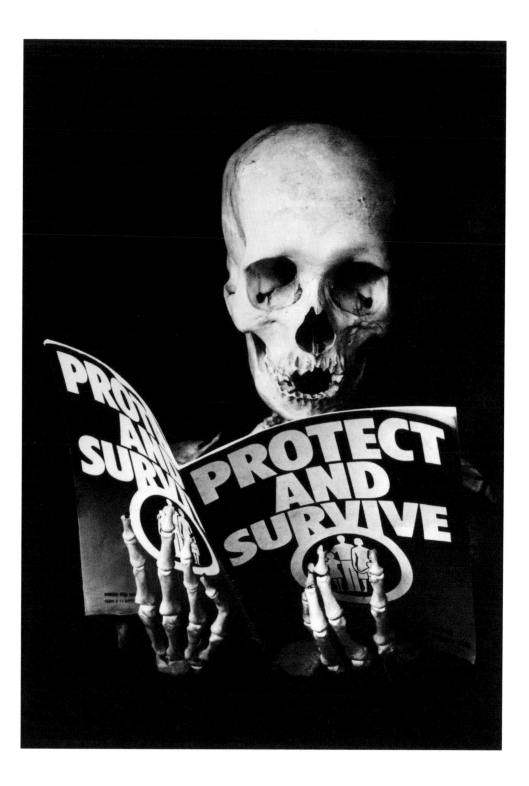

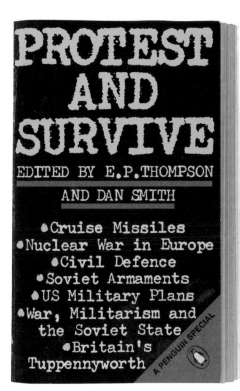

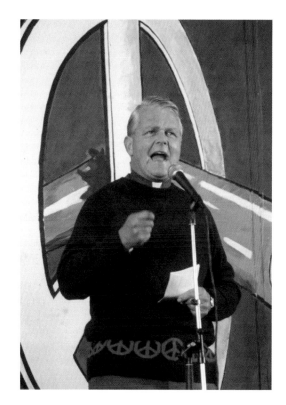

public presence was always very professional, he always wore his dog collar and jacket, but he came over as great fun.

Protect and Survive also inspried the graphic novel *When the Wind Blows* (1982) by the British artist and writer Raymond Briggs. The book tells the story of a nuclear attack on Britain by the Soviet Union from the vantage point of an ordinary elderly British couple, Jim and Hilda Bloggs, who follow, with blind trust, the ludicrous and inadequate government guidelines on what to do in such an event. All the official instructions they heed are taken from real government documents about civil preparations, which Briggs tracked down, notably *Protect and Survive*. Throughout the illustrated story, the couple are ignorant of radiation and have no real

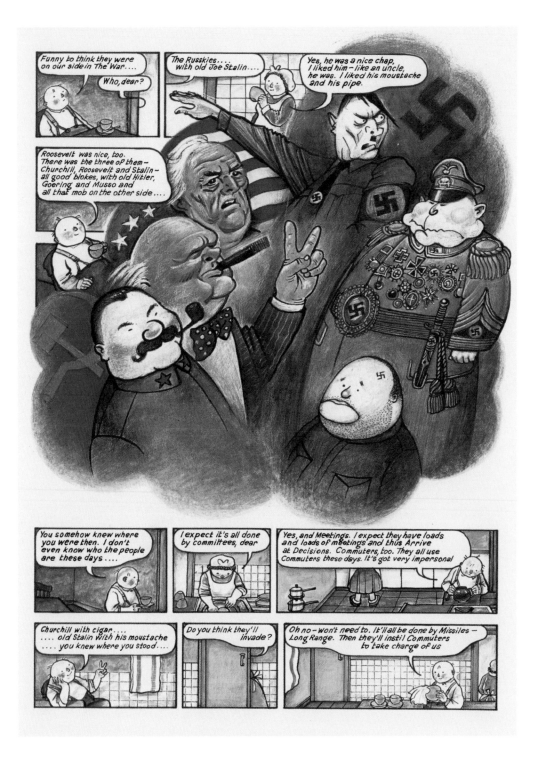

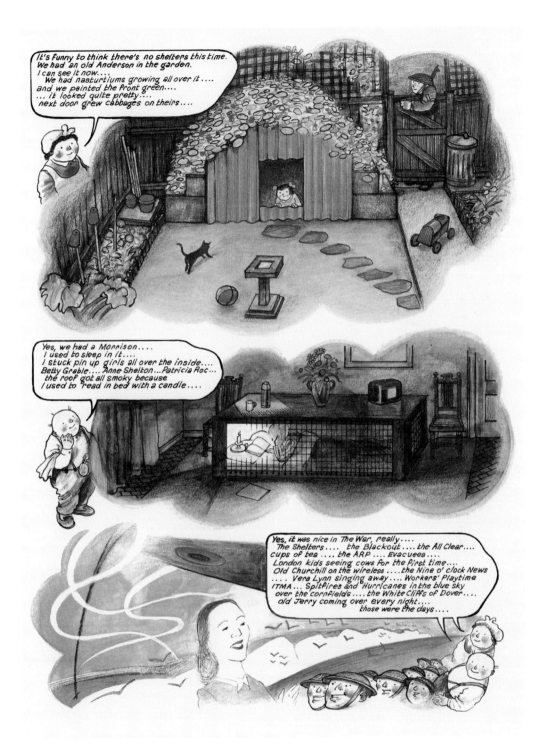

idea of the danger they are in; both come to a painful end. Copies of *When the Wind Blows* were sent by the publisher to members of both Houses of Parliament. Few responded but the Labour peer Lord Elwyn-Jones gave a robust reaction, saying that the book 'raised the gravest question of our time', and Michael Foot, Leader of the Opposition Labour Party, called it 'topical'. The book was an immediate success with the general public, selling 500,000 copies, and was translated into at least ten languages, giving it a huge global impact. As Julia MacRae, Briggs's editor at Jonathan Cape, observed: 'It changed the thinking of a generation of readers.'

On the political front, there was a shift to the Left in the Labour Party, evident at the party conference in October 1980 when there was a vote in favour of a commitment to unilateral disarmament in the manifesto. This gave a boost to the peace movement. It was, however, the decision on 12 December 1979 by NATO foreign and defence ministers to install ground-launched Cruise missiles in Britain and Pershing II missiles in Europe from 1983 onwards, in response to the Warsaw Pact build-up of SS-20 intermediate-range nuclear weapons, that provoked a huge resurgence in the numbers campaigning against nuclear weapons. In Britain, CND membership rose from 4,276 in 1979 to 90,000 in 1984, and the number of people involved at a local level is estimated to have been 250,000. Attendance at demonstrations against nuclear weapons in the UK and Europe reached an all-time high.

NATO's decision also led to the establishment in Britain of peace camps around the airbases where Cruise and other nuclear weapons were to be stored. They included RAF Burtonwood, Fairford, Molesworth, Upper Heyford and Welford. But it was the Greenham Common Women's Peace Camp, near Newbury in Berkshire, that was to became the most famous.

GREENHAM COMMON WOMEN'S PEACE CAMP

In the summer of 1981, a group of thirty-six women, four babies and six men set out from Cardiff, in south Wales, on a 125-mile march to RAF Greenham Common in Berkshire, which had been leased to the United States Air Force (USAF) in 1968. They had been provoked to action by the news of the construction of huge silos for the ninety-six Cruise missiles that were due to be located at the base. Their aim was to challenge the decision to site the missiles there. After ten days, they reached the gates of the airbase on 5 September 1981 and handed in a letter to the commander that included the following statement: 'We fear for the future of all our children and for the future of the living world which is the basis of all life.' The 'Women for Life on Earth', as they became known, found their desire for debate with the authorities ignored and spontaneously decided to set up a camp outside the perimeter of the base. They intended only a short stay, but the Greenham Common Women's Peace Camp, as it became known, turned into one of the most lengthy peace protests, lasting nineteen years, and made the deployment of Cruise missiles an international as well as a national political issue.

As news of the camp filtered through the peace movement, it began to grow and among the new arrivals were many highly educated, articulate and resourceful women, a good number of whom were CND members. Well-known women in the public eye, such as Yoko Ono and the actors Julie Christie, Sheila Hancock and Vanessa Redgrave, visited to give support and to attract media attention to the cause. Soon there were camps at each gate to the airbase; they were named after the colours

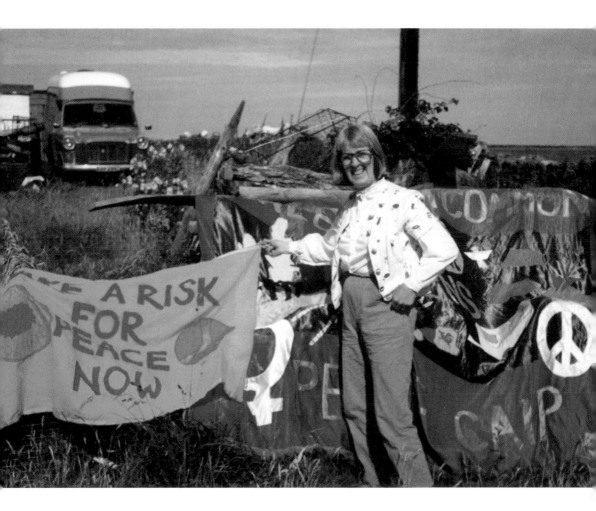

ABOVE Thalia Campbell pictured at her home in Wales with a selection of the banners she designed and made for the Greenham Common Women's Peace Camp, 1992.

OVERLEAF Annie Tunicliffe (left) and two friends deliver a fake Cruise missile to Greenham Common airbase in October 1981. This was printed on the front page of the *Observer* and gave the women the publicity they were seeking.

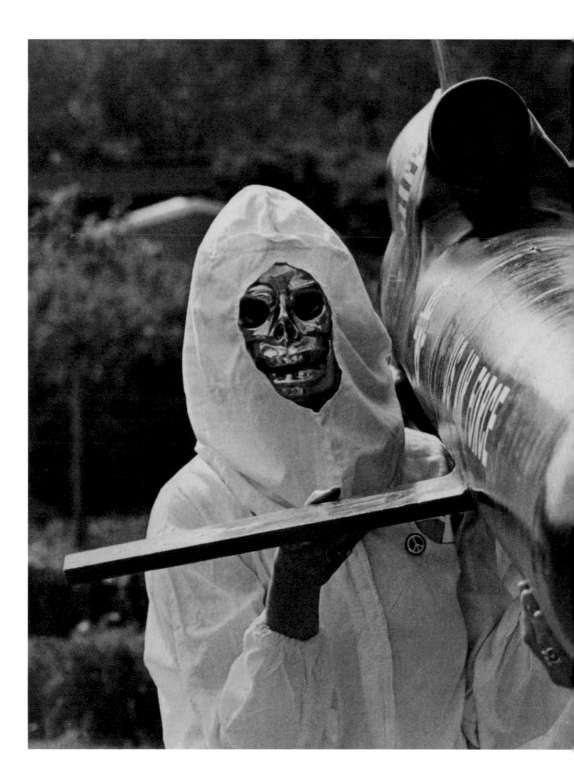

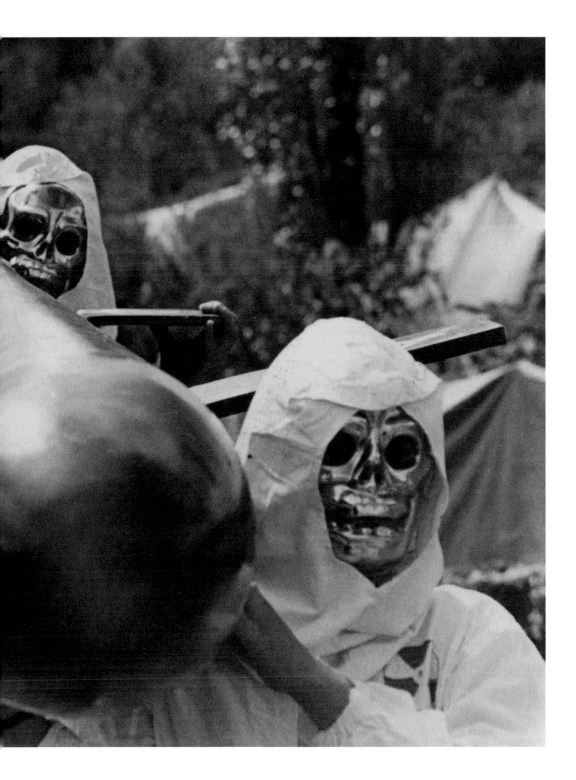

of the rainbow and each one had its own identity and loyal adherents. Women would come and go, such cycles providing, according to Fran Whittle, the 'lifeblood of the camp'. Some visited for just a single day, others stayed for days, weeks, months or years. But there was always a hard core of women living semi-permanently at Greenham, who left for only brief periods of respite.

The primitive outdoor living conditions in tents and benders without electricity or running water were a challenge. Also, the lack of organization and living in close proximity with a diverse range of women caused

One of the first camps at Greenham Common, September 1981. There was no proper sanitation or electricity, and the women lived in tents in all seasons. Some stayed for years, others a few days.

tensions for some. But it was the women-only issue, which came to the fore in February 1982, that caused the most passionate dispute, not only between the women and the men who had arrived at the camp during the early stages of its formation, but also within the peace movement generally. The women themselves were divided between those who stood for a mixed presence and those who successfully argued that the most important reason for a women-only camp was the non-violent nature of the actions they were determined to pursue in their confrontations with the police and army. Men who had moved into the camp were asked to leave; eventually they did, a few with understanding, some with sorrow, others with anger and violence. The women-only policy meant that lesbian women began to feel more comfortable there, but as a result lesbianism became one of the main lines of attack from sections of the media: the women were represented as sexually deviant, a slur that was adopted by local opponents of the camp.

Soon after setting up the peace camp it was decided to initiate a range of actions against the authorities, some with the intention of disrupting the construction that was being done in preparation for the deployment of Cruise, others to demonstrate the vulnerability of the base to outside intervention. This led to a change over time from actions occurring along the perimeter of the base, to those that breached its fences – a move from legal to illegal actions. Incursions into the base resulted in arrests, court appearances and, in many cases, prison. The range of actions undertaken throughout the camp's existence was vast and diverse but they all bore the special Greenham stamp of originality, spontaneity and daring.

Towards the end of 1982, the women planned a big international action to coincide

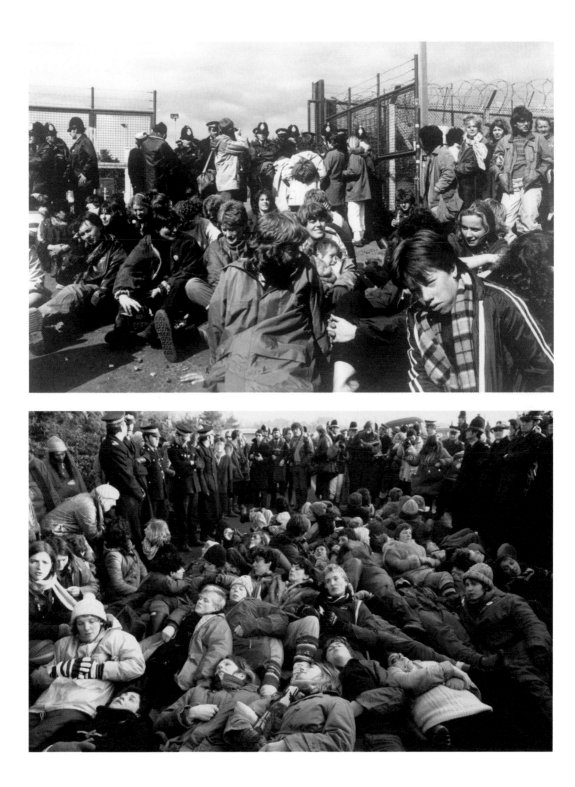

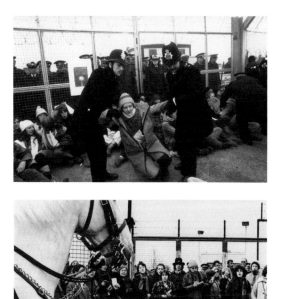

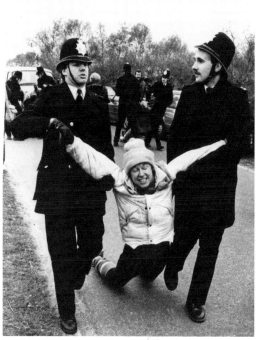

OPPOSITE, ABOVE Women
protest against the US
deployment of Cruise missiles
at Greenham Common airbase
in the early 1980s.

OPPOSITE, BELOW Protesters at
Greenham Common lying down
in the road, December 1982.

TOP LEFT Police drag a protester
demonstrating outside the
perimeter of the airbase during
the arrival of Cruise missiles in
November 1983.

ABOVE, LEFT Mounted police were
used to break up demonstrations
or blockades.

ABOVE, RIGHT A protester is
dragged away.

with the third anniversary of NATO's deci-sion on the deployment of Cruise missiles: 'Embrace the base on Sunday, close the base on Monday' was the result. Women from all over Britain, Europe and across the globe were invited to come to Greenham Common on 12 and 13 December to join together to surround the base. They were asked to bring personal items that expressed their lives and hopes with which to decorate the entire perimeter fence in a mass action 'that will...express the spirit of peace and the politics of peace'. Women arrived not only from all parts of the

ABOVE Service personnel on duty within Greenham Common airbase.

OPPOSITE The fortified fence surrounding the airbase. The women managed to scale this, or gain entrance by using bolt cutters, on many occasions.

UK and European countries such as Sweden and Germany, but also from as far away as Australia, New Zealand, the United States and Canada. Ann Pettitt, who had led the original Welsh women to Greenham, described how,

> *The whole of the fence was covered with these statements of what meant most to them: photographs, nappies, flowers; one woman left her wedding dress pinned on the wire...A whole dinner service was clipped to the fence – sacrificed. Embrace the Base became an icon of Greenham.*

The political artist Peter Kennard, who saw the decorated fence, felt that it was 'One of the greatest art works of the twentieth century... this eight-mile perimeter collage... an *extraordinary* creative work. You got all this life and humanity on one side and this blank on the other.' The protest gained the attention of the media that the women desired both in Britain and abroad. The *Daily Mirror*, for instance, proclaimed on its front page: 'PEACE. The plea of 30,000 women who joined hands in the world's most powerful protest against nuclear war.'

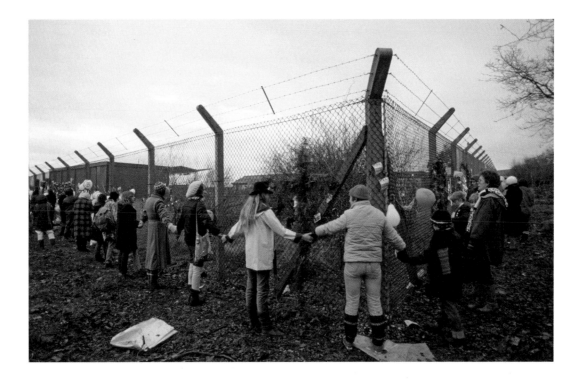

The Cruise missiles were expected to arrive in 1983, and the women felt something really dramatic was called for to focus attention on the silos that were being prepared to house the weapons. On 1 January 1983, forty-four women managed to cut their way through the perimeter fence and reached the top of the silos, where they held up a 'Peace 83' banner, joined hands and danced and sang to mark the new year. The scene of the dancing women was broadcast on TV and became another iconic image of the peace camp.

Many more imaginative and audacious operations took place before the Cruise missiles arrived in November 1983; once the women had got into the base, they wanted to repeat it. They did so by different means: the use of ladders, cutting down parts of the fence, undoing the bolts in the fence and slithering under it. They

ABOVE Women link up in the Embrace the Base event, 12 December 1982.

OPPOSITE Doves of peace decorate the fence for Embrace the Base. Art by men was also included.

OVERLEAF The iconic 'dance on the silos' on 1 January 1983 after women had cut their way into the airbase.

entered in the most creative ways – dressed as snakes, furry animals or dragons – and once in, their actions included having a picnic and the symbolic scattering of ashes. One of the boldest moves was on 25 July 1983, when seven women cut a hole in the fence and entered the base to

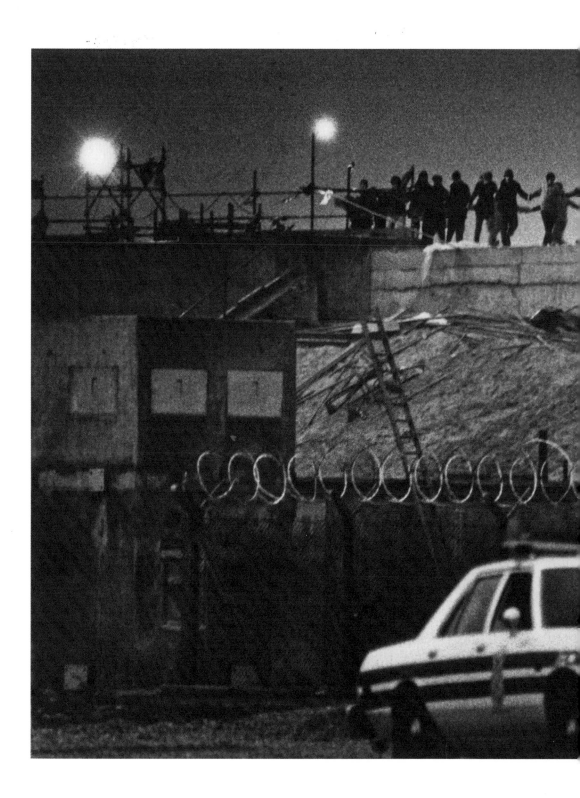

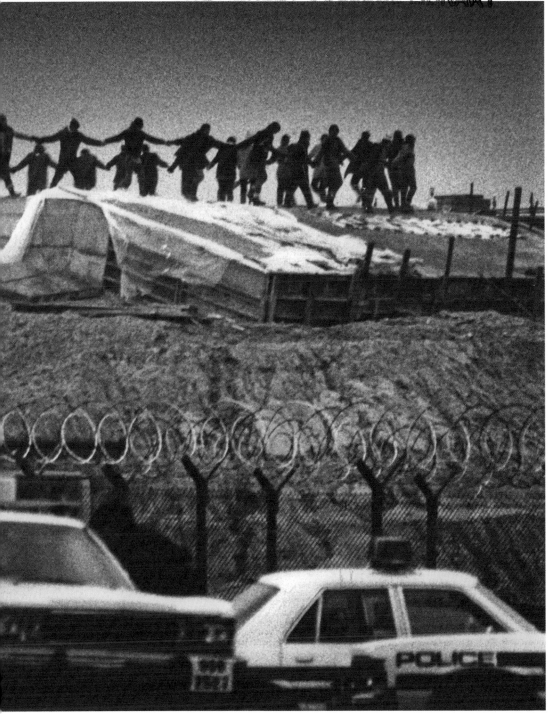

paint peace symbols on the SR-71 Blackbird, a US spy plane that had arrived for the International Air Tattoo at the base. After 2,000 women began to cut down four miles of the fence on 29 October 1983, two weeks before the missiles were due to arrive, Michael Heseltine, the Defence Secretary, would give no assurance to Parliament that intruders near the silos would not be shot. But the women were not deterred and continued their incursions.

Regular evictions of the camp were increasingly forceful and gruelling. There was also an escalation of violence by soldiers and the police during the women's attempts to blockade the base; the use of police on horseback to deal with these was particularly terrifying for the protesters. By this time, arrests, court appearances and prison sentences were becoming an accepted part of being an active Greenham woman. Jane Hickman, Elizabeth Woodcraft and Isabel Forshall, all qualified lawyers, helped those who had been arrested and charged, and they became an essential part of the women's campaign. When the accused was summoned, supporters would gather outside the court house, often chanting encouragement. Those who had been charged soon became expert in defending themselves, such that on one occasion Group Captain Stanley Keyte, the RAF commander of the base from 1987 to 1989, who was required to appear in court when the women were prosecuted, found it 'quite a chastening experience'.

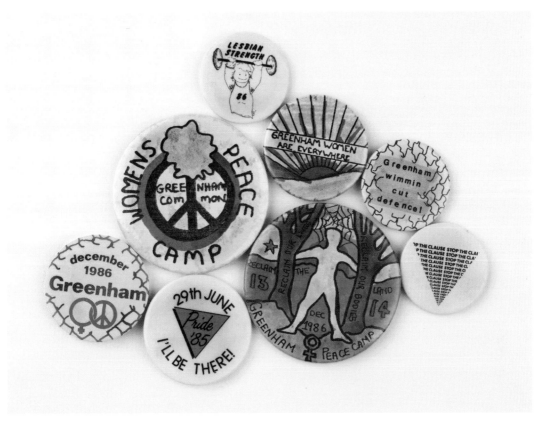

Badges

OPPOSITE Women in the vicinity of the Greenham Common Women's Peace Camp strip off for a refreshing dip.

ABOVE Badges of various designs produced in connection with the peace camp; some commemorate particular events.

Although supporters who lived in the area opened their homes to Greenham women for periods of respite and gave other assistance, the majority of local people were appalled at having such a large, untidy camp surrounding the huge perimeter of the base, as it affected the appearance of the countryside and the value of their homes. The Greenham women were well aware of their complaints and tried to respond. Jane Dennett, for instance, found that litter was her 'great burden' and she was endlessly moving around the camp gathering rubbish in a black bin bag. As for the accusations about sanitation, she felt that the women did their best:

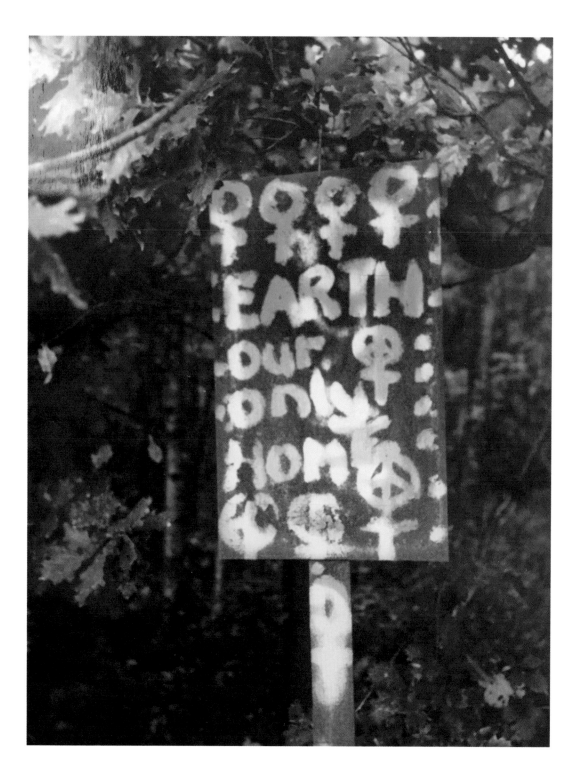

OPPOSITE A notice that shows the women's concerns for the environmental impact of nuclear weapons, erected in the woodland outside the perimeter fence of the airbase.

BELOW Greenham Common Women's Peace Camp banner designed by Thalia Campbell.

I went on the Jimmy Young [radio] show and he was taunting us with being a menace to the Newbury people. He said that we used their gardens as lavatories, and I said, 'We are very proud of our shit-pits.'

Groups such as Ratepayers Against the Greenham Encampment (RAGE) and Greenham Women Out (GWO) were set up by local people. All this hostility against the women was accompanied by vigilante actions that were often terrifying. The sub-camps at the various gates, situated near the roads surrounding the base, meant the protesters were vulnerable to men in passing cars hurling abusive remarks or shouting pro-Cruise slogans. After the pubs turned out, groups of men would creep into the camp

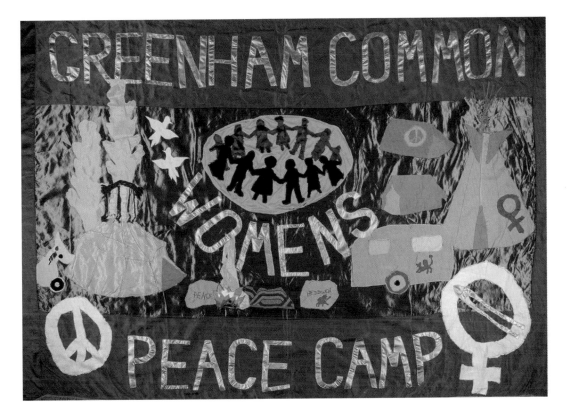

and throw paint, or slash tents and benders. Once a bottle of diluted acid and firecrackers were thrown at the women sitting around their camp fires. Katrina Howse recalled the horror she experienced one night when maggots were thrown at the heads of a group of women she was sitting with: 'A few weeks later they hatched out and, although we had tried to clear them up, we had a plague of flies – almost a bit of biological warfare isn't it?'

Greenham women never accepted the inevitability of the arrival of the Cruise missiles. They hoped that their actions and presence would prevent this as well as sustain peace activity and enthusiasm, not only at Greenham, but also in the other countries where Cruise or Pershing II missiles were to be deployed: West Germany,

ABOVE Katrina Howse, standing in front of her painting entitled *Imprisonment*, 1992. Howse lived at Yellow Gate at Greenham Common from August 1982 to February 2000, and spent months in prison for non-violent direct action during that time.

OPPOSITE This USAF trailer, carrying four nuclear Cruise missiles, operated on launch sites located on Salisbury Plain from 1984 to 1989. Seeing the convoys emerge from the base was an eerie and frightening experience for the Greenham protesters.

Belgium, Italy and the Netherlands. Links had been made with women's peace groups in Ireland and, with difficulty, women behind the Iron Curtain. On 24 May 1983, when over one million women worldwide took part in thousands of actions in celebration of International Women's Day for Disarmament, Greenham women held a day of silence and fasting.

The women also connected with the wider peace movement in the UK. On 1 April 1983, they held a joint action with CND, in which 70,000 people formed a fourteen-mile human chain linking Greenham Common with Aldermaston and the ordnance factory in Burghfield.

Despite all these actions, the first missiles were flown into the base on 14 November 1983, and were quickly transferred to the silos that had been prepared for them. It was a shocking and heart-breaking moment for the women when

they realized that all their efforts had been in vain. In the succeeding months the complete deployment of ninety-six missiles arrived, which prompted the women to renew their efforts.

Observing activity at the camp became important as well as tracking and disrupting the missile convoys taken out for exercises on Salisbury Plain, because Cruise missiles were designed to be fired from mobile launchers away from the base. This new stage of protest was marked by the formation in March 1984 of Cruisewatch, an impressive system designed to undermine the secrecy upon which the operation depended. The women set up 'telephone trees' to call for help with this monitoring work from supporters elsewhere in the country. Katrina Howse described how the women hunted the military vehicles over a sixty-mile area of Salisbury Plain:

Greenham Web

LEFT The 'telephone tree' of Lewes women's support group, designed by Fran Whittle. An incoming message from Greenham that Cruise missiles were out on manoeuvres could quickly alert women to come and help monitor and disrupt the convoy.

when other women's groups attached themselves to Greenham. Numbers at the camp were sometimes reduced to only twenty or thirty women spread out in small groups, but the hard core held on defiantly, continuing to confront the base and all it stood for, and to resist evictions by Newbury District Council. By the late 1980s, media interest had flagged and without the mass, enthusiastic support of earlier times for the few actions that were organized it all became somewhat disheartening.

It was just like looking for a needle in a haystack!...We had to face the MOD police, the British Army and USAF personnel with guns pointed at us, and we felt they would use them...We were unstoppable.

As time went on, the peace camp began to decline. Many participants felt that despite the satisfaction they obtained from disrupting the convoys, their energies would be better employed elsewhere. Some supported 'Women Against Pit Closures', established as part of the bitter year-long miners' strike in 1984–85. Tensions that had existed from the camp's beginnings continued, including the personal ones of affects on husbands, families and home-based commitments, but also those generated

EX-SERVICES CND

The Greenham Common Women's Peace Camp attracted a huge amount of publicity in the early 1980s, which was a great help in raising awareness about the dangers of nuclear weapons, but there were also other anti-nuclear campaigners who were active in this period. In March 1983, John Stanleigh, who had served in the Second World War, got together with a small group of fellow ex-servicemen to form what became Ex-Services CND. By September its numbers had grown to 500 and by 1989 the membership neared 1,000 men and women, with contacts in a number of other countries, including the Soviet Union. The vast majority of those who joined were veterans of the Second World War, but one member had fought in the First World

War and, as time went on, younger people who had seen action in the Falklands War of 1982 became involved. The members did not necessarily regret their military service but became active in the cause of peace because they no longer accepted governments' arguments that nuclear weapons were vital as a deterrence against aggressor states. In 2005, Ex-Services CND was amalgamated with CND.

Charles Besly, who had been an officer in the Royal Berkshire Regiment during the Second World War, described how CND always put Ex-Services CND members at the front of their marches:

> *As we go along the streets of London, we often get a cheer from the bystanders, which is very warming. I think it must have some effect if people think: Well, these guys have been through it and they're against nuclear weapons; perhaps there's something to be said for that point of view.*

THE ROUTE TO PARTIAL NUCLEAR DISARMAMENT

The ambition to achieve nuclear disarmament has been central to several organizations over the years. One of the most distinguished began with a manifesto composed by Bertrand Russell and Albert Einstein that was issued on 9 July 1955 and signed by them and nine other highly regarded scientists, including Joseph Rotblat. It highlighted the dangers posed by nuclear weapons and called on world leaders to seek 'peaceful means for the settlement of all matters of dispute between them'. This resulted in the formation of a body aimed at giving scientists a forum and a voice in international affairs, particularly concerning the elimination of all

ABOVE Joseph Rotblat, one of the founders and the first secretary-general of the Pugwash Conferences on Science and World Affairs, 1957–73. The organization is committed to the elimination of nuclear weapons and weapons of mass destruction.

weapons of mass destruction. The first conference was held in July 1957 at Pugwash, a small town in Nova Scotia, Canada, on the estate of the American philanthropist Cyrus Eaton, and since then over sixty such gatherings have been held worldwide, as well as many other regional and national meetings, attended by about 3,500 participants over the years. The creation of the Pugwash Conferences on Science and World Affairs, as the organization is called, was an important development because, as the

British astronomer Sir Martin Rees explained, in those Cold War years 'it was the only medium through which Russian and American scientists and others involved in defence could get together'. Pugwash became a conduit for technical discussion on arms control and helped in the development of East-West agreements in the 1960s and 1970s, such as the PTBT in 1963 and Anti-Ballistic Missile Treaty in 1972, and continues to promote nuclear disarmament and the elimination of weapons of mass destruction. It also provides a valuable forum where the social responsibility of scientists towards the world's problems can be aired. Rotblat became the first secretary-general and his commitment together with Pugwash's efforts in pursuit of

BELOW Four delegates attending the third Pugwash Conference, Kitzbühel, Austria, September 1958. Left to right: Sir Robert Watson-Watt, pioneer of radar; David F. Cavers of Harvard Law School; Cyrus Eaton, industrialist and philanthropist who gave financial support to the early Pugwash Conferences; and the French radiologist Antoine Lacassagne. The theme of the conference was 'Dangers of the Atomic Age and What Scientists Can Do About Them'.

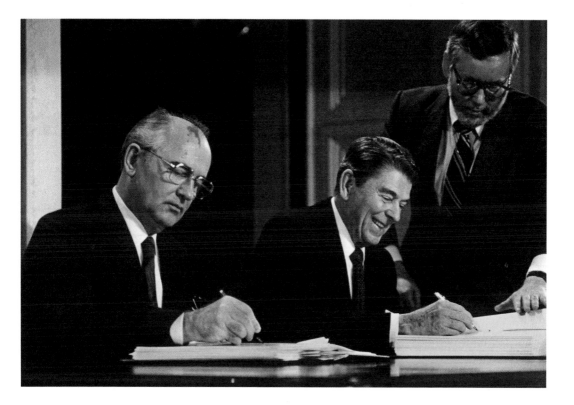

nuclear disarmament were recognized by the joint award of the Nobel Peace Prize in 1995.

Rotblat recalled that Mikhail Gorbachev 'acknowledged to us [Pugwash] that his planning was influenced by our ideas, and this changed the whole world situation'. Gorbachev became the Soviet leader in March 1985 and his appointment marked a turning point for the better in US-USSR relations. The deployment of Cruise in Britain and Pershing II missiles in Europe in November 1983 had prompted the Soviets to withdraw from the Intermediate-Range Nuclear Forces (INF) treaty negotiations and Strategic Arms Reduction Talks (START). But in his State of the Union address in January 1984, President Ronald Reagan made a direct appeal to the people of the Soviet Union, declaring that 'A nuclear war cannot be won and must never be fought', and therefore, 'Would it not be better to do away with them [nuclear weapons] entirely?' Reagan and Gorbachev met for the first time at the Geneva Summit in November 1985 and issued a joint statement calling for an 'interim accord on intermediate-range nuclear forces'. High-level discussions gathered pace in 1986, leading to the signing of the INF treaty between the US and USSR in December 1987, in which they agreed to the elimination of their

OPPOSITE The runway at RAF
Greenham Common after the airbase
had closed in 1993. A dug-up section
can be seen in the distance. The
material was used for the Newbury
bypass, then under construction.

ABOVE A view of Greenham Common
airbase from the perimeter fence, after
the USAF and RAF had departed. The
vehicle in the background is digging
up the runway. Newbury District
Council purchased much of the
common land in 1995.

intermediate-range and shorter-range mis-
siles, including those deployed in Britain, by
1991. For the Greenham women it seemed that
their continuous resistance had been rewarded
at last.

The first missiles left the base on 1 August
1989 and the final one on 5 March 1991. On
11 September 1992, the USAF handed the
military command of the airbase back to the
Ministry of Defence, which put it up for sale
in 1993. Much of the common land was pur-
chased by Newbury District Council in 1995,
which created New Greenham Park. Through
all this, a small group of women remained, to
ensure a proper outcome for the former base,
but the camp was finally brought to an end on
5 September 2000 after nineteen years of con-
tinuous presence. In 2002, a Commemorative
and Historical Site was inaugurated at Yellow

Gate on the land where the original camp had been located. To the satisfaction of local people as well as the Greenham women, this common, which once housed Cruise missiles, is now a haven for wildlife and a beautiful venue for outdoor activities, as well as home to a thriving enterprise centre that benefits the locality through business opportunities and the arts. There is one reminder of the former airbase: in 2012, the control tower became a listed building.

The Greenham women proved to be a powerful icon of female power from the 1980s to the present day. Their peace camp was the first of its kind and inspired similar ones around the world, from the Netherlands to the USA, Canada and Australia. Throughout its existence, the camp fostered a rich, distinctive culture – 'an explosion of creativity', according to Jo Engelcamp – in stark contrast to the forbidding, militarized side of the fence. Even those who opposed the women, such as Group Captain Stanley Keyte, were impressed: 'they were an irritation, but, yes, I had a respect for them: for their persistence, determination and single-mindedness and strength of purpose'.

Through their campaign of direct action the women shook up the peace movement in Britain and became its most radical wing. But their story also illustrates the continuity of the women's peace and protest movement. Their commitment, exuberance, ingenuity and courage were very much in the tradition of those who supported The Hague congresses of 1915 and 1919, from which the WILPF developed; or the members of the Women's Co-operative Guild with their 'Never Again' campaign in the 1930s against the return of military conscription for men in any future wars.

The East-West rapprochement in the mid-1980s not only affected the Greenham

ABOVE A bronze maquette of the statue known as the *Greenham Marcher* by the Maltese sculptor Anton Agius. The full-size statue is in City Hall, Cardiff, in honour of the women-led group that completed the 125-mile march from Cardiff to RAF Greenham Common, Berkshire, in 1981 to protest against the plan to store American nuclear missiles in the UK.

OPPOSITE In 1980, the British government announced that it was going to replace Polaris with Trident nuclear weapons. It provided a recruiting point for CND.

TRIDENT
£7,260m WORTH OF DEATH

THE TRIDENT SYSTEM will be the most destructive nuclear weapon ever devised.

● Each Trident carrying submarine weighs 16,000 tons and is 560 feet long with a top speed of around fourty miles an hour. The submarine is comparable to an underwater destroyer class ship.

● Each submarine will carry 24 Trident missiles. Each missile will have a MIRV (Multiple Independently Re-entry Vehicle) capacity of delivering between 8 and 17 warheads.

● Each warhead will have a blast of approximately 100 Kilotonnes (i.e. 100,000 tons of TNT equivalent). Each warhead will have a range of 7000 kilometers and will be manoeuvrable with an estimated 50 meter accuracy at maximum range and an unpreccedented 10 meter accuracy at shorter ranges.

● Replacing Polaris with Trident will cost an estimated* £4,500 million for roughly equivalent firepower. Each Trident missiles costs between £18 and £25 million (excluding warheads: cost unknown) Each Trident carrying submarine costs £500 million.

● To re place Polaris missile for missile and sub for sub would cost a minimum of £58 00 million. To honour the commitment to increase the nuclear submarine fleet from four to five would bring the replacement cost to a minimum of £7,260 million.

● The missiles will have to be imported (under the terms of the Nassau agreement) from the USA. To arrive at the true cost of the programme some allowance should be made for the cost of warheads, research and development and maintenance. Scrapping the Polaris system, almost in entirely, will represent a dead loss of some £5,000 million on its construction, development and maintenance to date.

● For comparison, the cost of construction staffing and equipping a medium sized general hospital was estimated in the summer of this year as £120 million.

* Farooq Hussain, New Scientist 4 October 1979.

JOIN CND NOW!

CUT ALONG THIS LINE

Membership rates.
Adults (£6). Two or more people at same address (£9). Students and youths under 21 (£3). Unwaged and school students (£2). Receive all our new publications with a CND lit sub. Extra (£2).
IF YOU CAN... Please pay by filling in and returning this
bankers order form

To the manager............Bank Ltd.

........................(Address)

Please pay the Co-Operative Bank Ltd., 110 Leman Street, E1 (Code 080308) for the account of the Campaign for Nuclear Disarmament (A/C No:

50036163) to sum of £...............

on theday of.......198......
and thereafter every Month/-Quarter/Six Months/Year* until countermanded by me, at two months notice. (*Delete as appropriate).

Signed...........................

NAME..............(block capitals)

Account Number...................

Address.............(block capitals)

Membership Category (for CND office use only)

Adult	
Student	
Unwaged	
Couple	
Youth + Lit Sub	

IF YOU CAN'T PAY BY BANKERS ORDER. Then please fill in the following form and send cash or a postal order filling in the membership category above.

I enclose my annual subscription: put it to good use!

£.................
Optional literature subcription (extra £2). Literature subscription is only open to those who are members or who are joining CND. You can't have a Lit Sub without being a member of the campaign.

Lit Sub £.........

Additional Donation (if any) £.........

Total £.........

Date of Application.........

Name and address (block capitals).....

...................................

All best wishes and many thanks! —
CND office workers.
11 Goodwin St, London N4

WE WILL PUT YOU IN CONTACT WITH YOUR LOCAL GROUP

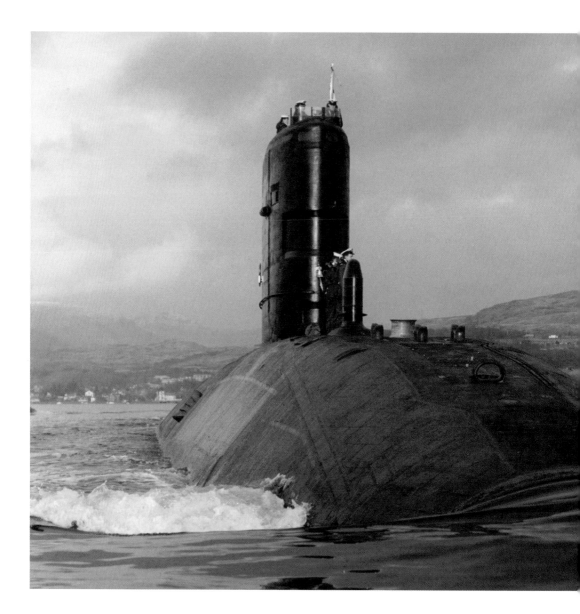

women's camp but also the interest of the general public in the wider peace movement. Membership of CND declined from 110,000 at the beginning of 1985 to 70,000 in 1988. That year, Air Commodore Alastair Mackie, a vice-president of CND, commented on the need to continue campaigning despite apparent victories:

One of the disadvantages of the INF [treaty] has been the leaping by the uninformed public to the conclusion that it's all over and we needn't bother any more...but it's a minor manifestation in a long process, a stimulus for us to do more...to redouble our activities.

The fall of the Berlin Wall in 1989 and revolutions in eastern and central European countries initially stimulated hope of a new era of nuclear disarmament. But with the disintegration of the Warsaw Pact and the Soviet Union in 1991, there were fears of nuclear technology and material being stolen or sold to terrorist groups and the threat of a new form of nuclear proliferation. In the UK, there was concern within CND about Britain contravening Article VI (a commitment to move towards nuclear disarmament) of the Non-Proliferation Treaty from 1968 with the introduction of Trident, the latest submarine-launched missile, underway. The *Vanguard*-class of submarines that would carry Trident began to be built in 1986 and work continued until 1998. This prompted a new wave of protests against nuclear submarine bases, and campaigners started tracking the convoys transporting nuclear weapons by road to bases in Scotland. The proposed US Strategic Defense Initiative, a research programme into ballistic missile defence, popularly known as 'Star Wars', also provoked opposition, and there was anxiety about the status of the 1972 Anti-Ballistic Missile Treaty after the collapse of the Soviet Union. The anti-nuclear struggle was far from over.

Ernest Rodker, speaking in 2015, paid tribute to CND's longevity:

> *What is remarkable is that CND has managed to keep going as long as it has. That is very, very unusual – over fifty years and still a quite well supported organization...very few organizations have lasted as long as CND and have still got a voice.*

HMS *Sceptre*, which carried Tomahawk Cruise missiles, at Gare Loch, Scotland, 1995. In the background is Faslane naval base, where the *Vanguard*-class nuclear submarines that carry the Trident ballistic missiles are stationed.

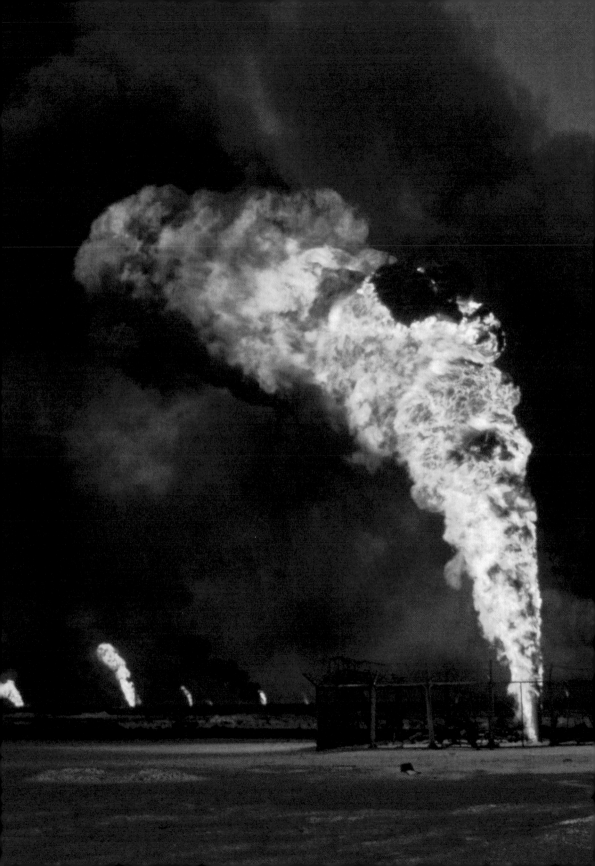

5 THE NEW WORLD ORDER

OPPOSITE Blazing oil wells, photographed by Laurie Manton, an official correspondent for the *Soldier* magazine in the Gulf War, 1991.

Since its campaigns in the First World War, the anti-war movement has constantly developed and evolved in response to changes in world affairs. When the Cold War ended in 1990, followed by the disintegration of the Soviet Union in 1991, the balance of power that had existed between the two superpowers and had introduced a degree of order to international relations gave way to a unipolar system, dominated by the United States. Although many shared President George H. W. Bush's vision of a new world order founded on peace and justice, others considered this merely a means to give legitimacy to narrowly defined American policy interests, in an era when, as Bush declared, 'what we say goes'. Kate Hudson, vice-chair of CND at the time, remembered how 'the first writing on the wall' that things had not changed' was when the Warsaw Pact was dissolved and NATO wasn't'. There was general concern that the threat of world nuclear conflict might have diminished but new and less manageable forms of warfare would emerge. And almost at once, regional and intrastate conflicts erupted in the Middle East and the Balkans, leading to Western intervention.

When President Saddam Hussein of Iraq invaded the oil-rich state of Kuwait in August 1990, the international response was immediate. By January 1991, troops from more than thirty countries, led by the United States, were poised in Saudi Arabia ready to enforce a UN demand for Saddam to withdraw unconditionally.

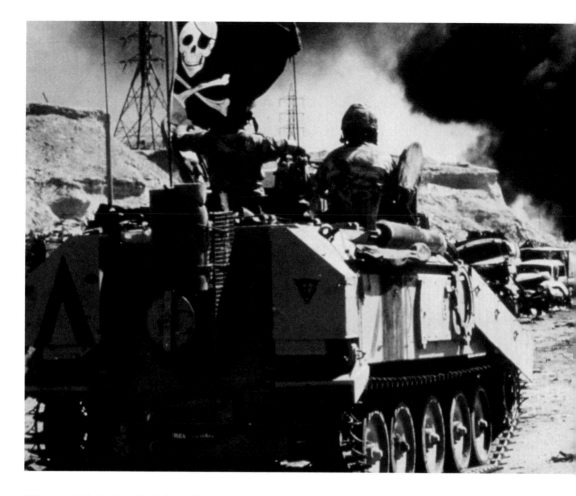

'Thomas Wadey', a British soldier, was keen to be part of the coalition operation, thinking that he would be 'keeping the peace blue-beret style'. It was during his training in Wales that he became increasingly unhappy, especially with lectures that he thought included repeated and explicit racism towards Arabs. He began to realize that the whole exercise was 'punitive, it was expeditionary, it was imperialist, it was based on lies...The hardest thing was that I was going to break my duty. And I knew I was going to have a hard time.' Having no idea of his rights as a conscientious objector, Wadey went on the run until apprehended by the authorities. After a court martial he was sent to jail for fourteen months for going Absent Without Leave.

Although all members of the British armed forces have been volunteers since the end of National Service in 1963, there have been a number of applications for conscientious objector status over the years. The Ministry of Defence considers that it has a 'well-established procedure' for such cases, which are handled by the relevant service. A non-departmental public body, the Advisory Committee on Conscientious Objectors (ACCO), was established in 1970 to hear appeals from those applicants rejected by the service authorities.

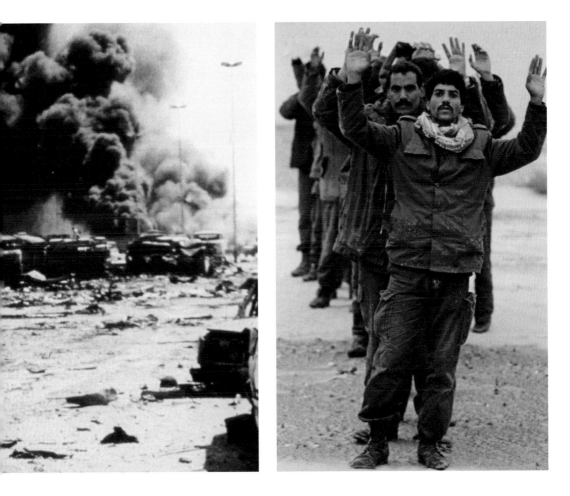

For the period 1971–2010, of those in the three services who sought to be COs, figures are only available for the Royal Navy: fifty-five applied, sixteen were turned down, and of those who appealed, three were successful and eleven unsuccessful.

On 17 January 1991, Operation Desert Storm began with massive bombing raids on Iraq and Kuwait; it was the most intensive air campaign ever waged with over 100,000 missions, dropping ten times the explosive power of the Hiroshima atomic bomb. After five weeks of air and naval bombardment, the ground offensive started on 24 February. On 26 February the

ABOVE, LEFT Operation Desert Storm: A British armoured personnel carrier drives down a highway filled with wrecked and burning Iraqi vehicles, 1991.

ABOVE, RIGHT Iraqi soldiers surrender during Operation Desert Storm.

Iraqi Army began to retreat from Kuwait City towards Basra and rapidly became a sitting target for attacks by US and Canadian air and ground forces – the resulting scenes of smoking vehicles and corpses led to the road being called the Highway of Death. Sergeant Eric Bollinger, working in an intelligence squadron of the US Marine Corps, debriefed pilots returning from the raids; he described how some 'saw a target-enriched environment and would do anything to get out there and drop bombs on the target…I had refused to even debrief some of those pilots because they were so crazy with bloodlust'. On 28 February, President George H. W. Bush declared a suspension of offensive combat and laid out conditions for a permanent ceasefire.

THE GULF PEACE TEAM, 1990–1991

In December 1990, during the build-up to Operation Desert Storm, the Gulf Peace Team, an international group of over seventy peace activists, which included the veteran British campaigner Pat Arrowsmith, set up a peace camp at Judayyidat Ar'ar on the Iraq-Saudi border, about 250 miles southwest of Baghdad. Their aim was to interpose themselves non-violently between the warring factions. Soon after the bombing campaign started, the Iraqis took them to Baghdad, then under heavy bombardment, and accommodated them in the al-Rashid Hotel. During their brief stay there, as well as witnessing the heavy raids on the

OPPOSITE The so-called Highway of Death
from Kuwait City to Basra where the
retreating Iraqis were heavily attacked by
coalition forces along the Mutla Ridge.

BELOW John Keane, *Mickey Mouse
at the Front*, 1991. This painting of the
seafront of Kuwait City after its liberation
shows a shopping trolley filled with anti-
tank rockets and a Mickey Mouse model
from a fairground ride. The beach
is covered in excrement.

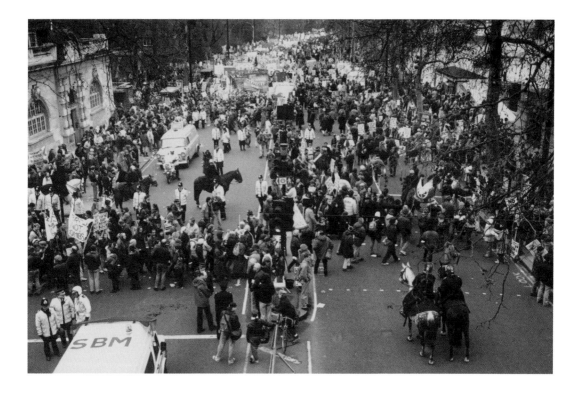

ABOVE Anti-Gulf War protesters
throng the Embankment in London
in January 1991.

OPPOSITE Two protesters with
placards prepare to join a
demonstration in London against
the first Gulf War in 1991.

city, they visited hospitals, monitoring the appalling conditions endured by patients and medical staff in the freezing weather: windows were shattered, water and electricity were non-existent and there was a shortage of medical supplies. In one well-publicized case, members of the peace team and the press were taken to a factory said to have produced powdered baby milk, which had been bombed by the Americans who claimed that it was a chemical weapons facility. One of the peace team, Mary Campbell, explained how she was convinced that the factory's product was innocuous: 'We saw evidence of milk scattered all over the place; packets of dried milk, and there were also some full boxes that had escaped the bombing.'

After three or four days in Baghdad, the Iraqis evacuated the peace campers west by road to Amman in Jordan, where some set

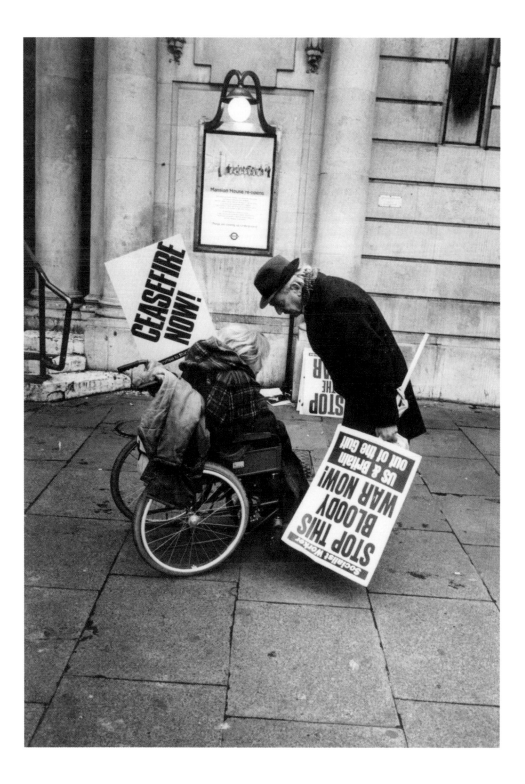

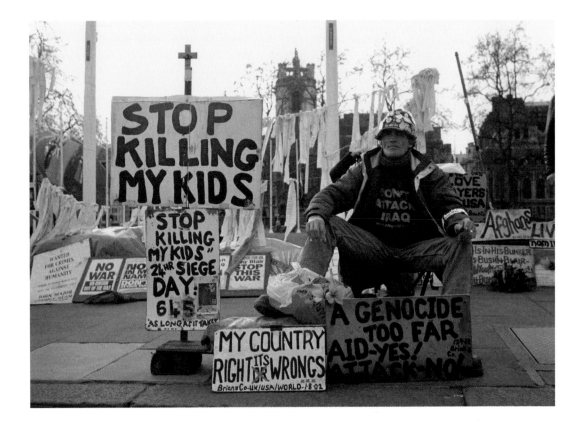

about investigating the possibility of establishing further peace camps while others returned to their respective countries. Although the Gulf Peace Team failed to have any impact on the course of the war, it had managed, for the first time, to place a group of peace campaigners between belligerents in a time of war and raised the issue of the role of unarmed 'interpositionary peacekeeping'. The concept was not new. In February 1932, following the Japanese attack on Shanghai, Dick Sheppard, the preacher and pacifist Maude Royden and Herbert Gray, a Congregationalist minister, wrote a letter to the *Daily Express* advocating a peace army of men and women who would 'volunteer to place themselves unarmed between the combatants'. They offered their services to the League of Nations and attracted 800 others, but their energies later diverted into the PPU.

BRIAN HAW'S PEACE CAMP IN PARLIAMENT SQUARE

The air strikes on Iraq in 1991 caused enormous damage to the country's infrastructure and the sanctions imposed after the first Gulf War had disastrous effects on Iraqi society. This was witnessed and publicized by peace activists in Britain and America who visited the country between 1991 and 2003. By 1996, half a million children were estimated to have died there, many as a result of sanctions preventing the delivery of essential medical supplies. It was the suffering

and deaths of Iraqi children as a result of US
and UK foreign policy that inspired the peace
campaigner Brian Haw to set up his one-man
protest in Parliament Square, Westminster, on
2 June 2001. This was three months before the
11 September terrorist attacks in the US; with the
outbreak of the war in Afghanistan in 2001 and
in Iraq in 2003, his campaign strengthened and
took on added significance.

There were numerous attempts by the
Greater London Authority and Westminster
City Council to evict Haw, but without success.
Surrounded by a vast, striking array of anti-
war banners, posters and placards, many of
which documented the horrific birth defects
that resulted from depleted uranium and other
pollutants from the Gulf War, his camp soon
became a London landmark. His concerns

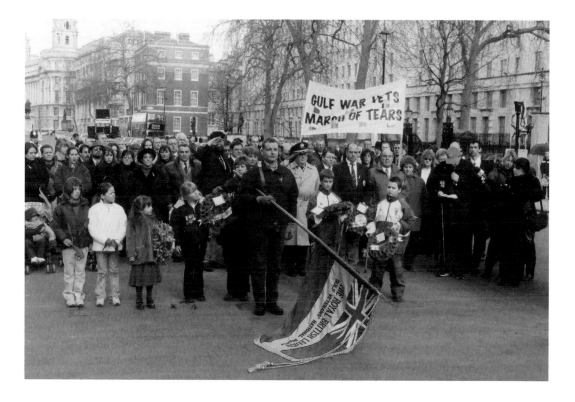

chimed with the veterans who suffered from Gulf War syndrome, which has sometimes been attributed to the effects of the 'protective' pills, injections and vaccinations the soldiers had been subjected to, as well as to the environmental hazards of the war. Haw was appalled at the lack of respect and recognition they had received and when they came to march to the Cenotaph in remembrance of their fallen comrades, he was very moved by 'one man who was bent over, a big powerful man he would have been, he could barely walk'.

Camped on the pavement, Haw was vulnerable to vicious attacks by hostile passers-by, especially when asleep in his small shelter. Although he gained many supporters – Tony Benn would hoot his car horn as he drove past – Haw was more often viewed as a nuisance and his camp considered an eyesore by many MPs. As the military conflicts unfolded through his ten-year occupation, his frustration knew no bounds: 'Where is law? Hope? "Salaam. Shalom. Peace. Justice. Peace now" – that's what I call out on my megaphone.' His objections to what he saw as the lies and evasions of President George W. Bush and Prime Minister Tony Blair blasted out continuously over Parliament Square, leading to complaints from within Parliament, and frequent calls for his removal. In the end, Haw's rudimentary living conditions – camping outdoors in all weathers – took their toll. In 2010, he was diagnosed with lung cancer and died in Germany, where he had been taken for treatment, on 18 June 2011, at the age of 62.

Many tributes have been paid to Brian Haw. Mark Wallinger, who recreated Haw's Parliament Square protest in its entirety in *State Britain* (2006), an installation in the Duveen Galleries of Tate Britain for which he won the Turner Prize in 2007, called him 'a unique

and remarkable man' and spoke of his 'tenacity, integrity and dignity'. Tony Benn regarded him as a man of high principle, writing in the *Guardian*: 'His death marks the end of a historic enterprise by a man who gave everything to support his beliefs.'

CONFLICT IN THE BALKANS, 1991–1999

At the time of the first Gulf War, tension was building in the Balkans, and by the spring of 1992 Yugoslavia had disintegrated. The process started in 1991 when Slovenia and Croatia declared their independence, and in 1992 Bosnia and Herzegovina followed, but the ethnic Serb populations opposed breaking away from Yugoslavia. This provoked internecine battles between Muslims, Serbs and Croats, age-old ethno-religious tensions that had been obscured in the Communist era, and the birth of the new states led to a series of civil wars, marked by savage ethnic cleansing. In the spring of 1992, the United Nations created the United Nations Protection Force (UNPROFOR) to monitor the ceasefire in Croatia, and bring humanitarian help in the bitter conflict raging in Bosnia. The Bosnian War was finally brought to an end with the Dayton Agreement, signed on 21 November 1995, but not before the worst episode of mass murder seen in Europe since the Second World War had taken place. This

OPPOSITE *Croatian and Muslim*, 1994, by Peter Howson, an official war artist for the IWM. The rape scene was based on victims' accounts of rapes that occurred in the Bosnian War.

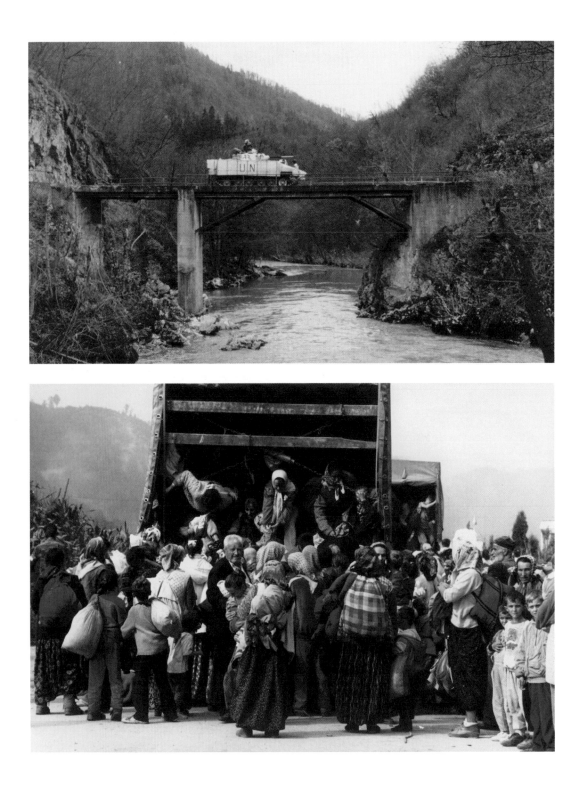

was the massacre in July 1995 of more than
7,000 Bosnian Muslim men and boys by Bosnian
Serb forces in Srebrenica, a town in eastern
Bosnia that the UN Security Council had formally
designated a 'safe area' in 1993. This left deep
and lasting emotional scars that have been an
impediment to reconciliation between Bosnia's
ethnic groups, as well as contributing to the rise
of jihadi groups in the region and beyond.

On 24 March 1999, just over three years
after the Bosnian conflict had ended, NATO
launched an intensive bombing campaign on
Kosovo and Serbia to prevent, it was argued,
a humanitarian disaster being inflicted by the
Serbs on the Kosovan Albanians similar to that
experienced earlier by Bosnians. The air strikes
were suspended in June and the Serbians agreed
to withdraw. Lindsey German, who in September

2001 co-founded and convened the Stop the War Coalition (STWC), considered that a lot of people were politicized by the Balkan wars, and that the conflict in Kosovo,

> was quite a popular war because people thought, This is saving the lives of refugees – a perfectly reasonable thing. But those who opposed it were very tough politically. They understood that it wasn't just a humanitarian issue, that there was an element of imperialism, and that's where I was coming from, too.

Since the UN Security Council had not given approval of the NATO bombing campaign, it has remained controversial in some quarters.

9/11 AND THE WAR ON TERROR

Concerns about an increasingly unstable world were heightened dramatically by the al-Qaeda terrorist strikes of 11 September 2001 on America. The attacks using hijacked civilian aeroplanes on the World Trade Center in New York and the Pentagon in Washington, DC, and the attempt that ended in a crash in a Pennsylvanian field, were profoundly shocking. Dianne Lee, a peace campaigner in St Louis, Missouri, remembered the horror of that day, 'but I think even more horrible were the days that followed, and hearing the hatred and calls for vengeance here in the United States'. President George W. Bush's call for a 'War on Terror' galvanized Americans and was initially welcomed in other parts of the world, too, although not his use of the word 'crusade', which was considered 'unfortunate' by many in Europe. Bruce Kent, at this point a vice-president of CND and founder chair of the Movement for the Abolition of War, established in 2001, felt that,

> In one sense, to be cruel, I think 9/11 was God's gift to the right wing in the States, because they could then declare a war that had no limits, no defined enemy, and no end in sight, and you can spend money hand over fist for this 'War on Terror'. The attack was a barbaric act, I don't justify it at all, it was a perversion of the Muslim faith, a crime of major murder.

In early October, the United States, assisted by the UK, began air strikes against the Taliban in Afghanistan, a regime that had supported al-Qaeda and provided sanctuary for its leader, Osama Bin Laden, thereby making itself, it was argued, a prime target. The Taliban were soon defeated in the short term, mainly by American military strength, supported by a limited 'coalition of the willing'.

The war in Afghanistan was the first phase of a wider and much more aggressive American strategy that attacked Islamic terrorism worldwide. In January 2002, the stakes were raised by President George W. Bush in his State of the Union address when he outlined an 'Axis of Evil', which included the 'rogue' states of Iran, Iraq and North Korea. The US National Security Strategy of September that year, which advocated a policy of unilateralist, pre-emptive war, was to have serious consequences for human rights. By 2004, Amnesty International reported that human rights and international humanitarian law were under their most sustained attack in fifty years.

OPPOSITE Smoke billows from the south tower of the World Trade Center in New York City after the hijacked United Airlines Flight 175 from Boston crashes into the building on 11 September 2001.

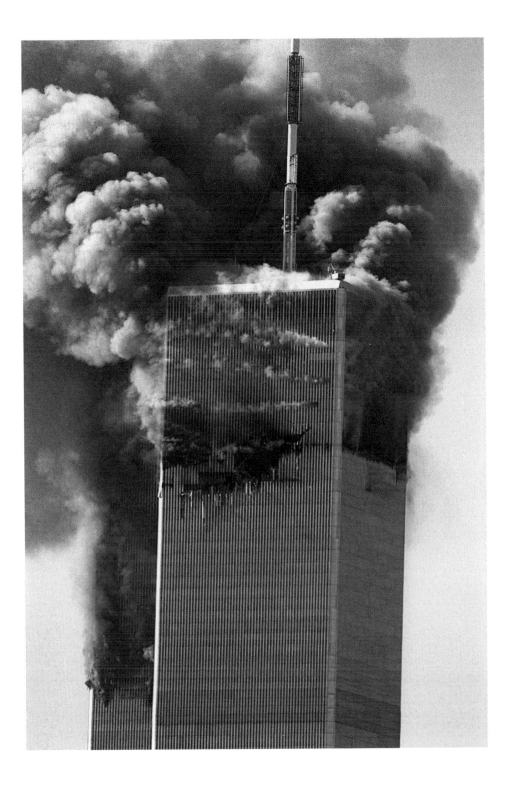

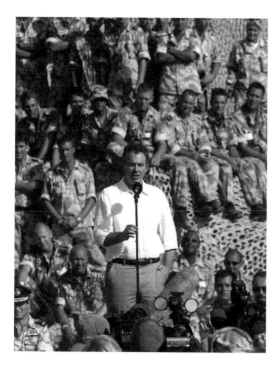

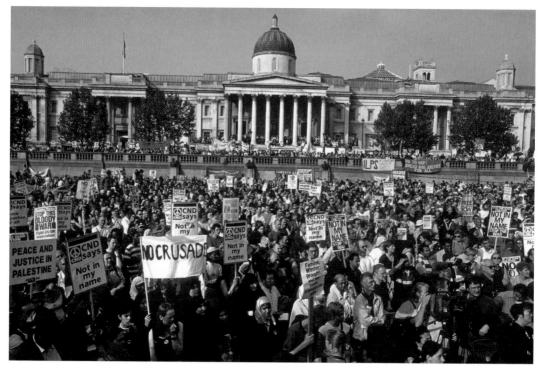

LEFT Prime Minister Tony Blair addresses British troops at Camp Sha'afa in northern Oman three days after the US-led Operation Enduring Freedom to oust the Taliban began in Afghanistan, October 2001.

BELOW A rally in Trafalgar Square, London, on 13 October 2001, following a march against the bombing of Afghanistan after the terrorist attacks in the US on 11 September 2001.

GUANTANAMO BAY PRISON CAMP

In Afghanistan, procedures such as imprisonment without trial, torture and extraordinary rendition – government sponsored abduction and transfer of a person without legal process – were adopted by the occupation forces, behaving in a way more associated with the representatives of police states than democracies. One of the most serious cases of human rights and humanitarian law abuses concerns Camp X-Ray – a hastily erected detainment and interrogation facility located at the US naval base in Guantanamo Bay, Cuba. Its story is inextricably linked with the controversial wars in Afghanistan and Iraq and with the continuing crises in the Middle East. On 11 January 2002, the first twenty prisoners arrived at Guantanamo, which was specifically selected as a prison for those who had been captured and sold to the Americans for a generous bounty by their allies in Afghanistan and Pakistan, because it was deemed to be beyond the reach of the usual US law. Since it opened, 779 prisoners have spent time in Guantanamo, all held without charge or trial, reaching a peak of 697 in May 2003. As of July 2016, there were still eighty inmates. Guantanamo developed into what has been described by Lord Steyn, a British Law Lord, as a 'legal black hole', with detainees held under a brutal regime of interrogation and subject to systematic physical and mental torture. Prisoners were denied access to their families and, until 2004, despite vigorous challenges from lawyers such as Clive Stafford Smith, without access to legal representation. They were labelled 'illegal enemy combatants', a category of prisoner recognized only by the White House and the Pentagon, and denied the protection of the Geneva Conventions.

Organizations such as Reprieve, Amnesty International and Human Rights Watch, outraged by the news that was leaking out, started campaigns to gain legal access to the prisoners and to obtain their release. In the UK, local anti-war groups and individuals were also very active. In Brighton, the 'Save Omar [Deghayes]' campaign, led by members of his family, local people and human rights groups, gained huge support from the community, including the city's MPs, council and leading newspaper, as well as from well-known activists such as Tony Benn, Bruce Kent and Vanessa Redgrave. This vigorous campaigning, spurred on by human rights lawyers such as Clive Stafford Smith and Gareth Peirce, had a huge impact and led to Deghayes's release in 2007 after nearly six years in captivity without charge or trial, during which he endured brutal beatings, including one in which he lost an eye.

It was not until October 2015 that the last detainee from the UK, Shaker Aamer, a British resident, was released after more than thirteen years in Guantanamo. Captured in Afghanistan, where he was engaged in humanitarian work, he was sold to the Americans for a bounty and incarcerated in the US prison at Bagram airbase before being flown in February 2002 to Guantanamo Bay. He was alleged to be a 'close associate' of Osama bin Laden and to have fought in the battle of Tora Bora in December 2001. During his imprisonment, he was subject to ill-treatment at times amounting to torture, endured long periods in solitary confinement, went on hunger strike and was force-fed. Allegations against Aamer were dropped in 2007, but it took another eight years before he was reunited with his wife and four children, the youngest of whom, Faris, he met for the first time. Shaker Aamer never expected to leave Guantanamo alive, but like Omar Deghayes, robust support groups and

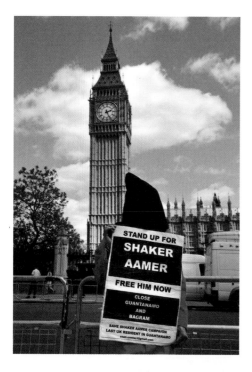

PRECEDING PAGES US military police guard the first prisoners to arrive at Camp X-Ray, Guantanamo Bay, Cuba, 11 January 2002.

LEFT The first of five daily protests by the London Guantanamo Campaign against the detention of Shaker Aamer, 3 June 2013. Formed in 2006, this group campaigns for justice for all Guantanamo's prisoners.

BELOW Members of the 'Save Omar' campaign demonstrate in Brighton during the Labour Party conference, September 2005. Omar Deghayes (Internment Serial Number 727) was detained in Guantanamo from 2002 to 2007.

OPPOSITE Protesters greet President Barack Obama outside Buckingham Palace during his state visit to the UK in May 2011.

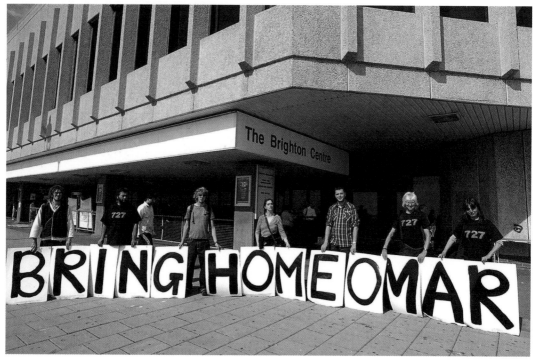

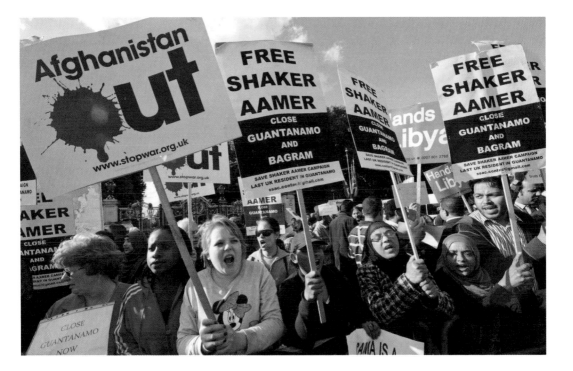

individuals were working on his behalf. These included the Save Shaker Aamer Campaign, We Stand With Shaker Aamer group and the London Guantanamo Campaign.

Despite President Barack Obama expressing a desire to close Guantanamo as soon as he assumed office in 2008, he ultimately failed to do so. In December 2014, a long-delayed report by the US Senate Intelligence Committee condemned the CIA interrogation programme, which Senator Diane Feinstein called 'a stain on our values and our history'. The information it revealed about the brutality perpetrated in Guantanamo and other secret prisons to which men were rendered is vital for understanding not only how damaging a climate of secrecy can be but also the enormous impact of the policy on the reputations of the United States and Britain, with repercussions that are still evident in the Middle East and elsewhere.

THE PATH TO WAR, 2003

Undoubtedly the decision to go to war against Iraq in 2003 was the issue that had the most consequences for the anti-war movement in recent times and for stability in the Middle East. It was ostensibly over the issue of weapons of mass destruction, which Saddam Hussein was accused of harbouring (and supposedly able to deploy at forty-five minutes' notice), and the claim by the United States that the Iraqi leader was involved in the 11 September attacks. Some of the evidence used for this was based on a false confession coerced under torture from Ibn al-Sheikh al-Libi, a Libyan member of al-Qaeda who had been captured in Afghanistan in November 2001 and rendered to Cairo for interrogation by the CIA. The US Secretary of State Colin Powell relied on this false intelligence in his speech to the UN Security Council in February

2003 when he argued the case for pre-emptive war. Al-Libi later admitted that he had made the false statements to stop the torture. Eliza Manningham-Buller, who was director general of MI5, 2002–07, in a declassified letter of 22 March 2002 to the Home Office that was presented as evidence to the Iraq Inquiry in 2010, stated that there was 'no credible evidence' to suggest that Iraq was connected to the planning of the 11 September attacks, and added, 'that was the judgment, I might say, of the CIA'.

Although the British government, led by Prime Minister Tony Blair, stood firmly behind President Bush in the War on Terror, other Western European governments perceived events differently and Germany, Russia and France together played an active role in thwarting US and UK efforts to achieve a UN resolution authorizing military action in Iraq. The French Foreign Minister, Dominique de Villepin, speaking at the UN Security Council on 14 February 2003 said that France felt the use of weapon inspections in Iraq 'had not been taken to the end' and presciently warned that premature military intervention 'could have incalculable consequences for the stability of this scarred and fragile region. It would compound the sense of injustice, increase tensions and risk paving the way to other conflicts.'

These developments were deeply alarming, not only to those in the anti-war movement but also to a wider public. For seasoned campaigners, the end of the Cold War and initial hopes of a more peaceful world had led to a lull in anti-war activity but it was not long before the failure of the 'peace dividend' provoked a resurgence in protesting. The first Gulf War, the Balkan wars, the Afghanistan War and escalating conflict in the Middle East had great impact on the movement, not least because of the vast number of civilian deaths in these struggles, graphically

portrayed in the press and on TV. Brian Haw's vigil was indicative of that. These developments, coupled with the prospect of another war in Iraq, prosecuted on what many thought was a fraudulent basis and driven by the ambitions of the Bush regime, fed the huge outcry against war in early 2003, and led to the mobilization of protesters to the ranks of new anti-war organizations in Britain. These included the Movement for the Abolition of War (MAW), and Stop the War Coalition (STWC), an alliance of activists from Labour's left, many from the major trades unions, Plaid Cymru, the Green Party, the Communist Party and the Socialist Workers Party. Later, after the war had started, there was support for Military Families Against the [Iraq] War (MFAW), an organization of people whose relatives or loved ones were members of the British armed services. The Muslim Association of Britain (MAB) also protested robustly against the war. It soon became apparent that much of the revulsion against war in the twenty-first century had a very different basis from the ideological and philosophical footings of earlier protesters, although pacifism was a continuing thread.

The groundswell of popular protest culminated in vast marches on 15 February 2003 in

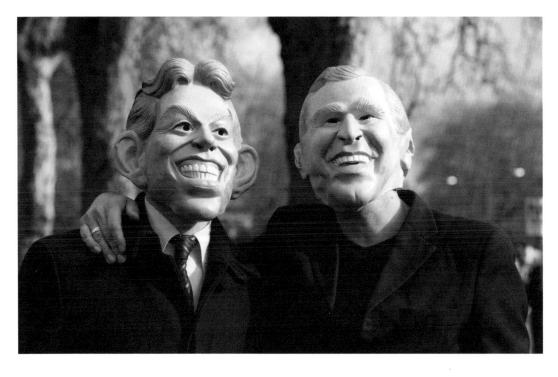

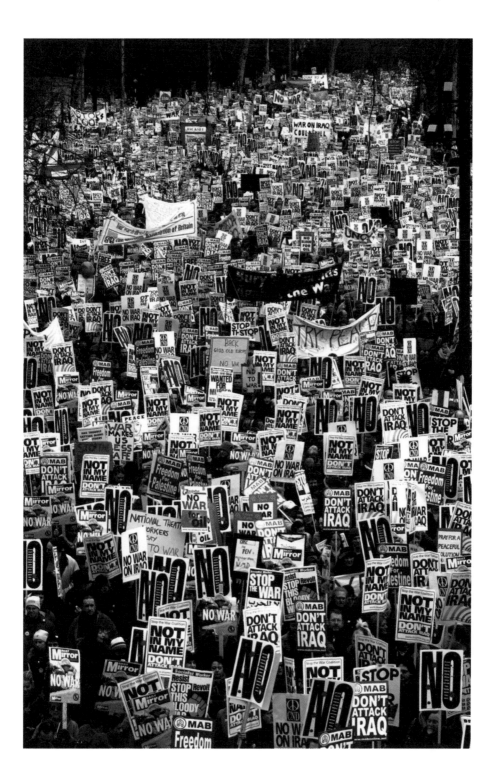

European capitals, the United States and cities worldwide. In the UK, 10,000 marched in Belfast, 50,000 demonstrated outside the Labour Party spring conference in Glasgow, where Tony Blair made a belligerent address, and an estimated two million people took to the streets in London – a record number for any such march in Britain.

In partnership with CND and the MAB, the march was organized by STWC. The hard core of the protesters were those who had opposed military action in Kuwait in 1990–91, Kosovo in 1999 and Afghanistan in 2001, but for the most part, the participants came from a diverse swath of the public, many of whom had never marched or protested before. They took to the streets not always from firm ideological positions or pacifism, but from a rising anger and fear that a war fought outside any international agreement or without UN sanction would make an already unstable world even more hazardous. David Gentleman, the artist, illustrator and designer who had created striking posters and placards for STWC, and coined the slogan 'Bliar', gave his view of the marchers:

> *The sea of people in Hyde Park was unimaginable – those two million – the biggest march in English political history...On such marches there are always some people who love chanting things and making a furore, but the great majority, it seemed to me, didn't look like red-hot political activists, but were thoughtful, amiable, ordinary concerned people...It was before the war started and I'm sure that's why it was the biggest march, because people had some hope that war – what was clearly to be a total debacle and bungle – could still have been averted. Which of course it wasn't.*

Maggie Shevlane, a teacher from Sandgate in Kent, had gone on the march because she felt strongly that the justification for war was missing:

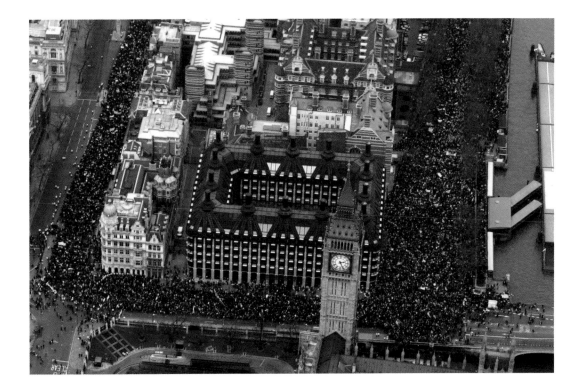

There was no direct threat to British interests; the idea of Saddam Hussein being able to send missiles within forty-five minutes was absurd...It didn't make any sense whatsoever. I went to say it was not in my name, my husband's name, my children's name.

Bruce Kent was on the platform in Hyde Park, where the march terminated: 'There were people as far as you could see. I think there was such a *massive* sense of betrayal in the country, people were outraged. Having seen the outcome of the first Gulf War, they thought: God, they can't do this thing again!' The veteran peace campaigner Ernest Rodker was on the march and remembered thinking:

This is going to have an impact; there were many there who'd never gone on a march, and nothing came of it...I think the downturn of that was that many people thought, What's the point...The biggest march that had ever been and no impact, just ignored by Blair.

On Tuesday 18 March, just over a month later, Tony Blair urged a packed, divided and sombre House of Commons that it had to 'give a lead: to show that we will stand up for what we know to be right; to show that we will confront the tyrannies and dictatorships and terrorists who put our way of life at risk'. On the evening of 20 March 2003, the war – hugely unpopular – went ahead with many questioning its legality. The Attorney General for England and Wales, Lord Goldsmith, argued that existing UN Security Council resolutions provided the necessary cover.

As the focus moved to Iraq, attention and resources – personnel and hardware – were

OPPOSITE An aerial view of the anti-war march in London of 15 February 2003, seen here passing Big Ben.

RIGHT AND BELOW Two of David Gentleman's striking designs, with his emotive blood spots, used on Stop the War Coalition demonstrations and marches, including that of 15 February 2003.

OVERLEAF Peter Kennard, *Weapons of Mass Destruction 0*, a photomontage from 2014.

Stop the War Coalition www.stopwar.org.uk 020 7053 2153/4/5/6 Designed by David Gentleman Printed by East End Offset Ltd (TU) London E3 ☎ 020 7538 2521

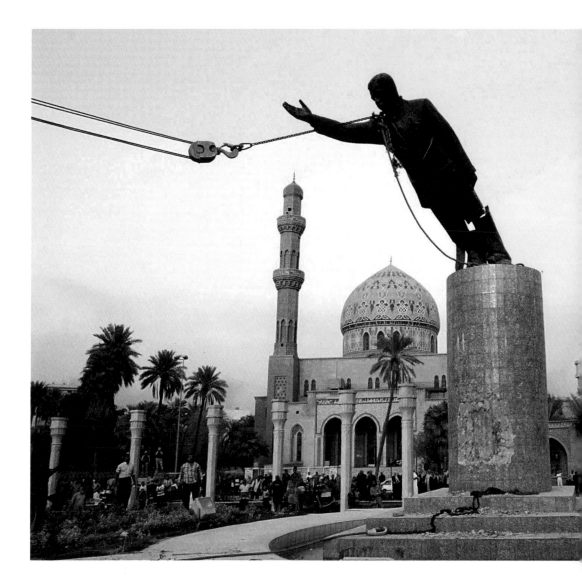

diverted from the ongoing war in Afghanistan, and the conflict there may well have been prolonged as a result. The Taliban regained strength and combat operations against them continued until 2014, with Britain and the US officially pulling out in October that year.

The war in Iraq started with 'shock and awe' explosions on Baghdad on 20 March 2003, and the ensuing campaign, led by the United States,

ABOVE A statue of President Saddam Hussein is toppled by Iraqis with the help of US Marines, Firdos Square, Baghdad, 9 April 2003.

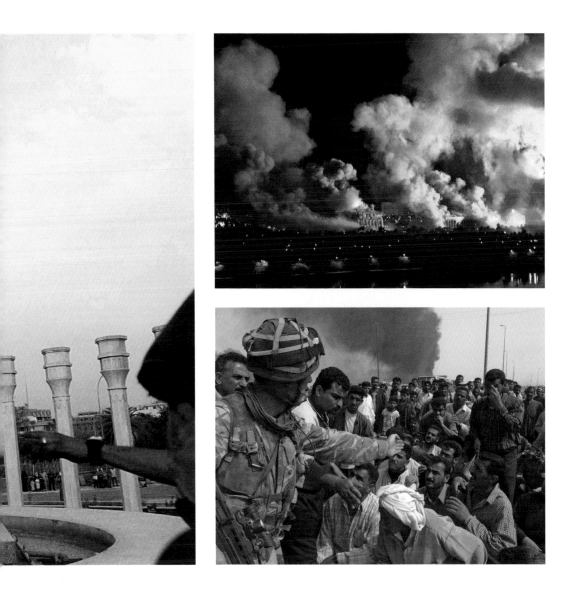

the mightiest military force in the world, with British support and more limited involvement by Australia and Poland, took just three weeks to depose Saddam Hussein. On 14 April, Tony Blair informed the House of Commons, 'we are near the end of the conflict. But the challenge of the peace is now beginning.' On 1 May, President George W. Bush, standing on the American aircraft carrier USS *Abraham Lincoln* under a

ABOVE Baghdad ablaze during the allied bombing on the first night of the 'shock and awe' operation, 20 March 2003.

BELOW Terrified Iraqis fleeing the fighting being guided by British troops across a bridge during the battle for Basra City, 21 March–6 April 2003.

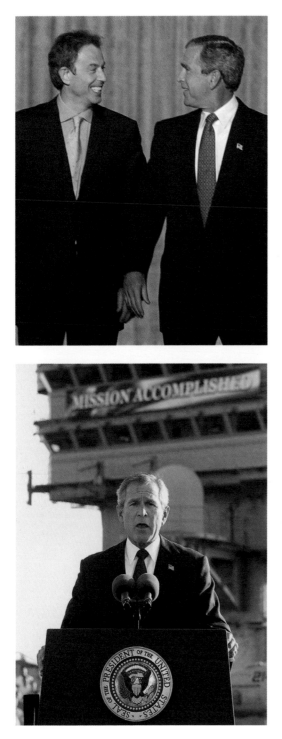

'Mission Accomplished' banner, declared in a speech to the crew: 'The liberation of Iraq is a crucial advance in the campaign against terror.'

Within a few weeks of George W. Bush's hubristic declaration, the Iraq Survey Group began looking for evidence of weapons of mass destruction – none was found, which fuelled the anger of those who had opposed going to war in the first place. Meanwhile, it became clear there had been very little postwar planning for Iraq, reconstruction was slow and attacks on coalition forces began; initially these came from Saddam's Ba'ath Party loyalists, but soon religious radicals and Iraqis angered or humiliated by the occupation joined the insurgency. Iraqi society, already weakened from the earlier war of 1990–91, began to unravel, with hundreds of thousands of violent deaths and millions being displaced. This disintegration and the bitter sectarianism that resulted from the divisive policies of the US-backed Shia government of Prime Minister Nouri al-Maliki provided a context for the emergence of one of the most menacing, powerful and resilient insurgency groups ever seen in the region or the world: the self-proclaimed Islamic State (IS).

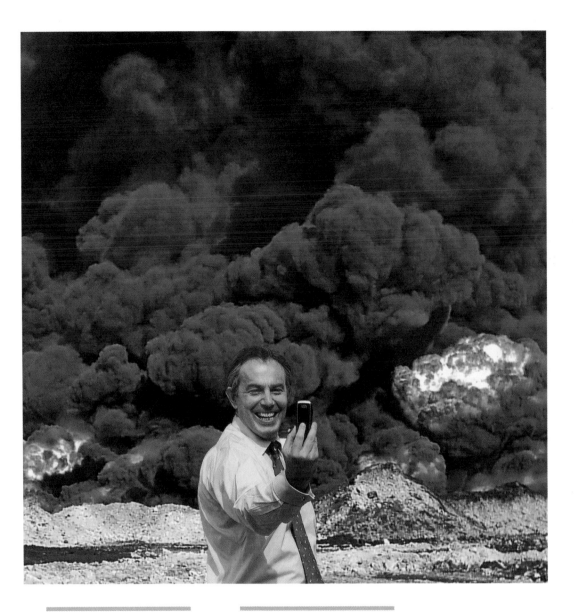

ABOVE kennardphillipps (Peter Kennard and Cat Phillipps), *Photo Op*, 2007. This montage of Tony Blair apparently taking a selfie in front of a huge explosion expresses the artists' anger at the government's decision to go to war in 2003 despite widespread public protest.

OVERLEAF Each of these 1,000 blood-spotted cards designed by David Gentleman represented 100 individuals killed in Iraq by 2006. To Gentleman, the juxtaposition with the Palace of Westminster was 'telling…because without Parliament's supine agreement those 100,000 would not be dead'.

THE RISE AND EVOLUTION OF ISLAMIC STATE

Throughout the turbulent years in which so-called Islamic State (IS) evolved, the British anti-war movement maintained its activities. After the rapid campaign to remove Saddam Hussein in Iraq, the scenario that many had anticipated and dreaded began to play out: with Iraqi insurgents fighting the US-led occupation forces, as well as each other in bitter sectarian conflict, it was clear that the occupation was going to be prolonged, multi-faceted and

costly in terms of civilian and military lives and resources. Also, as shocking evidence emerged in 2004 of serious human rights abuses – the torture and humiliation of captured Iraqis by US personnel in Abu Ghraib prison, for instance – the anti-war movement had fresh grounds for its opposition to the occupation, which it fought as vigorously as it had the war itself. It was never able to mobilize two million people on a demonstration again, but as Lindsey German, convenor of Stop the War Coalition, explained in an interview in 2016, something important had been achieved: 'I think one of the things we

An Islamic State propaganda photograph showing masked militants, armed with AK-47 automatic rifles, holding the black banner of Muhammad, January 2015.

did do [in February 2003] was to create a much more *permanent* anti-war consciousness... I don't think that consciousness has gone away.'

After the fall of Saddam, three objectives were adopted by STWC: to end the occupation of Iraq (bring the troops home); to hold the government to account; and no more wars. 'Don't Attack Iran' signs were seen on the streets from around 2006, when it was feared that George W. Bush's regime was thinking of extending the War on Terror to that country. It was the spread of conflict to Syria in 2011, however, that gave new impetus to the anti-war movement and fresh challenges were presented with the growth of IS and the spread of terrorism to Europe.

Islamic State was first known as al-Qaeda in Iraq (AQI), and originated with an al-Qaeda recruit named Abu Musab al-Zarqawi, who began building a base in Iraq in 2002 and, after the US invasion, fostered a Sunni insurgency against the majority Shi'ites. Al-Zarqawi was killed by US air strikes in June 2006, but his followers declared the Islamic State of Iraq (ISI) in October that year. However, the movement's strength waned after a US troop surge launched in Iraq in 2007. It was contact between former members of Saddam's Ba'ath Party and Sunni rebels in Iraqi prisons, together with the chaos in Syria following the Arab Spring uprising of 2011 against Bashar al-Assad's regime, that led to a resurgence. With the failure of the moderate opposition, the extremists of ISI and al-Qaeda filled the vacuum and radicalized the nascent civil war in Syria. By 2013 ISI had captured Raqqa, which became its eastern capital, and the name of the organization was changed to Islamic State of Iraq and al-Sham (ISIS).

In Iraq, the corrupt and sectarian rule of Nouri al-Maliki, and the American precipitate withdrawal of 2011, led to the capture of Mosul

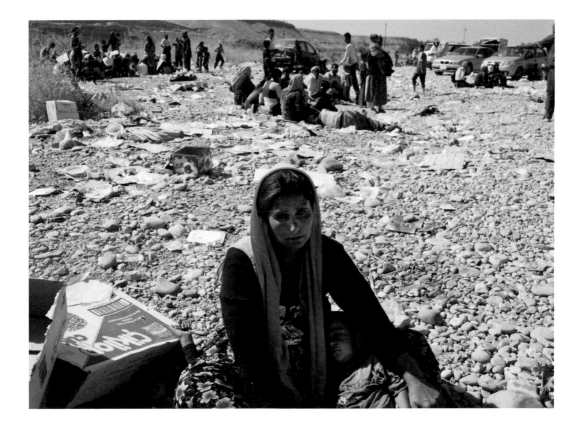

by ISIS on 10 June 2014. It was the shock of that city's fall that brought ISIS to the full attention of the West. ISIS continued to advance and by the end of June, having seemingly erased the northern part of the border between Iraq and Syria imposed under the Sykes-Picot Agreement of 1916, had declared itself a caliphate – an Islamic State (IS) – claiming an area greater than the size of the UK, with a population of six million. The so-called IS had now proved itself to be the most powerful jihadi group in the world. The fragmentation of Iraq and Syria into Shia, Sunni and Kurd areas meant that hopes of them remaining unitary states seemed unlikely.

Abu Bakr al-Baghdadi, leader of so-called IS since 2010 and caliph since 2014, claims to

ABOVE Thousands of Yazidis fled to Mount Sinjar to escape the IS advance in the area, August 2014.

OPPOSITE The famous Temple of Bel, in the ancient city of Palmyra, photographed in 2009, before the war in Syria.

OVERLEAF The remains of the Temple of Bel, Palmyra, photographed in March 2016 after it had been blown up by members of the so-called Islamic State.

be the successor of Muhammad and ruler of the *Umma,* the Islamic world, of 1.8 billion Muslims. The Islamic State's guiding ideology is based on Wahabism, a fundamentalist branch of Islam with roots in the eighteenth century, which is the dominant faith in Saudi Arabia. It rejects all other interpretations of Islamic faith, as well as other religions. Although religiously fanatical, and often presented in the West as backward and 'medieval' due to its brutality, the Islamic State is also a modern, well-organized, resilient political and paramilitary movement. A sophisticated propaganda system that disseminates its message through expert use of social media has been a vital factor in attracting and training a huge, diverse voluntary fighting force from countries worldwide. Its black-clad, masked fighters with their fluttering black standards displaying the seal of Muhammad strike fear into all those in their path.

In August 2014, the fall of the Iraqi town of Sinjar fully revealed the barbarous nature of IS. Members of the Yazidi community were killed, enslaved or forced to flee. With their belief system that is a mix of Christianity, Judaism, Islam and Zoroastrianism, they were considered to be 'devil worshippers' by IS. In the following months, the execution of Western journalists and aid workers shown in online videos brought home the brutality of the jihadists.

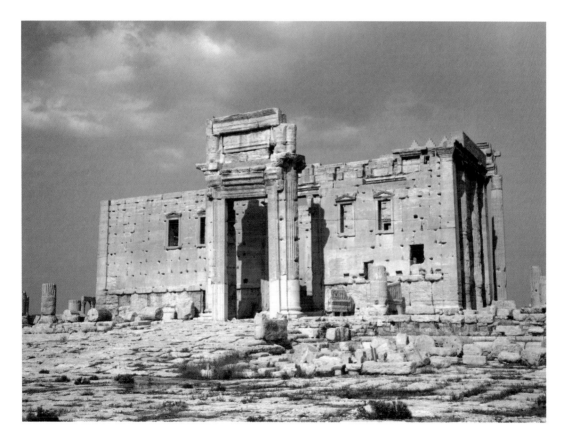

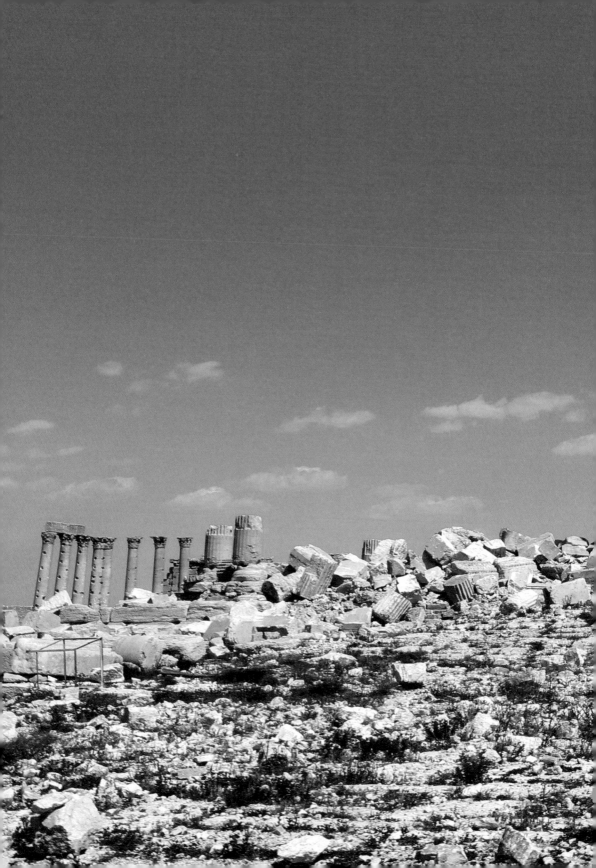

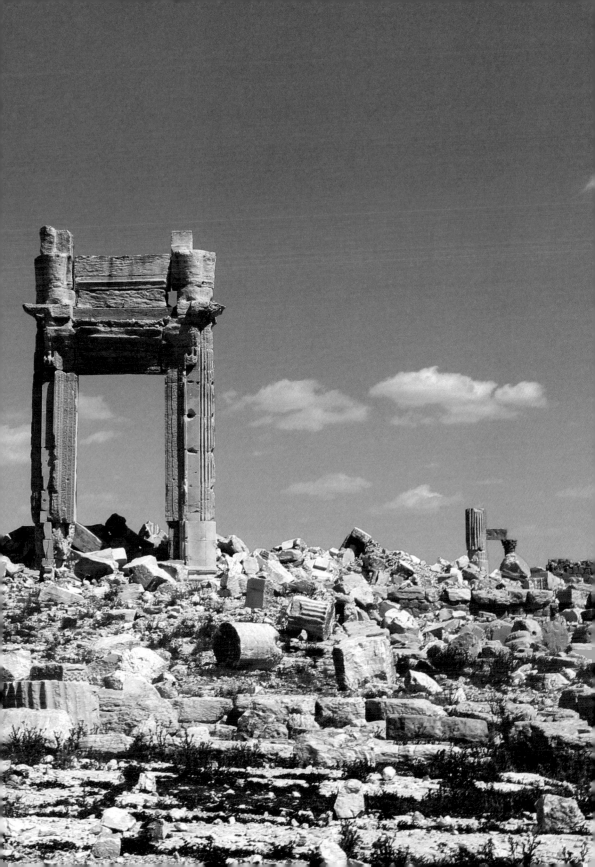

Actions of IS fighters have demonstrated a culture of intolerance and bigotry that has resulted in a systematic war against the 'idolatrous' culture of the region. In 2015, Nimrud, an ancient Assyrian city, was bulldozed and the World Heritage site of Palmyra attacked and ancient buildings destroyed. Treasures looted from these and other sites were sold to generate funds, which also derived from ransom payments from hostages, taxes on the populations of IS-controlled territories, and sales of oil from captured facilities.

The plight of the Yazidis brought the West back into the war in the region. A US-led campaign of air strikes started in August 2014. In September 2014 the British Parliament voted to support air strikes in Iraq, but the decision to extend the bombing to Syria was not agreed until December 2015, the government having lost a motion to attack Syria in August 2013. Russia launched its first air strikes in support of Assad's government on 30 September 2015.

Since the declaration of the caliphate in 2014, IS has attracted affiliates from a range of extreme Islamic groups worldwide and has evolved into a transnational movement. Since Osama bin Laden was killed in 2011, al-Qaeda has also spread and is now active in Afghanistan, Pakistan, Syria, Somalia and Yemen. It has been responsible for a range of attacks on Western targets, including the attack of 7 January 2015 on the Paris satirical newspaper *Charlie Hebdo* when twelve people were killed. This was the worst atrocity by the group since the 7 July 2005 bombings in London in which fifty-two people were killed.

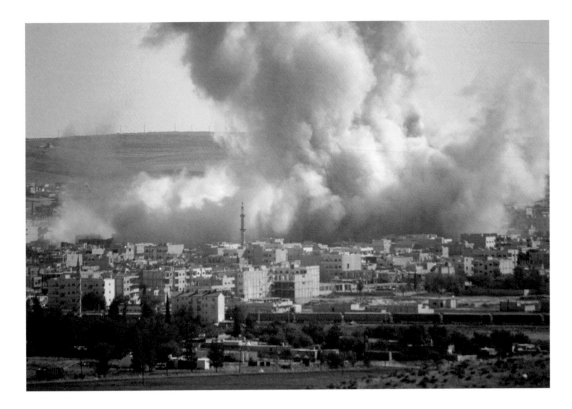

OPPOSITE Smoke rises over the
Syrian town of Kobani, following
US-led coalition air strikes in
October 2014.

ABOVE Tunisians rally in solidarity
and grief after Islamic militants kill
visitors to the Bardo Museum in
Tunis, March 2015.

Islamic State has inspired a range of so-called 'lone wolf' attacks in Western countries and trained those who have perpetrated massacres of tourists abroad. These range from the murder of the British soldier Lee Rigby in London on 22 May 2013 to the killing of twenty-two people, seventeen of them Western tourists, at the Bardo Museum in Tunisia in March 2015, and the death of thirty-eight people, including thirty British, in the Tunisian resort of Sousse three months later. On 31 October 2015, a bomb planted on a Russian airliner by the IS *Wilayat* (area under IS control) in Sinai exploded shortly after taking off from Sharm el-Sheikh, killing 224 people.

Attacks continued to escalate, with 130 killed in Paris at the Bataclan concert hall, various restaurants and cafés and the Stade de France in November 2015. This revealed signs of what military analysts call 'a complex attack' from a well-organized paramilitary underground operating in French and Belgian cities. It was planned not as one operation, but as part of a sustained campaign of urban guerrilla warfare that included attacks in Lebanon, Turkey,

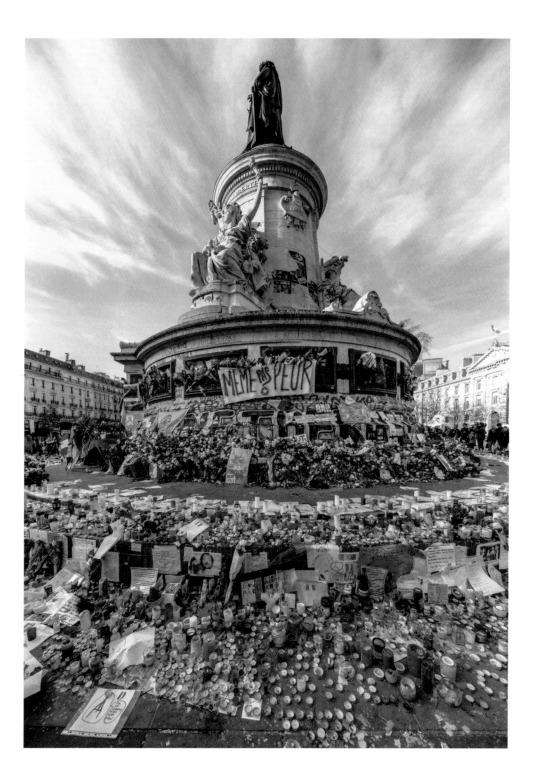

LEFT Flowers, candles and messages placed at the base of the statue of Marianne in the Place de la République in Paris in memory of the victims of the 13 November 2015 terrorist attacks.

BELOW Syrian refugees, many of them Kurds, wait behind barbed wire near Sanliurfa, after crossing into Turkey to escape advancing Islamic militants, September 2014.

France, Belgium, Kuwait and Denmark. By the end of 2015 it had killed 1,000 civilians outside war zones. IS claimed responsibility for the attacks, but had left its direction to those on the ground who were disciplined, professional and well equipped. Jean-Charles Brisard, the French terrorism expert, has called the Paris attacks of 2015 'a change of paradigm'. In Belgium in March 2016, some of those involved in planning the Paris attacks co-ordinated bombings at the airport and the Maalbeek metro station in Brussels. Further atrocities in France and Germany in the summer of 2016 were witness to the continued threat from Islamist militants.

The intention behind these attacks by IS was to demonstrate to existing and potential

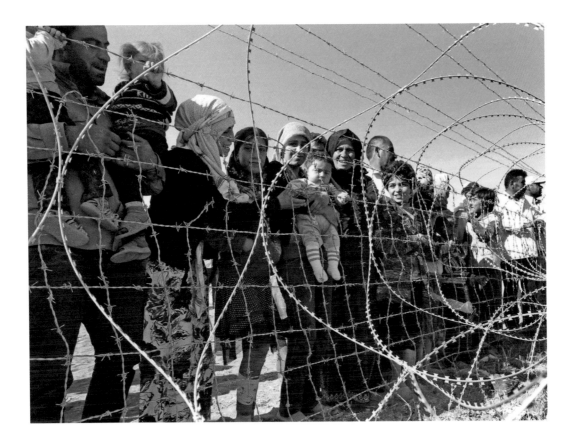

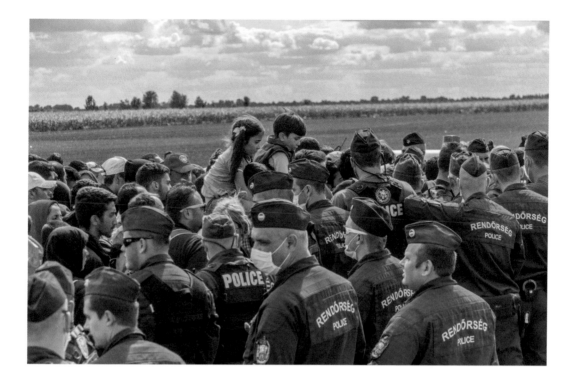

supporters the movement's capability. It also aimed to instill fear and incite community tensions by exacerbating bigotry and Islamophobia, especially in Western states with substantial Muslim minorities. These ambitions were aided by the vast influx of refugees and migrants to Europe from the Middle East, North Africa and beyond, provoked by the escalating conflicts. The EU struggled to find a co-ordinated response to the worst refugee crisis since the end of the Second World War. This played into the hands of IS: footage of exhausted Muslim families huddled before ranks of police behind barbed-wire fences, and scenes of desperate people tightly packed on flimsy rubber boats shown on social and mainstream media, provided ample propaganda for their cause.

The estimate of the number of paramilitary fighters within the movement varies and many

ABOVE Hungarian police at the border with Serbia try to block the advance of Syrian refugees attempting to reach a makeshift camp for asylum seekers near Roszke, southern Hungary, September 2015. A week later Hungary closed the border.

OPPOSITE, ABOVE The makeshift camp in Calais, nicknamed the 'Jungle', set up by migrants and refugees wishing to cross to the UK from France, photographed in November 2015.

OPPOSITE, BELOW Iraqi pro-government forces advance on Fallujah on 23 May 2016 as part of a major assault to retake the city from so-called Islamic State.

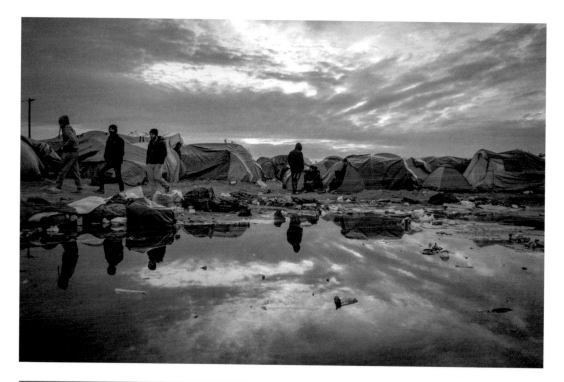

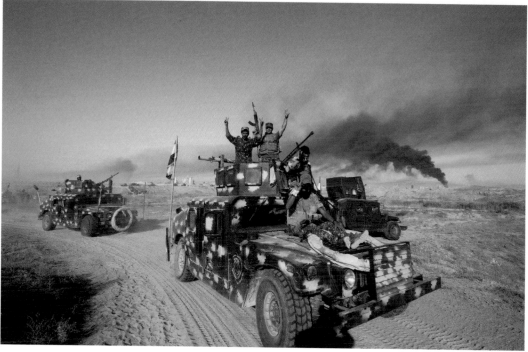

have been killed in air strikes. US intelligence agencies calculate those joining IS from outside Iraq and Syria at 15,000 in mid-2014, rising to between 25,000 and 30,000 in early 2016. But IS has suffered serious reverses since then, including the fall of Fallujah in May 2016, and a sustained attack on its stronghold of Mosul, which began in October that year.

Many in the anti-war movement fear that 'mission creep' will occur and that the Western bombing campaign in Iraq and Syria will be supplemented by a land offensive. Special Forces from the US and Britain are already operating covertly in the region, with no public or parliamentary accountability. There is also concern about a more overt conflict between the US and her allies, and Russia. All analysts predict a long and 'endless war'. In 2016, Lindsey German expressed her concerns for the region's future:

In my more pessimistic moments it reminds me of the Thirty Years' War in the seventeenth century; there are so many interests in keeping the war going. In the talks about Syria, the Americans until recently seemed determined to keep Assad out, and that means that you're never going to get serious talks;...you feel this situation could go on for a number of years with horrifying consequences.

PEOPLE POWER SINCE 2003

Peaks and troughs of activity have been a feature of the anti-war movement over the past hundred years. Following the high watermark of mass protests just prior to the Iraq War in 2003, campaigning declined but STWC, supported by other anti-war groups, maintained its ability to mobilize tens of thousands on the streets, sometimes in connection with other issues, such as the situation in Israel/Palestine. Islamophobia also became a major concern following the 7 July 2005 attacks in London and was more pronounced from 2014 when the IS-planned urban attacks on Western states started. Throughout, STWC continued to have good relations with the Muslim Association of Britain. The Movement for the Abolition of War sought to communicate with the Muslim community, and its leader, Bruce Kent, paid several visits to the Finsbury Park mosque, which had had a reputation as a centre of radical Islamism in the 1990s: 'I'm sure there are hundreds in the mosques who want to join in the dialogue', Kent reported.

Campaigns were also led against the erosion of civil liberties, in particular the government's 'Prevent' strategy, first introduced in 2011 'to stop people becoming terrorists or supporting terrorism' and updated in 2015. It did not specifically target Islamists, since it could not stigmatize a particular religion, but to begin with it appeared to relate mainly to Islamic issues with very little concern about right-wing groups. Lindsey German gave two examples: a case where a child in primary school drew a cucumber (which resembled a bomb) and was reported to the police; and an instance where a teenager who wore a Palestinian badge at school was told that it was not permitted and was interviewed by the police. As German explained:

We ought to be able to deal with those things proportionately and I fear that what's happening is that Muslims will either be frightened about being politically active... or they'll be attracted to groups that cut themselves off from everybody else, and I think that in that sense, it [the 'Prevent' strategy] can be completely counterproductive.

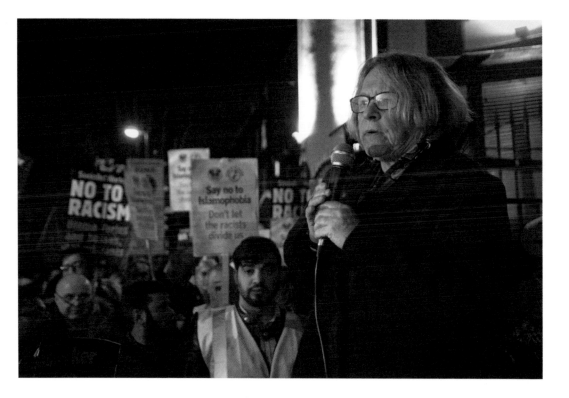

Lindsey German, convenor of Stop the
War Coalition, giving a speech against
racism and Islamophobia at a rally at
Finsbury Park mosque in north London,
November 2015.

A further contraction in the anti-war movement occurred when British forces were withdrawn from Iraq in 2009. However, in March 2011, during the Arab Spring uprising in Libya, there were demonstrations against the NATO air attacks on the Gaddafi regime. Ostensibly the military action, led by the US, British and French, came under UN Security Council Resolution 1973, calling for action to protect the civilians caught up in the fighting. This intervention thinly masked another case of regime change, this time of Colonel Gaddafi, who was overthrown and subsequently killed on 20 October 2011. Nonetheless, as Lindsey German has explained, given the complexity surrounding the Arab Spring uprisings and the bad reputation of Gaddafi, 'Libya was very difficult for us [STWC] to get a mobilization around...but...what we said about it was right'. Since the air strikes and death of Gaddafi, the state has collapsed into anarchy, giving space and opportunity for the so-called Islamic State to establish its control over three different areas of the country.

The British Parliament rejected possible military action in Syria to deter Assad's use of chemical weapons in August 2013 but the sentiment had changed by December 2015 with the spread of IS and once again MPs debated

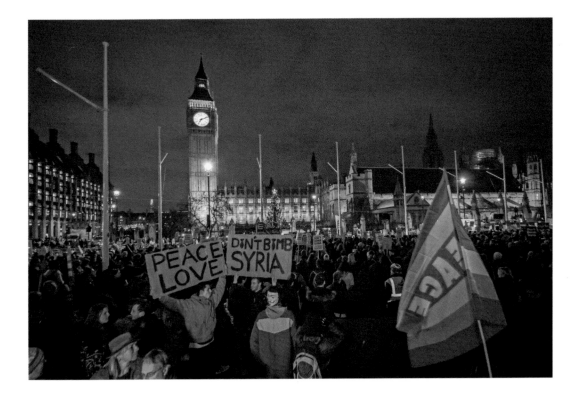

the case for air strikes in Syria. By this time the veteran anti-war campaigner Jeremy Corbyn was leader of the Labour Party and his election in September 2015 coincided with a surge in the anti-war movement. But despite his efforts against extending military action to Syria, supported by a large anti-bombing demonstration in Parliament Square, including a 'die in', the motion passed by 174 votes. Russian bombing in the area was equally condemned by the anti-war movement.

Soon after this, on 8 December, a small group of military veterans of recent wars, members of Veterans for Peace UK (VFP), threw down their medals outside Downing Street as a symbolic protest against the decision to bomb Syria. Daniel Lenham, who had

served in the RAF, held up his medals and told those gathered round that if they looked closely at them they would see,

> the reflections of dead Iraqis. You can see the embers of Libya. And you can see the faces of the men and women of the British armed forces who didn't return and also those who did with shattered limbs and shattered souls. I no longer require these medals.

The rest of the group did likewise; it was a dignified and powerful demonstration.

Veterans for Peace UK had been set up in 2011 by Ben Griffin and other military veterans. As of July 2016, VFP had 407 members, including former members from Ex-Services CND,

OPPOSITE Stop the War protest outside Parliament on the evening of the vote on extending air strikes against the so-called Islamic State to Syria, 2 December 2015.

RIGHT Ben Griffin of Veterans for Peace UK holds up his medals before throwing them on the ground outside Downing Street in July 2015, saying he no longer wanted them. In December 2015, Griffin organized a similar protest by four veterans against Parliament's decision to bomb Syria.

BELOW British actor Mark Rylance speaking at a protest outside the entrance to Downing Street against the British government's proposed air strikes against so-called Islamic State in Syria, 28 November 2015.

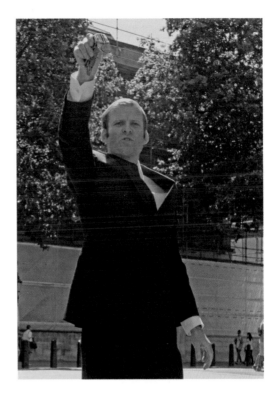

which no longer functions. It aims to resist war through non-violent action, to support war resisters, to counter militarism and to educate people of all ages, particularly the young, about the nature of war. It cooperates with Stop the War Coalition on many of its campaigns.

THE CHALLENGE OF ISLAMIC STATE

Anti-war demonstrations against the bombing of Islamic State should not be seen as indicating sympathy for the organization. From interviews conducted by the IWM with members of the anti-war movement, IS is generally viewed as a fanatical and barbaric threat to world peace. Its rise and evolution are regarded as a direct result of the failure of Western foreign policy in the region over many years, with the Afghanistan War of 2001–14, and particularly the Iraq War of 2003–09, marking important stages. Bruce Kent, for instance, speaking for Movement for the Abolition of War, explained its stance:

> We see IS as a major threat...There is a new aspect to it, as I understand their members are quite willing to commit suicide, that is a new element really...these people have got paradise fixed in their brains...I think their behaviour is horrific, but I can't be too prissy about it...it's not as if we're all lily-white and they're all bad. The people who dropped bombs on Hiroshima and incinerated 80,000 people at a go, well, how does that compare with chopping people's heads off?

There is also a firm belief that instead of bombing cities to dust, which only hardens attitudes against the West, the solution is to address the underlying conditions that have fed the conflict. In Syria, for instance, it is often forgotten that at the time of the Arab Spring in 2011, as a result of climate change, large areas of the country were experiencing drought and crop failures, which turned the country from a major exporter to major importer of grain. This displaced large numbers of people who sought work in nearby towns, which was difficult to obtain. The resulting high rate of unemployment, particularly among young people, together with the failed hopes of the Arab Spring, all contributed to the destabilization of Syria and the marginalization of Syrian youth, which helped to swell the ranks of a range of jihadi groups, including al-Qaeda and IS.

Lindsey German explained how STWC only grasped the full danger of IS when the kidnappings and beheadings started. But she argued that the threat from Islamic terrorists in Europe must be seen as proportionate:

> Everything in terms of Islamic terrorism is seen as a threat...But I think you have to say that it's not an existential threat...The problem, just as we remember from the IRA, is that you can have a small number of people who can cause a large amount of damage...It is also worth remembering if you look at the perpetrators, nearly all of them were born in Britain, or France or Belgium and are therefore in a sense homegrown, they're not an external threat. It seems to me that it has to be dealt with politically, you can't lock up every Muslim, so you have to think, How do we deal with this? And how do we get rid of their grievances?... This is a world we have created. It is a kind of underbelly of the neoliberal world really, where more and more people are left out of the successes of that world.

A protest against the renewal of Trident, London, February 2016. In the foreground, L-R: Kate Hudson (CND), Nicola Sturgeon (First Minister of Scotland), Caroline Lucas (Green Party), Roger McKenzie (Unison, the public service union) and Bruce Kent (MAW and CND).

In looking at solutions to the threat of IS, Bruce Kent also stressed the need for social justice, as well as the importance of striving to communicate with its leaders:

> *Although ISIS won't communicate, there will still be people you can talk to, to build bridges to them, then things may begin to move. It is important not to treat them as an endless enemy...We live in a world where you and I can expect to live until we're 70 or 80; in many African countries they won't make it over 45. That's the way we have constructed the world and until the world has some kind of equality, we're going to have ISIS or its equivalent developing as a revolutionary force saying: 'This is not just.'*

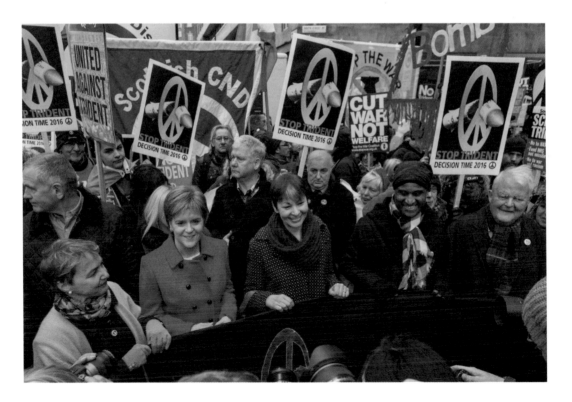

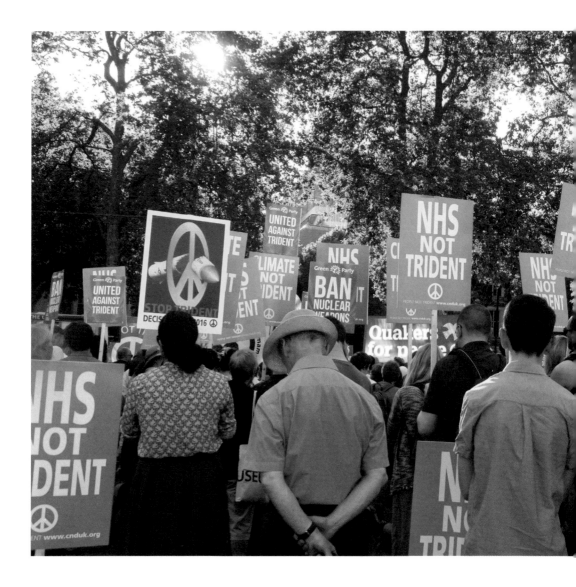

THE CAMPAIGNS AGAINST THE RENEWAL OF TRIDENT AND REMOTE WARFARE

A major and long-term concern of the anti-war movement relates to the Trident nuclear weapons system. In July 2016, MPs voted to replace Trident at a cost of £205 billion. In a blog of 12 May 2016, Kate Hudson, general secretary of CND, argued that it would be far better to spend the money 'on industrial regeneration, building homes and hospitals, tackling climate change, or meeting our defence needs in practical and usable ways'. Bruce Kent spoke of the huge concern MAW had about the decision and of the hypocrisy behind Trident's replacement; how,

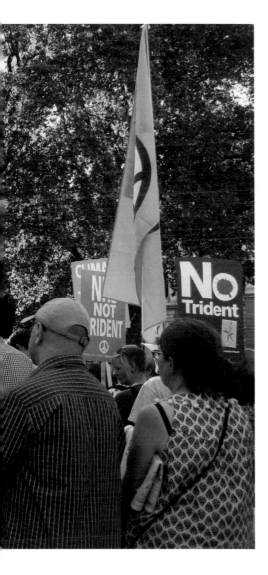

at the same time we think we can tell Iran and other countries that they shouldn't have nuclear weapons!...They still talk about the word 'deterrent'. It means nothing; it is a false pretence because it doesn't deter. I can't think of a conventional war in which nuclear weapons have had any significant effect on the groups we were fighting...Whatever the threat of ISIS, the answer to it is not nuclear weapons.

A mass lobby of Parliament organized by CND concerning Trident's renewal took place on 13 July 2016. Activists from a range of anti-war and anti-nuclear groups, including Japanese Against Nuclear UK (JANUK), who campaign to stop all nuclear power plants, demonstrated in Parliament Square. One of JANUK's members, Shigeo Kobayashi, expressed his concern that, as shown by the Fukushima disaster in 2011, damage from the eventual use of nuclear weapons or meltdown of reactors could destroy the planet.

When Parliament voted on 18 July 2016, a majority of 355 MPs chose to replace Trident. The Labour leader Jeremy Corbyn spoke out strongly against the plans. He explained that Trident's current forty warheads were each eight times as powerful as the atomic bomb that killed 140,000 at Hiroshima in Japan in 1945 and said that he did not believe that 'the threat of mass murder is a legitimate way to deal with international relations'. He added that it didn't stop the Islamic State, Saddam Hussein's atrocities, war crimes in the Balkans or genocide in Rwanda. Kate Hudson announced that CND would 'continue to campaign against replacement, working with those broad forces across society who wish to see an end to Britain's possession of weapons of mass destruction'.

A growing concern of the anti-war movement has been the increasing use of remote-control

A CND-organized vigil in Parliament Square, London, on 18 July 2016 while MPs were engaged in debate on whether or not to replace Trident. MPs from the SNP, Plaid Cymru, the Green Party and Labour joined the vigil at certain points to report on the debate and to offer solidarity.

warfare in the form of remotely piloted aircraft, most commonly known as drones. These are mainly American missions, but to date seven countries, including the UK, have used them in combat operations. Britain's role compared with that of the US is small, but it is significant. According to the anti-drone group Drone Wars UK, between September 2014 and June 2016 there were 1,427 UK Reaper Drone missions in Iraq and Syria, of which 448 released weapons, mainly over Iraq. The Drone Campaign Network, which has links with a wide range of anti-war organizations, calls for much greater transparency and accountability in the use of armed drones. Ultimately it seeks to end the use of them, arguing that they are counterproductive, undermining long-term counter-terrorism efforts and making the world a more dangerous place. Bruce Kent regards the drones as

weird, out of some horrible boys' comic...It's just chilling that modern technology can make that possible. People will say, 'Oh yes, but drones can kill war criminals', but how do you know they're war criminals until they've been through a legal process. They're not legitimate warfare at all, they're a means of assassination.

THE IRAQ INQUIRY, 2009–2016

A significant event for the anti-war movement and for those who marched in February 2003 to prevent the Iraq War, was the publication on 6 July 2016 of the Report of the Iraq Inquiry. This meant one objective of STWC had been successfully achieved: to 'hold the government to account'. In 2009, the Prime Minister Gordon Brown set up the inquiry under the chairmanship of Sir John Chilcot to examine the UK's involvement in Iraq, including the way decisions

were made in the run up to the war and to identify the lessons learned from the actions taken. By then, 179 British servicemen and -women had been killed in Iraq and many more had been seriously injured or suffered post-traumatic stress disorder (PTSD). The inquiry covered the period from mid-2001 to the end of July 2009.

It was initially intended to take no more than two years, but the final report, based on the testimony of more than 150 witnesses, as well as evidence gathered from 150,000 government documents, and running to 2.6 million words, was eventually published seven years later. It could be argued that if the report had come out earlier, it might have impacted on more recent cases of Western intervention in the Middle East. Undoubtedly the delay in publication added to the distress of the families of those killed and injured in the war.

The report gave a thorough and devastating critique of Tony Blair's decision to go to war in Iraq in 2003. It concluded that there had been no imminent threat from Saddam Hussein; that a containment strategy could have been adopted; that the severity of the threat posed by weapons of mass destruction was presented with an unjustifiable certainty; that the planning and preparations for postwar Iraq were totally inadequate and that the government failed to achieve its objectives. No judgment was passed on the legality of the war, but criticism was made of the way the legal basis was actually dealt with. Although there were complaints that the report failed to address certain aspects of the war – the central issue of oil reserves in Iraq, for instance – it was considered to be a far more scathing verdict than had been expected. This was acknowledged by Reg Keys, whose son Lance Corporal Thomas Keys was killed in Iraq in June 2003, with his comment: 'Thank you, Sir John, you've done the families

Former Prime Minister Tony Blair arrives to be questioned by the Iraq Inquiry at the Queen Elizabeth II Conference Centre, London, 21 January 2011.

proud.' Responding to the report in the House of Commons, Jeremy Corbyn, a long-term critic of the war who had voted against the invasion, apologized to the people of Iraq on behalf of the Labour Party for its role in the Iraq War. He went on to say that the International Criminal Court should have 'the power to prosecute those responsible for the crime of military aggression'.

The Iraq Inquiry confirmed what many had been thinking in 2003: that the British government was determined to go to war and, to quote Sir John Chilcot, that it was going to start before 'the peaceful options for disarmament had been exhausted'. The daily reality of life for Iraqis in large parts of the country, especially Baghdad, continues to be death, destruction, insecurity and displacement. Far from being 'an advance on terror', the Iraq War of 2003 and the precipitate withdrawal of US combat troops in 2011, have resulted in the total failure of George W.

Bush's War on Terror. What's more, it led to the rise of IS and the spread of terrorist attacks by Islamist militants in Europe. There appear to be ever-diminishing chances of peace and security, not only in Iraq, but in neighbouring Syria, and throughout the Middle East, North Africa and elsewhere.

In 1811, Percy Bysshe Shelley, then an 18-year-old student at Oxford and outraged by the conduct of the Napoleonic War, wrote a 172-line poem entitled 'Political Essay on the Existing State of Things'. Considered seditious at the time, the poem's themes are as relevant today as they were two hundred years ago. Shelley gives a passionate denunciation of war and of those responsible for its conduct, but his concluding hope that 'Peace, love, and concord, once shall rule again' should hearten the people who continue to fight for peace.

POETICAL ESSAY ON THE
EXISTING STATE OF THINGS

Percy Bysshe Shelley

Destruction marks thee! o'er the blood-stain'd heath
Is faintly borne the stifled wail of death;
Millions to fight compell'd, to fight or die
In mangled heaps on War's red altar lie.
The sternly wise, the mildly good, have sped
To the unfruitful mansions of the dead.
Whilst fell Ambition o'er the wasted plain
Triumphant guides his car – the ensanguin'd rein
Glory directs; fierce brooding o'er the scene,
With hatred glance, with dire unbending mien,
Fell Despotism sits by the red glare
Of Discord's torch, kindling the flames of war.
...

Ye cold advisers of yet colder kings,
To whose fell breast no passion virtue brings,
Who scheme, regardless of the poor man's pang,
Who coolly sharpen misery's sharpest fang,
Yourselves secure. Your's is the power to breathe
O'er all the world the infectious blast of death,
To snatch at fame, to reap red murder's spoil,
Receive the injured with a courtier's smile,
Make a tired nation bless the oppressor's name,
And for injustice snatch the meed of fame.
...

Let reason mount the Despot's mouldering throne,
And bid an injured nation cease to moan.
Why then, since justice petty crimes can thrall,
Should not its power extend to each, to all?
If he who murders *one* to death is due,
Should not the great destroyer perish too?
The wretch beneath whose influence millions bleed?
...

Snatch then the sword from nerveless virtue's hand,
Boldly grasp native jurisdiction's brand;
For justice, poisoned at its source, must yield
The power to each its shivered sword to wield,
To dash oppression from the throne of vice,
To nip the buds of slavery as they rise.
Does jurisprudence slighter crimes restrain,
And seek their vices to controul in vain?
...

 Freedom requires
A torch more bright to light its fading fires;
Man must assert his native rights, must say
We take from Monarchs' hand the granted sway;
Oppressive law no more shall power retain,
Peace, love, and concord, once shall rule again,
And heal the anguish of a suffering world;
Then, then shall things, which now confusedly hurled,
Seem Chaos, be resolved to order's sway,
And error's night be turned to virtue's day.

NOTE ON SOURCES

IWM Sound Archive

Unless otherwise stated in the text, all quotations have been taken from interviews conducted for the IWM Sound Archive, where they are held. The contributors are listed below in alphabetical order (with maiden name where appropriate), followed by the date(s) when the interview was conducted and reference number.

Allen, Denis, 1990 (11522)
Arrowsmith, Pat, 1995 (12525)
Baty, Private James, 2001 (21192)
Beaver, Douglas, 1980 (4788)
Benn, The Rt Hon. Tony, 2008 (31686)
Besly, Charles, 1992 (12746)
Bing, Dorothy, 1974 (555)
Bing, Harold, 1974 (358)
Bollinger, Eric, 1994 (14195)
Bottini, Reginald, 1980 (4660)
Bramwell, James, 1986 (9542)
Brocklesby, Bert, 1988 (10122)
Brockway, Fenner, 1974 (476)
Cadbury, Michael, 1987 (10051)
Campbell, Mary, 1991 (12222)
Daffern (Clough), Eileen, 2008 (31687)
Dennett (Rowley), Jane, 2001 (21017)
Douglas-Home, William, 1988 (10354)
Dutch, George, 1974 (356)
Eddington, Paul, 1986 (9328)
Englecamp (Wallis), Joanna, 1992 (12700)
Fox, Lloyd, 1988 (10173)
Gardiner, Gerald, 1988 (10456)
Gentleman, David, 2008 (31507)
German, Lindsey, 2009 (32727), 2016 (34609)
Gibson, Tony, 1991 (12267)
Goldring, Ernest, 1980 (4658)
Grant, Donald, 1975 (711)
Greaves (Catchpool), Jean, 1996 (16835)
Griffin, Walter, 1987 (9790)
Hardie, Leslie, 1991 (12179)
Hayler, Mark, 1974 (357)
Haley, Tom, 1988 (10143)

Haw, Brian, 2008 (32520)
Hayes, Denis, 1981 (4828)
Heard, William, 1980 (4760)
Hetherington, Bill, 2009 (32521)
Hoare, Joseph, 1974 (556)
Howse, Katrina (Kathrine Jones), 1992 (12904)
Hudson, Kate, 2009 (32734)
Huzzard, Ron, 1980 (4651)
Jenkins, Hugh, 1992 (12507)
Kennard, Peter, 2015 (34607)
Kent, Bruce, 1989 & 2008 (10925), 2016 (34608)
Keyte, Group Captain Stanley, 1993 (13376)
Kimber, Sir Charles, 1987 (9830)
Kings, Christine, 2003 (25524)
Lee, Diane, 2006 (29885)
Littleboy, William, 1974 (485)
Mackie, Air Commodore Alastair, 1988 (10138)
Marshall, John, 1988 (10307)
Marten, Howard, 1974 (383)
Meynell, Sir Francis, 1974 (333)
Morris, David, 1987 (9811)
Morrish, David, 1988 (10116)
Morrison, Sybil, 1974 (331)
Newcomb, Vic, 1986 (9400)
Norman, Frank, 1980 (4652)
Page (Watson), Nora, 1980 (4659)
Parker, Tony, 1986 (9233)
Pettit, Ann, 1992 (12745)
Petts, John, 1987 (9732)
Rée, Captain Harry, 1985 (8720)
Rodker, Ernest, 2015 (34606)
Rotblat, Professor Joseph, 1992 (12588)
Sharp, Peter, 2008 (30340)
Shevlane (Vitalis), Maggie, 2009 (32736)
Sinclair-Loutit (de Renzy Martin), Angela, 1987 (10040)
Swann, Donald, 1985 (9133)
Taggart, Mervyn, 1980 (4657)
Taylor, Dr Alan, 1993 (13649)
Turner, Doug, 1986 (9338)
Turner, Eric, 1988 (12225)
Whittle (Casselden), Fran, 1994 (13876)
Wigham (Derbyshire), Kathleen, 1980 (4761)

Winston, Stephen, 1976 (784)
Wray, Kenneth, 1980 (4696)

IWM Documents Department

The following documents have been consulted (IWM reference number in brackets):

Harrison, William (163 99/84/1)
Hayler, Mark (74/56/1)
Milne, A. A. (Spec misc J3, XX02)
Radford, John (87/63/1)
Skirth, J. R. (9023 99/53/1)

Private Papers of R. J. Petts (26178)
Red Cross Devils: A Parachute Field Ambulance in Normandy, 1945
Over the Rhine: A Parachute Field Ambulance in Germany, 1946
These two publications were written by members of 224 Parachute Field Ambulance, known as the 'Red Cross Devils', and privately printed for members only. John Petts was one of the authors and provided illustrations.

OTHER SOURCES
National Archives, Kew, London:
William Douglas-Home (pre-trial statement), Court-martial documents, 4 October 1944, Ref: WO71/917

Oxford Research Group (ORG):
Monthly reports, 2015–16, http://www.oxfordresearchgroup.org.uk/publications/paul_rogers

BIBLIOGRAPHY

Atkin, Jonathan, *A War of Individuals: Bloomsbury Attitudes to the Great War*, Manchester, Manchester University Press, 2002

Bamba, Nobuya, and Howes, John F., *Pacifism in Japan*, Kyoto, Minerva Press, 1978

Barker, Rachel, *Conscience, Government and War: Conscientious Objection in Great Britain 1939–1945*, London, Routledge and Kegan Paul, 1982

Bourke, Joanna, *An Intimate History of Killing: Face-to-Face Killing in Twentieth-Century Warfare*, London, Granta Books, 1999; New York, Basic Books, 1999

Braithwaite, Constance, *Conscientious Objection to Compulsions Under the Law*, York, William Sessions, 1995

Bell, Quentin, *Bloomsbury*, London, Weidenfeld and Nicolson, 1968; New York, Basic Books, 1968

Bell, Anne Olivier (ed.), *The Diary of Virginia Woolf*, 5 vols, London, Hogarth Press, 1977–84; New York, Harcourt Brace Jovanovich, 1977–84

Boulton, David, *Objection Overruled: Conscription and Conscience in the First World War*, 2nd edn, Dent, Cumbria, Dales Historical Monographs in association with Friends Historical Society, 2014

Brittain, Vera, *Testament of Youth*, London, Victor Gollancz, 1933

Brockway, Fenner, *Inside the Left*, London, Allen and Unwin, 1942

—, *Outside the Right*, London, Allen and Unwin, 1963

Brock, Peter, *Pacifism in Europe to 1914*, Princeton, NJ: Princeton University Press, 1972

—, and Socknat, Thomas P. (eds), *Challenge to Mars: Essays on Pacifism* from 1918 to 1945, Toronto, University of Toronto Press, 1999

Burke, Jason, *The New Threat from Islamic Militancy*, London, Vintage, 2016

Bussey, Gertrude, and Tims, Margaret, *Pioneers for Peace: Women's International League for Peace and Freedom, 1915–1965*, 2nd edn, London, WILPF British Section, 1980

Catchpool, Corder, *On Two Fronts: Letters of a Conscientious Objector*, 3rd edn, London, Allen and Unwin, 1940

Ceadel, Martin, *Pacifism in Britain 1914–1945: The Defining of a Faith*, Oxford and New York, Clarendon Press, 1980

Chadha, Yogesh, *Rediscovering Gandhi*, London, Century, 1997; *Gandhi: A Life*, New York, John Wiley, 1997

Cockburn, Patrick, *The Rise of Islamic State: ISIS and the New Sunni Revolution*, London and Brooklyn, NY, Verso, 2015

Cole, Chris, Dobbing, Mary, and Hailwood, Amy, *Convenient Killing: Armed Drones and the 'Playstation' Mentality*, Oxford, Fellowship of Reconciliation, 2010

Cole, Howard N., *On Wings of Healing: The Story of the Airborne Medical Services 1940–1960*, Edinburgh and London, William Blackwood, 1963

Connelly, Katherine, *Sylvia Pankhurst: Suffragette, Socialist and Scourge of Empire*, London, Pluto Press, 2013

Davies, A. Tegla, *Friends Ambulance Unit: The Story of the FAU in the Second World War, 1939–1946*, London, Allen and Unwin, 1947

Driver, Christopher, *The Disarmers: A Study in Protest*, London, Hodder and Stoughton, 1964

Einstein, Albert, *The Fight Against War*, ed. Alfred Lief, New York, John Day Company, 1933

Ellsworth-Jones, Will, *We Will Not Fight: The Untold Story of the First World War's Conscientious Objectors*, London, Aurum, 2008

Fisk, Robert, *The Great War for Civilisation: The Conquest of the Middle East*, London, Fourth Estate, 2005; New York, Alfred A. Knopf, 2005

Frängsmyr, Tore, and Abrams, Irwin (eds), *Nobel Lectures: Peace, 1981–1990*, London, World Scientific, 1997

Fussell, Paul, *The Great War and Modern Memory*, London and New York, Oxford University Press, 1975

Gaddis, John Lewis, *The Cold War*, New York, Penguin Books, 2005; London, Allen Lane, 2006

Gall, Sandy, *War Against the Taliban: Why It All Went Wrong in Afghanistan*, London, Bloomsbury, 2012

Glenton, Joe, *Soldier Box: Why I Won't Return to the War on Terror*, London, Verso, 2013

Greet, Kenneth G., *The Big Sin: Christianity and the Arms Race*, London, Marshalls, 1982

Gregg, Richard B., *The Power of Non-Violence*, Philadelphia and London, J. B. Lippincott Co., 1934

Guthrie, Charles, and Quinlan, Michael, *Just War – The Just War Tradition: Ethics in Modern Warfare*, London, Bloomsbury, 2007

Halliday, Fred, *Two Hours that Shook the World: September 11, 2001: Causes and Consequences*, London, Saqi Books, 2002

Harford, Barbara, and Hopkins, Sarah (eds), *Greenham Common: Women at the Wire*, London, Women's Press, 1984

Hayes, Denis, *Challenge of Conscience: The Story of the Conscientious Objectors of 1939–1949*, London, Allen and Unwin, 1949

Hersey, John, *Hiroshima*, Harmondsworth, Penguin Books, 1946

Holroyd, Michael, *Lytton Strachey, A Critical Biography*, 2 vols, London, William Heinemann, 1967–68; New York, Holt, Rinehart and Winston, 1967–68

Hudson, Kate, *CND – Now More Than Ever: The Story of a Peace Movement*, London, Vision Paperbacks, 2005

Huxley, Aldous, *Ends and Means: An Enquiry into the Nature of Ideals and into the Methods Employed for their Realization*, London, Chatto and Windus, 1937; New York, Harper and Brothers, 1937

— (ed.), *An Encyclopaedia of Pacifism*, London, Chatto and Windus, 1937; New York, Harper and Brothers, 1937

Kennedy, Thomas C., *The Hound of Conscience: A History of the No-Conscription Fellowship, 1914–1919*, Fayetteville, AR, University of Arkansas Press, 1981

Kilcullen David, *Blood Year: Islamic State and the Failures of the War on Terror*, London, Hurst and Company, 2016

Kurlansky, Mark, *Non-Violence: The History of a Dangerous Idea*, London, Jonathan Cape, 2006; New York, Random House, 2006

Lansbury, George, *My Quest for Peace*, London, Michael Joseph, 1938

Liddington, Jill, *The Long Road to Greenham: Feminism and Anti-Militarism in Britain since 1820*, London, Virago, 1989

McHugo, John, *Syria: From the Great War to Civil War*, London, Saqi Books, 2014

Mellanby, Kenneth, *Human Guinea Pigs*, London, Victor Gollancz, 1945

Milne, A. A., *Peace with Honour*, London, Methuen, 1934; New York, E. P. Dutton, 1934

—, *War with Honour*, London, Macmillan, 1940

Minnion, John, and Bolsover, Philip (eds), *The CND Story: The First 25 Years of CND in the Words of the People Involved*, London, Allison and Busby, 1983

Mitchell, David, *Women on the Warpath: The Story of the Women of the First World War*, London, Jonathan Cape, 1966

Moorhead, Caroline, *Troublesome People: Enemies of War 1916-1986*, London, Hamish Hamilton, 1987

Morrison, Sybil, *I Renounce War: The Story of the Peace Pledge Union*, London, Sheppard Press, 1962

Murray, Andrew, *Stop the War and its Critics*, London, Manifesto Press, 2016

—, and German, Lindsey, *Stop The War: The Story of Britain's Biggest Mass Movement*, London, Bookmarks, 2005

Nichols, Beverley, *Cry Havoc!*, London, Jonathan Cape, 1933

Oborne, Peter, *Not the Chilcot Report*, London, Head of Zeus, 2016

Oestreicher, Paul, *The Double Cross*, London, Darton, Longman and Todd, 1986

Oldfield, Sybil, *Women Against the Iron Fist: Alternatives to Militarism 1900–1989*, Oxford, Basil Blackwell, 1989

Pettitt, Ann, *Walking to Greenham: How the Peace-Camp Began and the Cold War Ended*, Dinas Powys, Honno, 2006

Prentice, Eve-Ann, *One Woman's War*, London, Duck Editions, 2000

Rae, John, *Conscience and Politics: The British Government and the Conscientious Objector to Military Service, 1916–1919*, London, Oxford University Press, 1970

Rogers, Paul, *Losing Control: Global Security in the 21st Century*, 3rd edn, London, Pluto Press, 2010

—, *Irregular War: ISIS and the New Threat from the Margins*, London, I. B. Tauris, 2016

Rose, Michael, *Fighting for Peace: Lessons from Bosnia*, London, Warner, 1999

Roseneil, Sasha, *Disarming Patriarchy: Feminism and Political Action at Greenham*, Buckingham, Open University Press, 1995

Russell, Bertrand, *Autobiography*, 3 vols, London, Allen and Unwin, 1967–69; Boston, Little, Brown, 1967–69

Scott, Carolyn, *Dick Sheppard: A Biography*, London, Hodder and Stoughton, 1977

Sinclair, Ian, *The March That Shook Blair: An Oral History of 15 February 2003*, London, Peace News Press, 2013

Smith, Alison, *John Petts and the Caseg Press*, Aldershot, Hants, Ashgate, 2000

Smith, Lyn, *Pacifists in Action: The Experience of the Friends Ambulance Unit in the Second World War*, York, William Sessions, 1998

—, *Voices Against War: A Century of Protest*, Edinburgh, Mainstream, 2009

Soper, Donald, *Calling for Action: An Autobiographical Enquiry*, London, Robson Books, 1984

Stafford Smith, Clive, *Bad Men: Guantanamo Bay and the Secret Prisons*, London, Phoenix, 2008

Thompson, Douglas, *Donald Soper: A Biography*, Nutfield, Surrey, Denholm House, 1971

Tolstoy, Leo, *What I Believe*, London, Elliot Stock, 1885

Weiss, Michael, and Hassan, Hassan, *ISIS: Inside the Army of Terror*, New York, Regan Arts, 2015

Wiltsher, Anne, *Most Dangerous Women: Feminist Peace Campaigners of the Great War*, London, Pandora Press, 1985

Woolf, Virginia, *Three Guineas*, London, Hogarth Press, 1938

PICTURE CREDITS

a=above, b=below, c=centre, l=left, r=right

Alamy: © Arcaid Images/Alamy Stock Photo 52, © Granger Historical Picture Archive/ Alamy Stock Photo 88, © Historic Collection/ Alamy Stock Photo 93, © SuperStock/ Alamy Stock Photo 128, © Pictorial Press Ltd/Alamy Stock Photo 145, 162b, © Mike Goldwater/Alamy Stock Photo, © Janine Wiedel Photolibrary/Alamy Stock Photo 160–61, 163bl, 194, © Homer Sykes Archive/ Alamy Stock Photo 166, © PCN Photography/ Alamy Stock Photo 201, © Paul Doyle/ Alamy Stock Photo 202b, © PjrNews/Alamy Stock Photo 206a, © Guy Bell/Alamy Stock Photo 207, © Bettina Strenske/Alamy Stock Photo 209a, © Trinity Mirror/Mirrorpix / Alamy Stock Photo 163r, 202a, 209b, 210, 212, 216, 217ar, © Handout/Alamy Stock Photo 222–23, © Gapper/Alamy Stock Photo 225, © Giannis Papanikos/Alamy Stock Photo 228, © ASK Images/Alamy Stock Photo 230, © epa european pressphoto agency b.v. Alamy Stock Photo 231, © Vedat Xhymshiti/ Alamy Stock Photo 232, © Guy Corbishley/ Alamy Stock Photo 236, © David Rowe/ Alamy Stock Photo 239; © The Argus, 206b; © Archives and Special Collections, Bangor University 63b; © Hilary and Stephen Benn 79; © Thalia Campbell 182; © Thalia Campbell/ Peace Museum 173; © Campaign for Nuclear Disarmament 124, 137, 183, 240–41; © The Commonweal Trustees and the University of Bradford 139a&b, 140–41; © The Estate of the Late Lesley Milne Ltd reproduced with the permission of Curtis Brown Group Ltd 75; © Daily Mail/Solo Syndication 45; © Peter Howson, Courtesy Flowers Gallery, London and New York. Private Collection 197; Getty: © Bentley Archive/Popperfoto 20, © PhotoQuest 27b, © Fox Photos/Stringer 71, © Bettmann 78, © Keystone-France 146, © Bettmann 147, © Hulton Archive/Stringer 153r, © Sahm Doherty 163al, © Johnny

Eggit 177, © AFP/Stringer 179, © Steve Eason / Stringer 192, © Art ZAMUR 198b, © US Navy/Handout 204–5, © Stephen Jaffe 218b, © Sebastian Meyer 224, Joseph Eid/Stringer 226–27, ETHI BELAID/AFP/Getty Images 229, © NurPhoto 233a, © AHMAD AL-RUBAYE/ AFP/Getty Images 233b, © Geovien So/ Barcroft Media/Barcroft Media via Getty Images 235, © LEON NEAL/AFP/Getty Images 237b, © Peter Macdiarmid 243; © Ben Griffin 237a; © John Hodder 158–59; Imperial War Museums: Image IWM 29, 99a. 144a, c & b, © IWM (Art.IWM PST 5086) 14, © IWM (Art.IWM PST 2734) 16, © IWM (Art.IWM PST 0410) 17ar, © IWM (Q 42036) 18al, © IWM (Q 70208) 18ar, © IWM (Art.IWM PST 5161) 19, © IWM (Q 81490) 23, © IWM (Q 107103) 24a, © IWM (Q 107105) 24b, Image IWM (Q 103667) 31, Image IWM (Q 103094) 32, Image IWM (Q 103669) 33, Image IWM (Documents.7652) 34al, 34ar, 35, Image IWM (SR 33) 38al, Image IWM (SR 32) 38ar, Image IWM (Documents.7652) 40, Image IWM (Documents.16782) 42–43, Image IWM (Documents.16782) 44, 46, © IWM (Q 65858) 53, © IWM (Q 31514) 54, © IWM (Q 95413) 55, © IWM (Art.IWM ART 2242) 56–57, © IWM (Art.IWM ART 1460) 58–59, © IWM (Q 33693) 62a, © IWM (HU 36260) 64, © IWM (EPH 2284) 66, Image IWM (LBY 83/4195) 74a, © IWM (Art.IWM ART 518) 76, © IWM (Art.IWM ART 4655) 77, © Vera Elkan (HU 71509) 80–81, © Vera Elkan (HU 71557) 82, Image IWM (HU 67513) 83, Image IWM (HU 85748) 84–85, © IWM (HU 5538) 92, © IWM (HU 36255) 94, © IWM (FX 4581) 95, Image IWM (HU 62359) 96–97, © IWM (Documents.3467) 99b, Image IWM (HU 36259) 102, © IWM (SR 382) 103, Image IWM (HU 49958) 110, Image IWM (HU 58432) 113, Image IWM (HU 52822) 114–15, Image IWM (HU 68043) 116, © IWM (BU 4058) 119, © IWM (MH 29427) 121, Image IWM (MH 2629) 123, © R. Kemish. Image

IWM (HU 51735) 130, © IWM (MAU 865) 131, © IWM (MH 23509) 132–33, © IWM (GOV 8867) 135, © IWM (K83/708) 150–51, © Isia Brecciaroli 162a, 164, 165, 170, © Pam Isherwood 167, Image IWM (AE3662.2) 171, Image IWM (4009.60.1) 175, © Fran Whittle 2009 176, © IWM (CT 2397) 184–85, © Laurie Manton (GLF 1388) 186, © IWM (GLF 1277) 188, © IWM (GLF 401) 189, © John Keane. John Keane Collection 190, © John Keane. Collection IWM 191, © David Trainer (GLF 1325) 193, © IWM (BOS 104) 198a, © IWM (EPH 3008) 199, © David Gentleman (Art.IWM EPHEM 00438) 213a, © David Gentleman (Art.IWM PST 8812) 213b, © IWM (OP-TELIC 03-010-32-293) 217br, © kennardphillipps (Art.IWM ART 17541) 219; © Helen E. Kay 28a; © Peter Kennard 127, 142, 214–15; © Peter Kennard (Art.IWM ART 15819) 152; © LSE Library 27a; © Mary Evans Picture Library 68; © Mirrorpix 21; Museum of London: © The Estate of John Hargrave/ Museum of London 67, © The Kibbo Kift Foundation/Museum of London 69a&b; © Peace Pledge Union 39 60; Reproduced by permission of Penguin Books Ltd 126l&r, 153l, 154–55; © Anna Petts and Mick Petts 90, 104; © Raissa Page/Photofusion 168–69; Press Association: © Matthew Knight/ AP/Press Association Images 28b, © AP/ Press Association Images 148, 178, © Sean Dempsey/PA Archive/Press Association Images 195, © Susan Walsh/AP/Press Association Images 218a; © Religious Society of Friends (Quakers) in Britain 49a&b, 50, 70, 87, 106, 111a&b; © Jess Hurd/reportdigital. co.uk 220–21; © Lyn Smith 118, 157, 172, 174, 180, 181, 211; © Strube/Express Newspapers/ N&S Syndication 26; © TopFoto 136; © Trustees of the Jones Estate 74b; © Wiener Library, London 86; Courtesy of Wikimedia Commons 8

ACKNOWLEDGMENTS

At the Imperial War Museum, I would like to express my gratitude to the Director-General, Diane Lees, for allowing the use of the museum's resources. Richard Hughes and Richard McDonough in the Sound Archive and Tony Richards, Simon Offord and the staff of the Documents Department have given a great deal of help. I am grateful to David Fenton, Head of Publishing and Retail, for his support. The enthusiasm of the publications team has been invaluable, and I would particularly like to acknowledge the encouragement of the Publishing Manager, Madeleine James, who has efficiently guided this book through to publication, and the assistance of Caitlin Flynn. I also wish to express my thanks to the former Head of Publishing, Elizabeth Bowers, who was responsible for setting up the project. Hannah Edwards has provided valued support in the selection and sourcing of the photographs, which form such an essential element of the book. I have enjoyed working with Sarah Gilbert and Matthew Brosnan in the Exhibitions Department, and I am indebted to Matthew for his historical expertise and editorial suggestions.

At Thames & Hudson, I thank the commissioning editor, Roger Thorp, for his support and continuing enthusiasm for the project. I am particularly grateful to my editor, Julia MacKenzie, for her fine editing skills; I also appreciate the work done by the rest of the team at Thames & Hudson, who have each contributed to the book in their own specialized way. Once again I am indebted to my agent, Barbara Levy, who has always provided advice and assistance when needed; and I am most grateful for the encouragement my friends and family have provided, with special thanks to my husband, Peter, and children, Nicholas, Alison and Kate.

I would especially like to thank Sheila Hancock, whom I have heard speaking against war in the most inspiring way on several occasions, for contributing the Foreword to this book. There are also many others who have given their own particular help, and my thanks go to: Thalia Campbell, Ben Griffin, Kathrine Jones (formerly Katrina Howse), Helen Kay, Christine Kings, David Larder, Anne Moore, Ernest Rodker, Roger Smither, Fran Whittle and Kazuyo Yamane.

Finally, I am thankful to the various copyright holders for their generosity in granting permission for the use of recordings, documents, poems, works of art and photographs, particularly the family of Tony Benn, Michael Carter, David Gentleman, Lindsey German, Mr Wilfrid Hayler, Peter Howson, Kate Hudson, John Keane, Peter Kennard, Bruce Kent, Clova Morris, Anna Petts, Mick Petts, Donald Swann Estate, the Estate of the Late Lesley Milne Ltd, and the family of William Douglas-Home. 'The H-Bomb's Thunder' is reprinted with permission from the John Brunner Estate. My apologies to any copyright holder I have been unable to trace. This story would not have been possible without the co-operation of those who have given time and effort to record their testimonies of the anti-war movement, and I gladly acknowledge that my greatest debt is to them.

It is hoped that this book, together with the Imperial War Museum's groundbreaking exhibition, will provide insights into the complexity of the anti-war issue, as well as offering a counterbalance and complement to the vast array of military accounts of armed conflict. For my part, it has been a pleasure and a privilege to meet so many people who, each in their own way, have fought against war and tried to push the world along the path of peace.

Lyn Smith

INDEX